GLAZES

FOR THE
CONTEMPORARY
MAKER

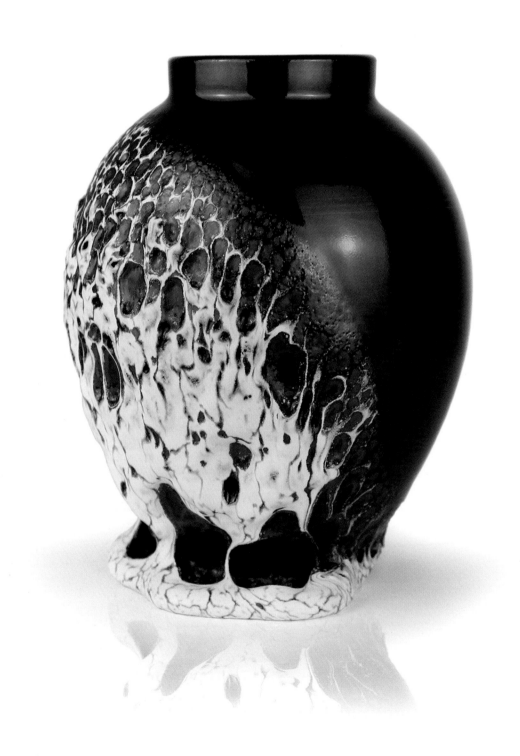

Louisa Taylor

GLAZES

FOR THE
CONTEMPORARY
MAKER

THE CROWOOD PRESS

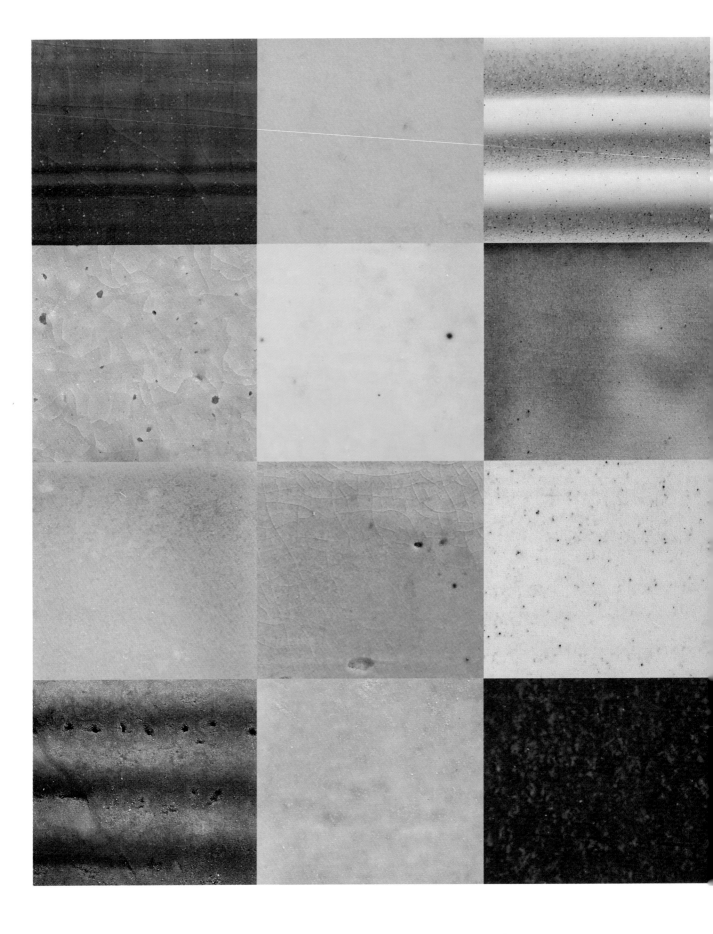

CONTENTS

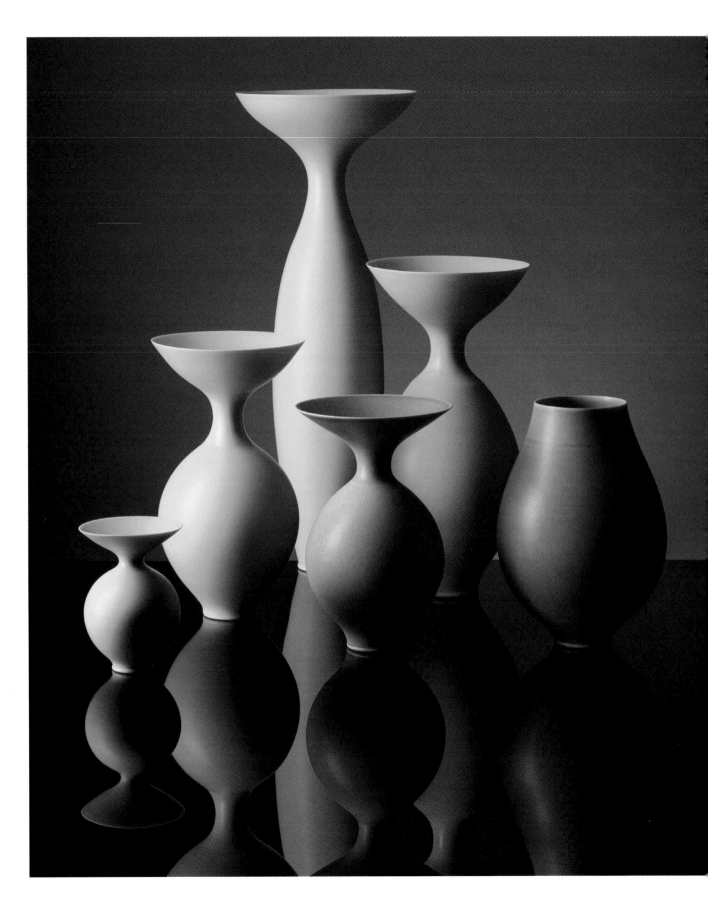

INTRODUCTION

Glaze is an integral part of the ceramic process and offers great potential for intrigue and discovery. Through the alchemy of materials and application of heat, it is possible to orchestrate unique outcomes that act as a visceral record of the process and represent the artistic pursuit of the individual. The thrill of opening the kiln and being rewarded with a piece that exceeds expectations is very addictive and can be the driving force behind establishing a successful creative identity.

On the flip side, there is a perception that glaze is a very technical or overly complex subject, and this can deter many from exploring it in greater depth. This assumption is not surprising considering the high-risk factor and failure rate that is often associated with this area of ceramic practice. Understandably, if a great deal of time and effort has been invested in the production of a piece, one is more likely to be risk averse when it comes to deciding on the glaze choice or its application. Here, the focus of this book is to help demystify the many different aspects of glaze practice and clearly explain the principles of glazing, the materials used and methods of application via detailed step-by-step guidance and informative text – drawing on my own experience of over twenty years as a ceramics practitioner. The aim is for you to feel sufficiently confident and assured to instigate your own glaze journey.

One of the biggest misconceptions about glaze is that you need to have a scientific mind to be successful, but in fact just a general interest in glaze is a great place to start. The whole process is very visual and soon you will find yourself wondering why certain results happen or how to control your glazes and develop them into something distinctively unique to you.

As you gain understanding of specific glaze terminology and secure basic chemistry knowledge, this will stand you in good stead to progress to the next level of proficiency.

Throughout this book, the content is intended to be accessible, informative and to prompt intrigue. The principle here is to first instil a foundation and grounding within the subject that will elevate your knowledge to carry forwards and continue to build on. There are many different approaches you can take but key attributes to be successful at glazing would be to just have an enquiring mind – don't be satisfied with your first results; continue to experiment, take risks and be inquisitive about the process. Try not to be deterred by what you don't know – one of the great joys of glaze is that so much can be learned by simply having a go and establishing deep understanding and knowledge as you progress with experience. The aim of this book is to ignite a passion for glaze and be a go-to guide that will support you through your learning and ultimately, enable you to determine your own creative pathway through this dynamic field.

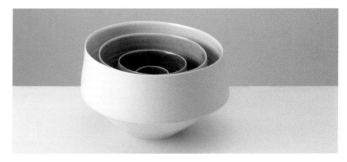

Louisa Taylor, *Ven* set of nesting bowls, H:15cm. Thrown and altered porcelain, fired to 1280°C (2336°F/cone 9). The glaze palette for this piece was inspired by museum collections of eighteenth-century porcelain wares.

◀ Anna Silverton. Group of porcelain vases in yellow and grey soft matt dolomite glazes (2021). H: 55cm. Finely wheel-thrown porcelain, fired to 1280°C (2336°F/cone 9).

ESTABLISHING YOUR GLAZE PRACTICE

If you are coming to glaze as a complete novice at the very beginning of your glaze journey, or as an experienced practitioner keen to build confidence and new skills, you might be feeling a little apprehensive or even intimidated about what it entails. However, by adopting a pragmatic approach – as well as an inquisitive mindset – you will soon be able to unleash a flair for glazing and strong command of your own methods. Be sure to shake off any beliefs that glazing lets you down; much like other aspects of ceramic practice such as learning to throw a pot on the pottery wheel or constructing a hand-built form, the more time you invest in honing your techniques, the more likely it is that you will achieve successful outcomes. The aim of this chapter is to introduce to you the fundamental elements of what constitutes a glaze and how to develop and define your practice going forward.

ORIGINS OF GLAZE – A BRIEF HISTORY

Many glazes we use today have been developed over the course of time by civilizations dating back thousands of years. The earliest known use of glaze originated from Ancient Egypt (or Mesopotamia) around 4000 BCE in the form of Egyptian paste, or Faience. Sourced from natron, a naturally occurring rock consisting of soluble alkaline salts, the mixture was combined with copper-bearing minerals, formed into a paste and dried. The salts migrated to the surface, forming a crust. When fired, the paste melted into beads of opulent turquoise-blue glaze and was commonly used for decorative artefacts and jewellery

(a recipe for Egyptian paste is included in Chapter 8). This technique later evolved into the practice of applying glaze materials to the surface of wares to create a fused layer of glass, although it was not uncommon for the glaze to flake off the ware after firing or craze badly.

The discovery of lead as a glaze material was an important advance and is believed to have originated in ancient Syria or Babylonia. Here, the practice involved dusting the wares with a fine, powdery coating of the lead ore, galena, which was then subsequently melted at low temperatures. Lead glazes were considered more durable and offered a superior quality to earlier alkaline predecessors. Various oxides such as copper, iron, manganese and cobalt were added to produce colourful glazes. This knowledge spread to China, with some of the earliest examples of lead-based glazes dating to 500 BCE, then reached the Middle East and Europe. Early English, lead-glazed slip-decorated pottery made in Staffordshire offers some particularly fine examples. There was no awareness of the dangers of lead poisoning until the nineteenth century.

In China, the development of the down-draft chamber kiln is said to have initiated the progression of high-temperature firings of above 1200°C/2192°F. The kilns were fuelled by wood and the potters observed how the fly ash that was blown around the kiln chamber during the firing settled on the wares and formed a glassy coating on the surface. The Chinese potters of the Han dynasty (206 BCE to 220 CE) are largely credited with the development of felspathic glazes and for improving kiln efficiency and design. Beautiful celadons and iron-rich tenmoku from the Song dynasty (960–1270 CE) are considered to be some of the finest examples of pottery in the world.

◀ Tessa Eastman, *The Kiss* (2021). H: 42cm. Glazed ceramic. Tessa Eastman's lively sculptures are complemented by the application of highly tactile crater glazes and vivid use of colour.

The medieval Islamic potters of the Middle East imitated the elusive qualities of Chinese porcelains by coating bisque-fired pottery with tin glaze and applying intricate decoration using copper, cobalt, iron and manganese oxides. These techniques filtered through to Spain after the Moors invaded in around 711 CE, and by the late medieval–early Renaissance period it became known as Maiolica ware (later, Majolica – from the nineteenth century onwards) named after the ports of Malaga in Spain and the Spanish island of Majorca (Mallorca). This highly decorative style of tin-glaze earthenware migrated across Europe where it was known as Faience in Italy (also Italian Maiolica), and Delftware in the Netherlands and British Isles.

During the fifteenth century, salt-glazed pottery was developed in Rhineland, Germany and this became an industrious glazing method that spread across Europe, becoming a common practice in the UK. Silica-rich slips and oxides were applied to the raw clay wares prior to firing. As the kiln reached high temperatures, salt was thrown into the chamber, where it vapourized and reacted with the silica present in the clay body and slips – forming a layer of glaze in the process. This action was repeated over the duration of the firing until a sufficient coating of glaze was achieved. Salt-glaze pottery has a distinctive orange-peel texture and colours range from tan-orange, greys and cobalt blues.

Throughout history, it is remarkable to consider that some of the most beautiful glazes in the world that we know and use in modern ceramic practice were achieved largely by trial and error, without any of the scientific understanding and knowledge of chemistry we have today. Much of this knowledge can be accredited to the German chemist Hermann Seger (1839–1894), who during the nineteenth century worked in industrial ceramic production and developed the Seger system of analysis – or unity molecular formula (UMF) as we call it today, to understand and group ceramic materials based on their molecular composition. This is discussed in more depth in Chapter 2, but it is a useful starting point to introduce the key components of a glaze as we proceed through the text.

WHAT IS A GLAZE?

A glaze can be defined as a layer of glass fused to a ceramic surface. It is typically applied as a liquid to bisque-fired ceramic and is quickly absorbed, leaving behind a coating of dry powder on the surface. It is then melted onto the body at a high temperature in a kiln. Glaze is not the only conclusion to a ceramic surface, but it is fundamental for wares intended for use. A glaze layer provides an impervious seal to render the ware hygienic and fit for purpose, to aid cleaning and offer stain resistance. This is particularly important for earthenware/low-temperature pottery which remains porous after firing. Glaze can help strengthen the ware, offering more resilience to the knocks of everyday use. Another application of glaze is for decorative and aesthetic purposes, to bring artistic expression through the surface, uniting it with the form. Glazes can offer a broad range of appealing surface finishes from high gloss, translucent, dry matt, opaque, to highly tactile volcanic and oozy qualities. It can also be used to mask an undesirable fired colour of clay body with a more attractive colour, as well as enhancing carved texture or under-glaze decoration.

Glazes can be categorized into the following temperature groups (discussed in Chapter 4). A suitable glaze will have good maturation between clay body and glaze:

	°C	°F	Cone #
Raku/low fired:	900–1000°C	1652–1832°F	010–06
Earthenware:	1020–1180°C	1868–2156°F	06–4
Mid temperature:	1200–1220°C	2192–2228°F	5–6
Stoneware:	1220–1300°C	2228–2372°F	6–10
Porcelain:	1220–1350°C	2228–2462°F	6–13

A selection of glaze tiles from the earthenware temperature range, illustrating the broad scope of colours and variety that can be achieved.

UNDERSTANDING GLAZE

Most glazes comprise ceramic materials, called oxides, which derive from minerals and rocks and are combined together in variable amounts to promote specific attributes, such as high gloss or mattness. The basis of a standard glaze consists of three principal components – glass formers (silica), fluxes and alumina (stabilizers).

Silica (silicon dioxide SiO_2) is the principal glass-forming ingredient in all ceramic glazes. It is found in abundance on the earth's crust, with the minerals flint and quartz being the most common source for glazes. Silica is considered refractory – by this, we mean it has a very high melting point of 1710°C (3110°F). This temperature would be incredibly difficult to reach in a kiln and too high for most clay bodies, which would melt. Therefore, fluxes have to be added in order to lower the melting point of the silica to a more attainable temperature, and one that is suited to the clay body and intended glaze. When two or more ingredients are mixed in certain proportions to allow the lowest possible melting temperature, this is called a *eutectic*.

Fluxes are primarily a group of oxides including sodium, potassium, lithium, calcium, magnesium, strontium, barium, zinc, lead and boron (boron being the exception whereby it is both a glass former and flux), which help control the melting temperature point of silica. During the firing, the flux operates by surrounding the particles of silica, breaking down the silica chains or the bonds between the silica molecules, causing the glaze to melt.

It is common practice for more than one flux to be used in a glaze recipe, and this function can be described as the primary and secondary flux. The main role of the primary flux is to lower the melting point of the silica, but a combination of fluxes can also promote useful attributes in the glaze including strength and durability. The secondary flux can improve the melt and give chemical stability, as well as desirable characteristics to the glaze such as enhanced colour tone, craze resistance, crystal growth, high gloss or matt surfaces. Examples of primary fluxes include sodium, potassium and lithium for high-temperature glazes, and lead and boron for low-temperature/earthenware glazes. Common secondary fluxes include calcium, magnesium, strontium, barium and zinc oxides.

The combination of silica and flux alone is enough to produce a glaze, but the result would be very runny and difficult to contain on the ware. Therefore, alumina (Al_2O_3), consisting of clay-type material is the third element in a glaze. The purpose of alumina is to bring stability and viscosity to the glaze and aid adhesion to the ware. Increasing the amount of alumina in a recipe can have the effect of making the glaze matt, resulting in dry or satin matt finishes depending on the quantity added. Sources of alumina include china clay, red clay powder, ball clay and feldspars (which contain alumina naturally).

Each material within a glaze has a role to play, providing either the glass former (silica), flux or alumina component. However, some materials, such as the feldspar group, for example potash, soda, nepheline syenite, by nature can encompass all three components and have the potential to make a glaze in themselves, although a very unrefined one. Another important consideration is that the behaviour of the glaze materials is largely determined by their chemistry – the glass formers (silica) are acidic, fluxes are primarily alkaline and alumina is generally amphoteric (neutral).

To help understand the role of the silica, flux and alumina, a simple experiment to try is to take a typical glaze recipe, such as the one below, and play around with adjusting the ingredient amounts to see how this impacts the final outcome, from shiny to matt results. Here the percentages of the primary flux (Cornish stone) and alumina (china clay) were increased and decreased whilst the other ingredients remained the same.

	Tile 1	Tile 2	Tile 3
Cornish stone	60	40	20
Whiting	20	-	-
Silica	10	-	-
China clay	10	30	50
Copper Oxide	0.5	-	-

The test tiles were made from stoneware clay and fired to 1280°C (2336°F/cone 9) in an electric kiln (oxidized).

Shiny: The large quantity of flux in this recipe has produced a smooth, shiny glaze.

Satin: By reducing the flux and increasing the alumina quality, this has produced a semi-matt surface.

Dry matt: The high alumina and low flux quantity in this glaze has resulted in a very dry, refractory surface.

Colour

Most glazes when fired without any colouring additions are somewhere between transparent to white, depending on the component ingredients and quantity parts. Colours in glazes are achieved by two sources (the specifics of each material will be discussed in more depth in Chapter 2). These include oxides of metal, for example copper, cobalt, manganese, iron, chrome,

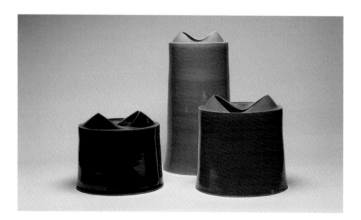

Tanya Gomez, *Undulated – Group of Three* (2022). H: 33cm (tallest). Thrown and glazed porcelain. The midnight blue piece was fired in oxidization and the two remaining pieces were fired in reduction to 1280°C (2336°F/cone 9). Here the bold use of colour accentuates the softness of the thrown forms and undulating rims.

nickel; and glaze stains – colouring pigments that are commercially prepared by the ceramics industry. When considering your glaze aesthetic, the choice of colouring agent will play a significant role in the outcome of the work. Oxides offer a wonderful array of tonality and depth. Glaze stains enable the user to create consistent, bright colours such as reds, yellows and pinks that would be difficult to achieve with oxides.

Opacity

A glaze can be made opaque (not see-through) by the addition of a specific group of minerals called opacifiers which enable the glaze to obscure the colour of the clay body underneath. They work by resisting full integration into the molten glaze and remain as finely dispersed particles in the glaze. Opacity can also be caused by the presence of very tiny bubbles, or crystals in the glaze, which refract the light and induce a cloudy or milky appearance. Oxides and glaze stains can be added to the glaze for colour. Opaque glazes are a good base for making pastel shades or used as a base colour for applying decoration.

Examples include:

Tin oxide – bright white, used for Maiolica glazes
Zirconium silicate – white
Titanium dioxide – creamy white and mattness

Texture

Glazes can appear matt if they are underfired or applied too thinly and there is insufficient glass former and flux to create the melt. An over-saturation of colouring oxides can also have the same effect. A true matt glaze will typically have a micro-crystalline structure whereby it is made up of tiny, microscopic crystals that scatter the light. Ceramics materials that contain magnesium, such as magnesium carbonate, dolomite and talc will produce satin-matt glazes, and are improved further with slow cooling. Higher proportions of calcium, such as whiting, wollastonite, dolomite (which contains both magnesium and calcium), and alumina – china clay, feldspars, will also produce matt glazes by increasing the melting point of the glaze.

Matt glazes are rarely transparent because the components that make the glaze matt also make it opaque. A way around this is to glaze a piece in a shiny transparent glaze and use a sandblaster or sanding tool to abrade the surface to take away the shine. Colourful matt glazes that contain calcium and magnesium can appear muted, in comparison to barium carbonate which is used to promote colour response such as bright turquoise blue (in combination with copper), as well as a broad range of smooth matt glazes. However, barium is toxic and should be avoided

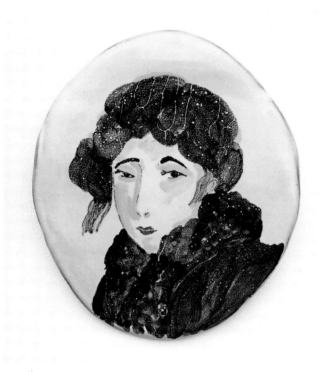

Agalis Manessi, *Mrs Nobuko with Fur Collar* (2019). Dia: 20cm. Hand-built terracotta. Maiolica (tin-glaze), hand painted with oxides and stains, mixed with glaze, on the raw unfired glaze.

Louisa Taylor, *Lemon Decanter Set and Beakers* (2016). H: 22cm. Porcelain, thrown. Matt glaze coloured with yellow stain is contrasted by the shiny glaze on the neck of the decanter.

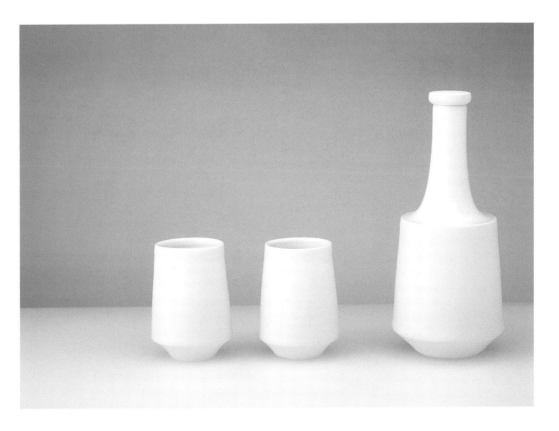

for functional wares. Strontium carbonate is deemed a safer alternative, but the compromise is that the colours are not as bright (*see* Chapter 2 for more specific information).

GLAZE PROPERTIES

Glazes are often named after the fluxing ingredient, or material which gives the glaze its characteristic trait, such as dolomite glaze – smooth, satin matt, barium glaze – textured, mottled matt or tin glaze – bright white glaze. However, there are a number of common terms used in practice to define specific properties of a glaze, which you will also see used in Chapter 8 to describe each glaze.

These include:
Transparent – a clear, see-through glaze
Shiny – high gloss, reflective glaze
Opaque – obscures the clay body underneath
Satin/eggshell – silky to touch
Semi matt – somewhere between a shiny and matt glaze
Matt – smooth, almost dry glaze
Dry-matt – very dry and rough to the touch
Crystalline – fine network of needle-like spurs within the glaze
Oil spot – mottled texture
Special effect, for example volcanic, crawl, flaky – unique surface qualities

Ceramic glazes offer a dynamic interplay between light and surface quality, and this can be exploited to great effect. For example, a shiny glaze has a brightness which is very appealing, whereas a matt glaze will rebound shadows and imbue a softness that invites interaction. The choice of a shiny, matt, satin, dry glaze surface, or even how we apply glazes can influence the way we interpret a form. This opens up much potential for exploration to experiment with texture and decoration. Here you see four identical cylinder forms, made from porcelain and fired to 1280°C/2336°F/cone 9 in an electric kiln (oxidized). Each cylinder has been applied with a different type of glaze and demonstrates the practical applications and unique benefits the glaze offers:

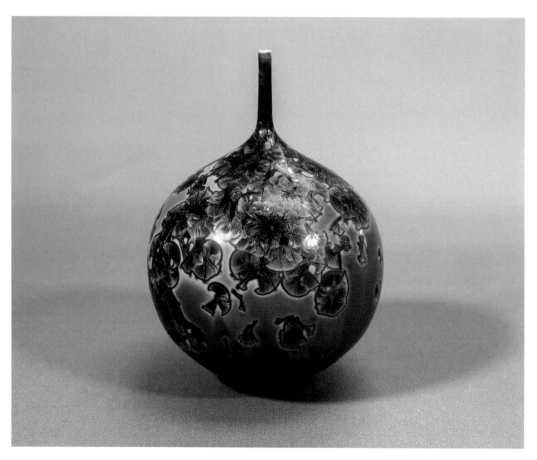

Matt Horne, *Metallic Red and Blue Bottle Form* (2022). H: 15cm. Porcelain, thrown. Crystalline glaze and post-fired reduced to produce striking pink-coloured crystals with turquoise halo.

1

Transparent shiny glaze: high shine, glossy glazes are very practical and durable, especially for items intended for utilitarian/functional use. Transparent shiny glazes applied over any underglaze or slip decoration will enrich the colours.

2

Matt glaze: Smooth, satin-like surface. Less suitable for functional wares as susceptible to scratching, but can be applied to the outside of wares, as well as for sculptural and decorative use.

3

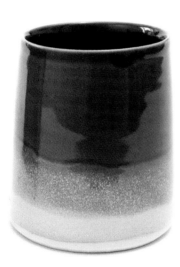

Colour glaze: Colour glazes can enhance a form by highlighting texture, or be a feature in their own right.

4

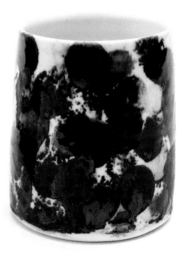

Decorative: Here, glazes have been stamped with oxides to create a lively and playful surface.

SOURCES OF GLAZE

Glazes can be made by following a recipe and weighing out component ingredients to which water is added (*see* Chapter 5), or alternatively bought as commercially prepared ready-made glazes, all of which can be purchased from a pottery supplier – a directory is included in the Resource section. It is also possible to make glazes from locally sourced materials such as wood ash, chalk and quartz. The main focus of this book is to equip you with the skills and knowledge to confidently prepare your own glazes. However, it is important to acknowledge the role of ready-made glazes and the advantages and disadvantages of both approaches are outlined below:

Ready-made

If you enjoy ceramics as a hobby or have ever attended a pottery class, you may already be familiar with the use of commercially prepared glazes to decorate your pieces. The benefits of using a

ready-made – and the reason they are so popular – is because they are so easy to use, the results are generally reliable and the range of colours, finishes and effects available to buy is vast. It is not uncommon for professional potters and artists to use a combination of their own glazes as well as ready-made glazes for specific tasks. Ready-made glazes are supplied either as dry powder to which you add water, or as prepared tubs of 'brush on' glaze. A drawback of ready-made glazes is the much higher cost of the product compared to making your own glazes. Ready-made glazes are specifically formulated by the ceramics industry, which ensures consistency but can make it difficult to then adjust and alter the recipe. However, on the flip side one could argue that storing large quantities of raw glaze materials takes up a lot of studio space, as well as accounting for the time and effort to weigh out and prepare a glaze. Ultimately, this really comes down to personal choice and preference. An option could be to buy a powdered glaze such as a transparent glaze or smooth matt and adapt it yourself by adding quantities of stain or oxide to generate a spectrum of colours.

Brush-on glazes are as the name suggests – glazes that are commercially prepared and ready to use straight from the tub. They are formulated to be very easy to use and are blended with an organic additive, such as CMC gum (carboxymethyl cellulose), which helps carry the glaze material, giving a smooth coverage that burns away in the firing. A brush-on glaze is applied in two to three layers for best results which can be more time-consuming in comparison to dipping a pot; it is also more expensive in terms of coverage. It is important to make sure the glaze container is sealed after use because brush-on glazes are prone to evaporating and can be very difficult to reconstitute if they dry out. One of the great benefits of a brush-on glaze is that it can provide a useful point to apply a specific colour or effect that might be too difficult to achieve by conventional means. For example, you could add dabs of ready-made glaze such as a bright red for a punch of strong colour, or use a special effect glaze to bring a distinctive surface quality to the work. Like any aspect of glaze practice, there is much experimentation to be had, so don't be deterred from using it as part of your practice just because you didn't make it yourself.

Make your own

When you are new to ceramics, the prospect of making your own glazes and getting to grips with the chemistry can feel very daunting, but you should think of it as the next step in your

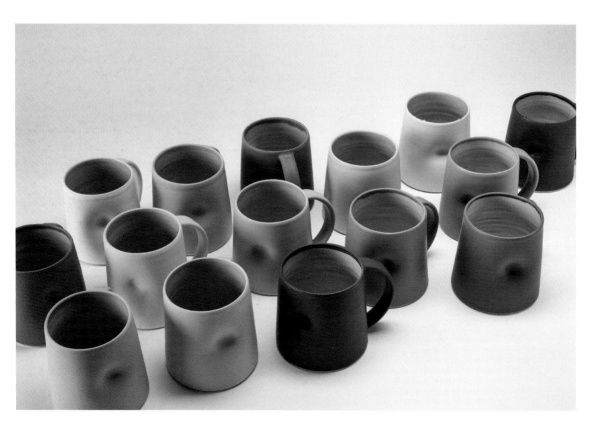

Emma Lacey, *Everyday mugs* (2022). H: 9cm. Stoneware, thrown. Commercial matt glaze coloured with stains and oxides, producing a wonderful variety of different colours and tones.

progression as a maker and an opportunity to inject your own creativity and imagination into a glaze aesthetic. Of course, you might have some mishaps along the way – that is all part of the learning process, but the benefit of developing your own glazes is the integrity and distinct connection to the maker they hold.

One of the main reasons for making your own glaze is the cost implications, particularly for scenarios such as batch production or glazes needed for high-volume use. By buying larger amounts of raw materials, you will be able to make much bigger batches of glaze which will last longer and save money in the long run. Another factor to making your own glazes is that it gives you greater control over the final outcome by allowing for greater experimentation and opportunity to broaden your glaze palette. Once you become more familiar with the process, you will soon be able to build on your knowledge and gain confidence as you go along.

BUILDING A GLAZE IDENTITY

The development of a signature glaze colour, effect or style can involve a lot of hard work and patience to fully resolve, but the process of investigation is an extremely enjoyable and rewarding activity that firmly underpins an evolving ceramic practice. There are a number of important factors to consider before you embark on your glaze journey, all of which are instrumental to the final conclusion of your chosen aesthetic. These include the clay body the piece is made from, type of kiln you have access to (electric, gas or other), firing temperature (for example earthenware/mid-temperature/stoneware) and whether the piece is intended to be functional, decorative or sculptural/experimental. For example, if your work is made from red terracotta clay, this clay body has a high iron content (4–7 per cent) and typically has a maximum firing range of around 1200°C/2192°F/cone 5. Above this temperature it could melt and blister, therefore you should aim to work within the confines of its firing range. Perhaps you are making a large sculpture to be located outdoors; the hardy properties of a stoneware clay body and subsequent stoneware firing temperature of 1260°C+/2300°F/cone 8+ will determine your glaze choice. Likewise, if you are making porcelain tableware and enjoy the qualities of traditional celadon and tenmoku glaze, then you ideally need access to a reduction kiln to achieve this result.

Once you have these principles in place, you can move forward with your planning. The key to achieving success with glaze is to first really understand exactly what surface finish you are aiming for as this will help you define your pathway and make apt decisions. For example, let's say you are interested in organic qualities – therefore a place to start might be to experiment with dry, textural glazes and play around with layering the application. This may seem obvious but too often the temptation is to resort to an appealing glaze recipe and apply this to the work without proper consideration for its relevance to the form, suitability, or how it will contribute to the overall success of the piece. When so much time has been invested in the making of a piece, equal time and thought should be given to its resolution. Glaze should never be an afterthought or done on a whim, otherwise the risk of failure or a poor outcome will increase significantly. Here are some useful tips and information to help you develop this area of practice:

Initial research

To establish a successful glaze aesthetic, it can be helpful to reflect on the creative motivations that drive your work, with the aim to forge a link between the form and surface. You might already have a clear vision for your work and therefore it is a case of investigating suitable glazes that fit your criteria. However, if you are unsure where to begin, there are a number of ways to prompt ideas. In particular, sources of inspiration for surface qualities can be found all around you, from the natural world, landscapes, art, history, textiles or fashion, to name a few. You may prefer a traditional approach to glaze development or be completely experimental. Another area of interest could be to emulate real objects through glaze, playing on hyper-realism effects. Expand your influences further by visiting museums, galleries or places of interest. Research the work of other potters, artists, historical and contemporary – what draws you to their work? What can you learn from their techniques and methods? This process of investigation and research will help ground your work and enable you to achieve a strong approach that is unique to you.

Visual material

A sketchbook or notebook can act as an incredibly valuable record of your thoughts and compilation of ideas. How you curate your sketchbook is completely up to you; it could be a very personal resource with notes and annotations, including pages of drawings and rough sketches. This could be further supported with samples or images that capture your interest.

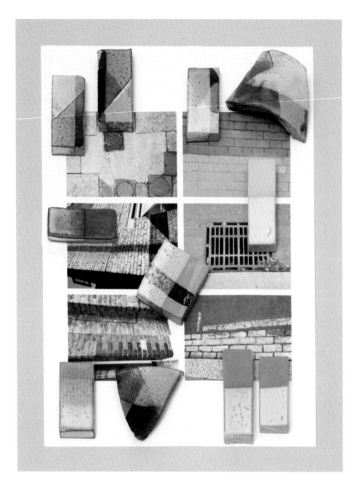

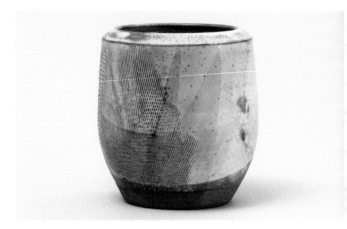

Rachel Cox, *Vestige* (2022). 14 × 14cm. Thrown and textured stoneware, brushed slips, engobes and tin glaze. Here the artist has pulled together the sources of inspiration from her initial research into one resolved object and has sensitively conveyed these qualities through rich surface decoration.

A sketchbook page by Rachel Cox, illustrating a collection of materials and surfaces that document an area of South London. Her glaze tiles and samples explore a variety of processes, including textured and brushed surfaces with oxide rich slips, engobes, tin glaze and screen-printed details to emulate the qualities of the built environment.

A sketchbook doesn't even have to be a physical resource – you may prefer to keep a digital record, using a tablet device to collate your ideas, or engage with an online mood board such as Pinterest, allowing for social interaction with others. Whatever your preference, continue to gather everything that inspires you into one place so you can access and refer to it as your practice develops. Many artists have a seamless interplay between their two-dimensional and three-dimensional creative work. Specifically drawing and painting can feed into the glaze application, leading to a strong connection between the two. The same can be said for photography – allowing you to focus on points of interest, taking influence from textures, colours and capturing the ambience which can be interpreted into distinctive glaze qualities.

Colour referencing

A simple but effective way to develop a colour collection is to start collecting paint charts and booklets from DIY shops/ paint suppliers, including wallpaper samples, textiles and fabrics. You could expand this further by sourcing found objects or curiosities that interest you such as a decayed leaf, seashells or animal bone. By having a selection to hand, this can provide a very useful reference for a general overview of colours and textures that appeal to you. These swabs of colour can be a practical way to sample colours together and build colour ranges. From here you can then start to think about how you would translate the colour into a glaze using oxide, stain or a combination of both. At a more professional level, you could invest in an industry-standard colour referencing book, an example being 'Pantone', which operates a code-based system. Having a specific reference code for a colour is particularly useful in a scenario whereby you need to communicate a colour to a third party such as a manufacturer or client.

Colour planning

When combining colours or creating a new range, a helpful tip is to apply a 60:30:10 technique – 60 refers to the percentage of overall colour, for example 60 per cent coverage – this could be a neutral or less dominating colour which anchors the range; 30 = 30 per cent coverage and ideally should be a complementary colour that supports the main 60 per cent colour; 10 = 10 per cent coverage and acts as an accent colour

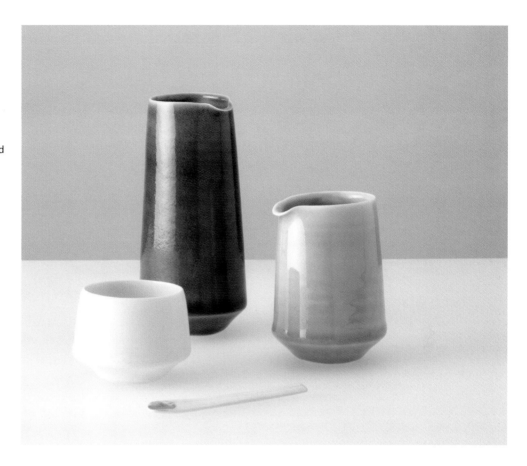

Louisa Taylor, *Cornflower, Set of Jugs, pickle pot and gold tipped spoon* (2010). H:14cm. Thrown and altered porcelain, gold lustre. Fired to 1280°C (2336°F/ cone 9). The glaze colours for this set derived from hand-painted decoration of delicate cornflowers found on eighteenth-century dining wares. Gold lustre on the tip of the porcelain spoon acts as the 10 per cent accent colour and brings a sense of opulence to the set.

that brings everything together – this could be a contrasting bright 'pop' colour or even a special effect glaze. If colour is an area of interest to you, refer to the bibliography for information about specific colour theory and practical advice.

IMPORTANCE OF GLAZE TESTING

An artist/potter renowned for their glazes would have spent many years refining their practice, honing their skills and establishing strong ownership of their techniques. It is not a quick fix and you have to be prepared for a considerable investment of time and effort. Such is the importance of testing that a whole chapter is dedicated to the subject in this book. You should always allow for a period of testing before you even consider glazing your final piece. Therefore, ensure you accommodate sufficient time into your making schedule to avoid the indecision and uncertainty that comes with last-minute glaze and surface application. As your practice evolves and your glaze palette becomes more established, you will eventually have a catalogue of go-to colours on hand from which you can continue to build and expand on. Always keep your mind open to new approaches to help your work stay fresh and original.

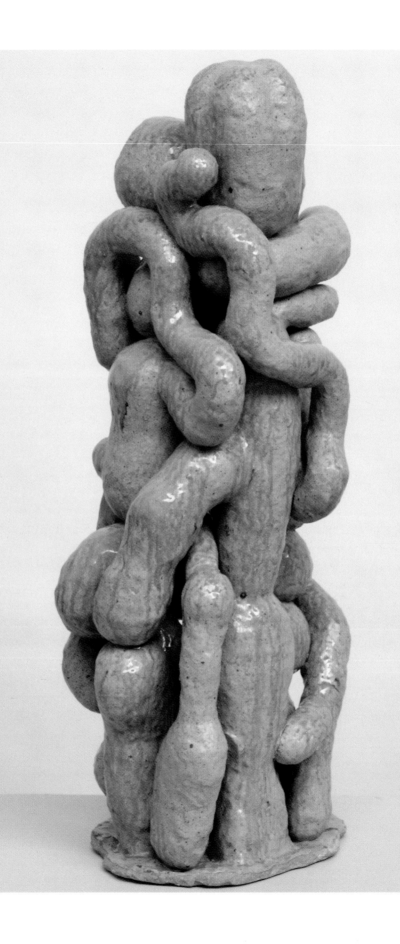

GLAZE MATERIALS

To help progress your glaze practice, one of the most important steps to take is to acquaint yourself with all the different types of materials and their specific properties that form the main constituents of a glaze. By gaining secure knowledge in this area, you will begin to understand the role these materials play within a glaze and how to adapt and even substitute materials for others to promote desirable attributes.

WHERE DO GLAZE MATERIALS COME FROM?

Ceramic materials consist of minerals, rocks and chemicals, and derive from a variety of sources such as weathered igneous rocks, limestone (chalk) and deposits of clay. They can be sourced directly if you intend to make your own natural glazes, but in general, these materials are commercially mined, processed and sold via pottery suppliers. The benefit is that the materials come ready for use in powdered form, and usually have been ground to a fine mesh size ranging from 200–400 mesh (the number of holes per linear inch), which ensures a consistent melt. Materials are typically referred to by either their mineral name, for example quartz (silica), location of source, for example Cornish stone (mined in Cornwall, UK) or product/brand name, for example whiting (calcium carbonate).

With any naturally occurring material, they can vary from batch to batch even though the manufacturers strive for consistency, so you should be mindful of how these variables may affect your glazes. Some raw materials can contain contaminants or impurities of other materials, for example zinc oxide is known to contain traces of lead, cadmium and copper. Occasionally, the mines that materials are extracted from become depleted or close entirely and this then impacts on the availability of some materials – an example being Cornish stone. This material is no longer commercially available in the UK and has been replaced by a substitute with similar chemical composition. Alongside natural materials, others, such as frits, are specifically made by the ceramics industry to provide a reliable source of ceramic oxides, reduce exposure to toxic materials and achieve consistent results. In terms of health and safety of each material, a supplier will be able to provide you with a safety data sheet (SDS) which gives information on chemical products and describes any associated hazards they present.

Materials should be stored in lidded containers in a cool, dry location.

◀ Jonathan Wade, *Pile Up* (2020). H: 90cm. Hand-built stoneware with applewood ash glaze. Gas reduction fired.

MATERIAL PROPERTIES

Each material we use in a glaze will bring its own unique properties; for example, the temperature where it becomes an active flux or melts, through to crystallization or promoting excellent colour response. Some materials are refractory – whereby they do not melt readily at high temperatures and in certain conditions can make a glaze more viscous and stiff. Thermal expansion and contraction of a material is an important factor too and refers to how materials increase and decrease in size when heated and cooled. The aim is to ensure suitable glaze fit, whereby the glaze is compatible with the clay body underneath, thus avoiding issues with crazing and shivering faults. Likewise, if the materials cause high surface tension in a glaze, this can lead to crawling whereby the glaze pulls away into beads, leaving exposed areas. We also need to be mindful of the safety hazards each material presents so we can respond accordingly (refer to health and safety, end of this chapter).

Solubility

The term solubility can be defined as the ability to be dissolved, especially in water. The application of temperature (for example hot water), pressure or agitation are all contributing factors. We can compare this to sugar crystals in warm water that dissolve and form a solution when stirred, compared to sand which is insoluble, and remains suspended in the water. The solubility of ceramic materials is an important factor when it comes to glazes – we need the materials to largely remain insoluble in the water so that the chemistry of the glaze is balanced, and crucially when the glaze is applied to the work, the water content is absorbed into the body but leaves behind an even layer of glaze material coated to the surface. If the materials were all soluble, as the water is absorbed into the clay body it would take the materials with it, which would seep through to the surface and destabilize the glaze.

Another important factor is one of safety. If the materials are toxic and in solution, this increases the risk of absorption through the skin. Many raw materials we use in ceramic glazes are slightly soluble to some degree; these include nepheline syenite, lithium carbonate, colemanite, to name a few. We also need to be mindful of material interactions that can affect solubility, for example a material that is classed as insoluble can become soluble when combined in a glaze, which highlights the importance of wearing protective gloves when mixing glazes.

HOW ARE GLAZE MATERIALS CATEGORIZED?

Ceramic glaze materials are primarily oxides – which can be defined as a combination of oxygen and another element. As discussed in Chapter 1, the German chemist Hermann Seger sought to bring clarification to ceramic science by establishing a system of analysis referred to as the unity molecular formula (UMF), which could predict and control glaze behaviour. The formula follows the principle that glaze recipes are calculated by the number of molecules, rather than the physical weight of the raw materials.

Seger identified silica as the main glass former and alumina as the stabilizer, proposing that fluxes could be classified into three distinct groups (based on the position on the periodic table). These include alkali metal oxides (R2O), alkaline earth oxides (RO) and metallic oxides (RO). The formula expresses the ratio between fluxes – with the total fluxes equalling 1.0, and the total ratio between the fluxes to the alumina and silica. For example, 1:8 alumina to silica will produce a glossy glaze, and a lower ratio of 1:5 will be more matt. The flux ratio 0.3:0.7 R2O:RO (with total flux = 1) gives the optimum chemical stability, so it is food safe and dishwasher safe. This method allows us to analyse glaze compositions to troubleshoot and adjust recipes to achieve optimum performance. Although the focus of this book is not to delve too deeply into this area of glaze science (the bibliography lists a number of excellent resources

There are twelve basic oxides considered to be the building blocks of ceramic glazes. They are categorized into the following groups based on the principles of the UMF:

Flux: Alkali Metal Oxides (R_2O)	Flux: Alkaline Earth Oxides (RO)	Flux: Metallic Oxides (RO)	Glass Former (RO_2)	Stabilizer (R_2O_3)
Potassium K_2O	Calcium CaO	Lead PbO	Silica SiO_2	Alumina A_2O_3
Sodium Na_2O	Magnesium MgO	Zinc ZnO	Boron* B_2O_3	
Lithium Li_2O	Barium BaO			
	Strontium SrO			

*Boron is the odd one out, whereby it is both a glass former and a flux, although its main use in glaze chemistry is as a powerful flux.

on the subject), it does offer a logical manner to organize and explain the properties of the glaze constituents, which can prompt further research and investigation into this area of ceramic study.

FLUXES

Fluxes are a group of oxides that lower the melting point of the glass formers (silica). They can be categorized into the following groups:

Alkali metal oxides (R_2O)

Oxides from the alkali metal group are active fluxes. They are considered the primary fluxes, with the three main oxides, sodium, potassium and lithium, commonly sourced from feldspars.

Sodium oxide Na_2O (natrium oxide)

Sodium oxide is a powerful alkaline flux and is active from 800°C (1472°F) upwards. It has low toxicity and can produce bright and rich colour responses from colouring oxides, such as vivid turquoise from copper and deep cobalt blues. Sodium oxide is highly soluble and therefore it is introduced into glazes as insoluble sources, either as frits or feldspars. It has a high expansion and contraction rate which can cause crazing in glazes. Sodium oxide acts very similarly to potassium oxide in glazes, but it is more fluid when melted. Glazes containing sodium oxide are generally softer and less durable which can make the surface prone to scratching and deterioration over time. Sodium is volatile at temperatures above 1200°C (2192°F) and high amounts can cause flashing on the wares. As such, it is used in the soluble form of soda ash or common salt for vapour firing techniques.
 Sources:
 Insoluble: Soda feldspar, sodium frits, nepheline syenite (slightly soluble), it is also present in other feldspars including potash feldspar, Cornish stone, and volcanic ash
 Soluble: Soda ash, bicarbonate of soda, salt, borax, unwashed wood ash

Potassium oxide K_2O (kalium oxide)

Like sodium, potassium oxide is a very active flux and promotes strong colour response. It is also soluble in water but is supplied in glazes as insoluble frits or feldspars. The fluxing action of potassium starts a little earlier than sodium, at 750°C (1832°F)

and has a wide firing range. It is a predictable flux and useful at all temperature ranges, but like sodium, it shares the same trait of high coefficient of expansion, which can cause crazing. However, potassium can produce more durable and hardier glazes compared to sodium. Most feldspars contain sodium and potassium to some extent and therefore this can make substitution easier without too much impact on the overall glaze.
 Sources:
 Potash feldspar
 Cornish stone
 Volcanic ash
 Small amounts in some frits and soda feldspars
 Unwashed wood ash (soluble)

Lithium oxide Li_2O

Lithium oxide is a strong alkaline flux and gives a similar response to that of potassium and sodium oxide. Lithium is slightly soluble and has the advantage of a much lower expansion and contraction rate which can counteract crazing. However, high amounts in a glaze can cause shivering (the opposite of crazing whereby the glaze flakes off the body). Lithium can increase gloss and offer excellent colour response with colouring oxides, such as electric copper blues and cobalt pinks. It can also create mottled effects and smooth matt surfaces. Lithium can reduce maturity times and lower the firing temperature, which is useful when altering a high-temperature stoneware glaze to a mid-temperature glaze. All lithium compounds are toxic, and you should ensure good health and safety practices when using them.
 Sources:
 Lithium carbonate
 Petalite
 Spodumene
 Lepidolite

Alkaline earth oxides (RO)

Most glazes benefit from a combination of fluxes to produce specific qualities and traits within the glaze. Alkaline earth oxides are secondary fluxes and act in eutectic mixtures to lower the melting point of the glaze.

Calcium oxide CaO (lime)

Calcium oxide is one of the most important fluxes in medium- and high-temperature glazes and is commonplace in many recipes. It becomes active in temperatures above 1100°C (2012°F) and acts as the principal flux in many stoneware and

porcelain glazes. In high amounts it can stimulate crystalline growth during cooling, producing matt surfaces. Calcium causes relatively no glaze faults and is extremely useful for promoting strength, durability and resistance to acids. It can have a moderate effect on colours, which may appear slightly muted in some glazes, however, in reduction it can improve the grey-blue colour of celadon and iron-rich tenmoku.

Sources:
Whiting (calcium carbonate)
Dolomite (contains magnesium and calcium)
Wood ash
Wollastonite
Frits (such as calcium borate frit)
Bone ash
Colemanite (calcium and borate) (slightly soluble)
Gerstley borate/Gillespie borate (slightly soluble)
Some feldspars

Magnesium oxide MgO

Magnesium oxide is prominently used as a secondary flux in high-temperature glazes. The fluxing action of magnesium only becomes active at temperatures above 1170°C (2138°F) but at low temperatures it can provide opacity and make a glaze matt.

Linda Bloomfield, *Lichen-effect porcelain bowl* (2020). H: 7cm. Thrown porcelain, lichen-effect glazes, fired in an electric kiln to 1250°C (2282°F).

Magnesium oxide can produce attractive smooth satin qualities and delicate colour response. For example, cobalt will produce lavender blues, and various pastel shades can be achieved in combination with stains. Magnesium oxide has a low expansion and contraction rate which can improve craze resistance, but its viscous nature can cause high surface tension and become more susceptible to crawling and pin-holing faults. In excess, magnesium oxide can produce dry-matt surfaces and lichen effects in glazes. Magnesium has low toxicity and is widely available.

Sources:
Talc
Dolomite (contains magnesium and calcium)
Magnesium carbonate
Epsom salts (soluble)

Barium oxide BaO

Barium oxide is a secondary flux in earthenware and high-temperature glazes, becoming an active flux from around 1130°C (2070°F). It functions similarly to calcium and magnesium, and is used for its excellent crystallizing properties to produce smooth satin matt glazes. In excess it will produce very dry, stiff glazes. The benefit of barium over other oxides is that is does not dull the colours and instead can enhance vivid colour response from oxides ranging from bright turquoise – copper, neon blues – nickel, yellow green – chrome, plum violet – manganese. Barium compounds are highly toxic before and after firing and should be handled with extreme care. Be mindful of airborne dust and wear protective gloves when mixing glazes containing barium to avoid possible absorption through the skin (barium is insoluble but can become soluble in acid bases). Glazes containing barium are not suitable for functional ware because of the increased risk of leaching when in contact with acidic foodstuffs and liquids.

Sources:
Barium carbonate
Frits

Strontium oxide SrO

Strontium oxide is a secondary flux and shares similar properties to calcium oxide and barium oxide. In the form of strontium carbonate, it is an active flux from 1090°C (1994°F) but requires interaction with other fluxes to become effective. Like calcium, in excess it can induce crystalline matt surfaces and add strength and durability to a glaze. It is not as widely used in ceramic practice, particularly because it is more expensive than

other oxides that perform similarly. However, strontium oxide is non-toxic and considered a safer alternative to barium as it has a similar effect on glazes, although the colour response is not as vivid. Strontium is stronger than barium – approximately 75 per cent of strontium is equivalent to 100 per cent of barium, and therefore less is needed in a glaze.

Sources:
Strontium carbonate

Metallic oxides (RO)

Metallic oxides are sources of fluxes and can promote a strong colour response in glazes.

Lead oxide

Lead oxide has been used as a powerful flux in low and medium temperature glazes for thousands of years. Beginning its fluxing action around 500°C (932°F), lead has low thermal expansion and produces bright, glassy glazes that are hard to rival. Lead offers exceptional colour response with oxides, in particular a long tradition of brilliant bottle greens (copper) and rich honey (iron) lead glazes to enhance slip-decorated wares. Unfortunately, lead is incredibly poisonous in its raw form; therefore, it goes through a fritting process to chemically bond it to other materials and make it safer to use – although it should still be handled with care. Lead frits are more widely available in the UK and Europe but less so in the US, where they have largely been discontinued. In principle, avoid using any lead glazes for functional ware. Even if the glaze is considered to be correctly formulated (commonly referred to as 'low-solubility'), the risk of it becoming unstable and potentially leaching is increased by the addition of colouring oxides such as copper, manganese or chrome. This is exacerbated further by contact with strong acids, namely vinegar or fruit juices. Glazes that contain lead (in the form of frits) have a maximum firing range of 1200°C (2192°F) and are not suitable for reduction which can result in blistering and discolouration of the glaze.

Sources:
Lead bisilicate
Lead sesquisilicate

Zinc oxide ZnO

Zinc oxide is a useful secondary flux for oxidized glazes covering mid to high temperatures. It remains refractory in glazes below 1050°C (1920°F) and can be used as an opacifier in low-temperature glazes in amounts of 5–10 per cent. Zinc acts as the key ingredient in macrocrystalline glazes whereby it provides the 'seed' for crystal formation to grow and establish. Zinc has equal benefits and disadvantages. These include a low expansion rate and good craze resistance, as well as offering strength and durability to a glaze. In contrast, certain colourants do not respond well to zinc. Chrome oxide is particularly affected and will turn brown in the presence of zinc. This extends to some commercial stain colours (chrome tin pink can turn grey), and it is advisable to avoid their use with zinc-bearing glazes. On the contrary, zinc can actively enhance cobalt blues, copper greens and nickel greens. Zinc has a high shrinkage rate and in large amounts it can cause crawling and pin-holing. This trait can be put to good use for crawl or lichen-effect glazes. Zinc is not suitable for reduction atmospheres because it will change to metal and evaporate. Zinc is very toxic and can contain other impurities such as lead, therefore extra precautions should be taken when handling it.

Sources:
Zinc oxide
Calcined zinc oxide

Frits

A frit is formed when a toxic or unstable material is melted together with silica in a crucible, quenched in water and then ground to a fine powder, which renders it both safer and more suitable to use. Although frits will form a glass by themselves, they are normally used as bases to which other ingredients are added. Frits are commercially prepared by the ceramics industry and formulated to achieve consistent, predictable results. The frits listed below span a temperature range between 850–1180°C (1562–2156°F).

Calcium borate frit: Used in earthenware glazes as an alternative to lead. Contains, calcium, boron, sodium. Also useful as a flux in mid-temperature glazes.

Ferro frit 3110: Soft low-alumina sodium borosilicate frit. It has high expansion and is used in crystalline and crackle glazes, and raku glazes.

Ferro frit 3124: Contains boron and calcium. Can be used to lower the temperature of glazes, for example high-temperature stoneware to mid-temperature.

Ferro frit 3134: Similar to frit 3124 but higher in boron and calcium with no alumina.

High alkaline frit: High alkali metal content (sodium and potassium), very soft and fluid frit with high thermal expansion ideal for crackle and raku glazes. Promotes turquoise copper blues and plum-brown colours from manganese.

Lead bisilicate: UK/Europe – clear, multipurpose frit with excellent colour response. (Refer to health and safety for guidance of safe use.)

Lead sesquisilicate: Similar to lead bisilicate but specially coated to reduce solubility (as above).

Standard borax frit: Often used as an alternative to lead frits in earthenware glazes, although the colours are not as vivid. Can cause a slight milkiness, especially over red clays. A small amount of borax frit (around 5 per cent) added to stains and oxides can improve their melt when applied as underglaze decoration.

Glass formers (RO$_2$)

Glass formers are oxides that readily form a glass. They are the essential material in all glazes.

Silicon dioxide S$_2$O

Silicon dioxide – or silica as it is more commonly referred to – is the fundamental oxide in all clays and glazes. It is the main glass former in a glaze and naturally occurs as quartz, rock and sand – the most common sources used in glazes are flint and quartz. Silica is also present in many other ceramic materials such as feldspars, clays and silicates. Ceramic glazes consist mainly of silica, which has a very high melting temperature of 1710°C (3310°F), therefore additional materials in the form of fluxes and alumina are added to reduce this temperature and modify the glaze in some way, for example to promote shine, or make the glaze matt. Increased amounts of silica in a glaze can raise the maturing range of the glaze, and improve durability, strength and acid resistance. It can also improve thermal expansion and craze resistance. Silica dust (referred to as free silica) is classed as a health hazard and over-exposure can cause a debilitating lung disease called silicosis. Therefore, always wear a protective respirator when handling ceramic materials and keep your work area clean and dust free.

Sources:
Silica
Flint
Quartz
All feldspars
All clays
Wollastonite
Talc
Zirconium silicate
Sand

Frits
Wood ash
Bentonite

Boron oxide B$_2$O$_3$

Boron oxide is both a glass former and a flux – becoming active around 300°C (573°F). It is commonly used in low-temperature glazes as an alternative to lead oxide. Boron has low toxicity but is highly soluble in water, therefore it is usually added to a glaze as a frit. The benefit of boron is that it has a low expansion and contraction rate which can counteract crazing (although, in excess amounts this can increase crazing) and it promotes strong colour response in glazes.

Sources:
Borax, borax acid (soluble)
Colemanite, Gerstley borate/Gillespie borate (slightly soluble)
Frits, including calcium borate frit, standard borax frit (insoluble)

Stabilizers (R$_2$O$_3$)

The role of stabilizing oxides is to stiffen the molten glaze and prevent the glaze from becoming too runny when fired.

Aluminium oxide Al$_2$O$_3$

Glazes that consist entirely of glass formers and flux material would be very unstable and fluid. Therefore, a third element in the form of aluminium oxide – or alumina as it is known, is introduced to the glaze to bring stability, viscosity and aid adhesion to the ware. Alumina has a high melting point of 2050°C (3722°F) and is considered refractory. In excess it can make a glaze matt and inhibit colour response. Alumina is beneficial for preventing crystallization during cooling to help keep glazes smooth and bright, although this can interfere with crystal development in crystalline glazes. Alumina is insoluble and usually introduced into the glaze as a clay-type material such as china clay or ball clay. The choice of clay will influence the glaze in some way. China clay (kaolin) is whiter and can enhance the colour of the glazes, whereas some ball clays contain iron and other impurities but are highly plastic, which can improve adhesion.

Sources:
China clay (kaolin)
Ball clays, for example AT ball clay, Hyplas 71, TWVD, HVAR
Calcined alumina
Hydrated alumina

Fire clay
Powdered red clay
Feldspars

Opacifiers

The following oxides act as opacifiers in a glaze, whereby they obscure the clay body underneath:

Tin oxide SnO_2 (stannic oxide)

There is a long tradition of using tin oxide as an opacifier in glazes – most notably for Maiolica glazes. Tin produces soft, delicate whites that serve as an excellent base for on-glaze decoration. It is slightly refractory and has high expansion and contraction which can cause some issues with pin-holing and crazing. In reduction, tin can lose some of its opacity but when added to a copper-red glaze in amounts of 1–5 per cent, it can improve the overall colour response. Tin is sensitive to vapours from chrome oxide and can blush pink-brown if in close contact. To achieve opacity, tin is added to glazes in amounts of 1–12 per cent. As a guide, 4–7 per cent will produce a semi-opaque white, and 8–10 per cent will produce a strong white.

Sources:
Tin oxide
Stannic oxide

Zirconium oxide ZrO_2

Zirconium oxide is very refractory and has a high melting point of 2700°C (4892°F). It remains unmelted in the glaze as tiny suspended particles, which give the opacity effect. Zirconium is about half the strength of tin oxide and is often used in combination with tin as a less expensive substitute. The whites produced by zirconium are very bright and quite stark, but can be knocked back to a softer tone with tin. Zirconium has a low expansion and contraction rate and can improve strength and durability in a glaze. It is added to glazes in amounts of up to 15 per cent.

Sources:
Zirconium silicate
Zirconium oxide
Zircopax (brand name)

Titanium dioxide TiO_2

Titanium dioxide will produce creamy white opaque colours and mottling effects in glazes. Unlike tin or zirconium, it creates opacity by the formation of small crystals within the glaze which refract the light. In small amounts of 1–2 per cent it can help stabilize the colour response of colouring oxides, particularly iron. Between 2–5 per cent it will create mottled textures – with 5–8 per cent the suitable amount to give opacity. In high amounts of up to 20 per cent, it can produce crystalline matt and semi-matt surfaces which can soften colours.

Sources:
Titanium dioxide
Rutile (iron and titanium)
Ilmenite (iron titanate)

Copper red glazes benefit from the addition of 1–3 per cent tin oxide to promote strong colour response. Glaze CR7 without tin (left) and with 3 per cent addition of tin (right).

COLOURANTS

Colour in glazes derives from two main sources – metal oxides or stains. Metal oxides (also referred to as colouring oxides) bring depth and tonality, and have a broad response to the firing temperature, kiln atmosphere (oxidized, reduction) and the main flux used in the glaze. Glaze stains in comparison have the advantage over oxides, whereby the colour in the raw state is closer to the final colour after firing. They are useful for creating colours such as bright reds, yellows and pinks that would be difficult to achieve using oxides. However, glaze stains cost more to purchase and require a greater amount to colour the glaze. They do not offer the same tonal quality as oxides and can suffer from looking a little flat. Oxides and stains can be combined in various proportions to produce blends, tones and new colours.

Colouring oxides

Only a small amount of oxide is usually required to colour a glaze (up to 5 per cent) although some weaker oxides require higher amounts (up to 12 per cent). Carbonates are essentially the same as the oxide but slightly weaker and break down during the firing, giving off carbon dioxide in the process.

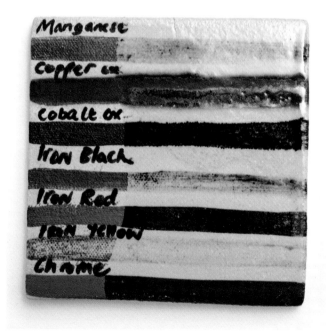

A tile applied with a selection of metal oxides with a transparent stoneware glaze applied on top to reveal the individual colours.

Copper oxide CuO

Copper oxide is one of the most widely used colouring oxides and can produce a broad scope of vibrant colours, such as decadent turquoise blues in sodium-based low alumina glazes, green-yellow in potassium glazes, greens in magnesium glaze, and blue-turquoise in barium glazes. It is sensitive to kiln atmosphere and in reduction, copper can produce a deep red colour – referred to as 'ox blood' or 'sang de boeuf', which can intensify further in the presence of tin. Copper is a reasonably strong colourant and small amounts of 0.25–1 per cent are sufficient to colour the glaze. In amounts above 5 per cent it can bring the glaze to metallic black. Copper carbonate is weaker than the oxide but reduces the risk of speckling and gives a more consistent colour. Copper is a very strong flux and can improve the shine of glazes but increases the fluidity and runniness. It is also very volatile at high temperatures and vapours can cause flashing on wares in close location. Additions of copper oxide can cause the solubility of lead in low-solubility glazes, so it should be avoided on the interiors of vessels intended for food use.

 Sources:
 Black copper oxide
 Copper carbonate
 Red copper oxide
 Copper sulphate

Cobalt oxide CoO

Cobalt oxide is a powerful flux and produces a strong blue colour even in small amounts. The carbonate form has lower cobalt content but produces a less overpowering blue and reduces speckling in the glaze; 1–3 per cent carbonate or 0.5–1.5 per cent oxide produces vivid blues in alkaline glazes, and lavender purple and pinks in magnesium glazes. The deep blue colour of cobalt remains consistent across oxidized and reduction atmospheres. As cobalt is an active flux, this can destabilize some glazes so try not to use more than 2 per cent to help keep this in control. Cobalt works very well in combination with other oxides, such as manganese – blue-purple, and copper for blue-green.

 Sources:
 Cobalt oxide
 Cobalt carbonate
 Cobalt sulphate

Chromium oxide Cr_2O_3

Chromium oxide (chrome) is a strong colourant and generally produces dark, mossy green colours in amounts of 1–2 per cent.

It is highly refractory and can achieve a broad palette of colours ranging from soft-red brown and yellows in barium or sodium glazes, or brown in zinc-bearing glazes. In combination with cobalt, it will produce green-black, and give pink-crimson in the presence of tin. It is unaffected by oxidized or reduction atmospheres. At higher temperatures above 1200°C (2192°F) chrome becomes volatile and can pollute other wares in the kiln, for example glazes containing tin oxide are particularly susceptible to fumes and can develop unattractive pink-brown streaks. Chrome fumes can also permeate the brickwork of the kiln, affecting subsequent firings. Chrome is highly toxic and releases harmful fumes during firing, therefore extra precautions should be taken.

Sources:
Chromium oxide
Potassium dichromate
Iron chromate

Iron oxide FeO

Iron oxide is present in almost all raw materials and is one of the most widely used oxides in ceramics. It can produce a broad spectrum of warm colours from yellow, red, grey, browns, greens and blues and is very stable at high temperatures. Iron is a weak oxide and typical amounts in a glaze range from 1–12 per cent. It is commonly added to glazes in the form of red iron oxide (Fe_2O_3) which is considered the most stable form of iron. In its raw form it will produce a red-brown colour when used as a decorative medium. The other common form of iron is black iron oxide (Fe_3O_4); it will largely give the same colour results as red iron oxide but does not disperse as readily in a glaze. Iron is very sensitive to oxidized or reduction atmospheres. In oxidization, iron acts as a refractory material and will mostly produce browns and yellow tones, for example 2–10 per cent red oxide will achieve honey colours to dark brown and can accentuate slip-decorated wares; 1 per cent of titanium dioxide added to iron-based glazes can help stabilize yellow-orange colours. In reduction, iron acts as a flux and can create delicate blue-green colours in percentages of 1–3 per cent for celadon, and at the other end of the spectrum, 8–12 per cent for rich tenmoku browns. Iron is useful to bring depth and richness to other colouring oxides and stains, a suggested amount being 2 per cent.

Sources:
Red iron oxide
Black iron oxide
Yellow iron oxide
Purple iron oxide
Synthetic iron oxide – red, yellow and black oxide
Ilmenite coarse/fine
Rutile (iron and titanium)
Iron sulphate
Iron chromate
Crocus martis
Yellow ochre
Red clay powder
Iron spangles
Rust

Manganese dioxide MnO

Manganese is refractory but can act as a flux at higher temperatures. It typically produces brown colours, ranging to plum-purple in alkaline glazes, and purples when mixed with cobalt. It is used in commercial stains to produce black. Manganese is quite a weak oxide and requires amounts of 2–4 per cent

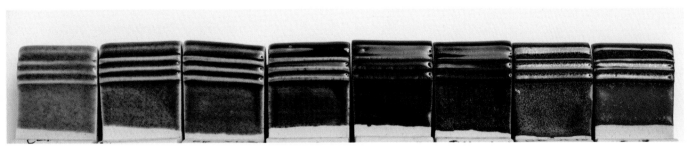

In high temperature reduction glazes, a celadon is created with the addition of 1–3 per cent red iron oxide to a base glaze, while a Tenmoku is created with the addition of up to 10 per cent red iron oxide. Left to right: starting with celadon, iron increases in increments of 2 per cent; leading to a classic Tenmoku (centre right); progressing to Tessha and Kaki (right).

for stronger colour response. In large amounts, manganese can produce metallic bronze and gold glazes. Manganese is toxic, and should be handled with care.

Sources:

Manganese dioxide

Manganese carbonate

Nickel oxide NiO

Nickel oxide is a strong colourant and colours range from grey-browns, pinks, and blues. In high zinc glazes it can produce yellow in oxidization and blue when reduced. It can sometimes give an unpleasant colour response by itself, but comes into its own when used in crystalline glazes where it produces steel-blue crystals. It can also produce neon-pink when in combination with barium. Nickel is highly toxic and gives off hazardous fumes.

Sources:

Nickel oxide

Rutile TiO_2 + FeO

Rutile is a natural ore and contains iron and titanium dioxide. It is used to create a wide range of colours from light brown, tan yellows, gold, creams and pinks. During cooling, rutile crystallizes and can bring unique streaking effects and opalescent

Rutile can produce opalescent, streaking effects in glazes, which is enhanced further when applied in combination with other colouring oxides.

qualities. It is added in amounts from 4–12 per cent and is excellent for modifying other oxides and stain colours.

Sources

Rutile light

Rutile dark

Ilmenite

Vanadium oxide V_2O_5

Vanadium produces a weak yellow colour in glazes. It is volatile at higher temperatures and can disrupt glaze surfaces with interesting mottled and textural qualities. The vapours can pollute areas where the clay body is exposed (unglazed) and leave an unpleasant grey tinge which is more noticeable on white clays. Vanadium is typically added to glazes in amounts of 1–6 per cent. Vanadium is highly toxic and should be handled with care.

Sources:

Vanadium pentoxide

Rare earth oxides

The rare earth oxides include neodymium (Nd), praseodymium (Pr) and erbium (Er). They are not as commonly used in glaze practice, mainly because they are weak colourants and more expensive when stains offer comparable colours. However, these oxides are worth mentioning if you seek pale, watery colours ranging from powder blue, lavender purples, pinks and lime green. Use in amounts of 3–15 per cent.

STAINS

Stains are commercially produced colours made using the fritting process. They consist of a combination of colouring oxides, silica, alumina and opacifiers which are fired and ground to a powder. They offer a consistent and reliable source of colour that might otherwise be difficult to achieve using conventional means. For example, reds and oranges derive from cadmium and selenium which are too toxic to use in studio practice, but these vibrant colours are made possible as a stain without the associated hazards.

Unlike colouring oxides, the colour of a stain in its raw state is indicative of its final glaze colour. Stains can be used in oxidized and reduction atmospheres, but some stains can burn out or become less effective at certain firing temperatures and conditions. Glazes that contain zinc can also affect the performance of certain stain colours, such as chrome tin pink. Another important consideration is that stains are refractory, and only a small amount

Glaze stains produce bright, appealing colours that would be difficult to achieve using oxides.

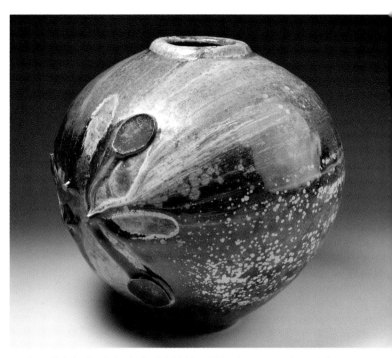

Matthew Blakely, *Cumbrian Jar* (2020). H: 29cm. This piece was made entirely from rocks and clays collected by the artist and covered in a slip using Cumbrian volcanic ash. The glazes are made using a variety of Cumbrian rocks – granite, limestone, quartz and tuff. The piece was fired on its side in a wood kiln to encourage the glaze to flow around the neck.

of stain melts or goes into solution. Therefore, processing the stain through a fine 120–150 mesh sieve can improve the saturation of the colour by breaking down the particle size. Glaze stains are more expensive than metal oxides, and require larger amounts to colour the glaze. Typical amounts are 2–4 per cent for pale shades, 5–8 per cent medium strength, 8–12 per cent maximum strength. A useful tip is to keep a stock of yellow, blue and red stains and use oxides to broaden the colour palette further. For example, yellow stain can be made acid green with the addition of 1 per cent copper carbonate, and red can be made purple with the addition of 0.5 per cent cobalt carbonate. Blue stain can be enriched tonally with the addition of 1–3 per cent red iron oxide.

SOURCING YOUR OWN MATERIALS

You can make your own glazes from locally sourced materials, such as quarry dust, chunks of flint, chalk and clay dug from the ground. They are not as refined of course and will take some processing and experimenting with to make suitable for use, however these materials can bring a distinctive range of effects and qualities to a glaze. Refer to the bibliography for specific books on the subject if this is an area of interest.

One of the most common and accessible materials to source yourself is wood ash, as outlined below.

Wood ash

Wood ash, or ash from organic matter such as plants and grasses, contains all the key components of a glaze, including silica, flux and other useful oxides – phosphorus and iron. Wood ash can vary widely and different tree species can impact on the composition of the ash, bringing unique qualities to the glaze. Ash can be gathered from a stove or fire pit; you will need a fair amount to make a glaze. Make sure that no other fuel source, such as coal, is present that could contaminate the ash. Wood ash can be unwashed and used straight in a glaze to bring texture, but it is usually washed before use to remove soluble alkali compounds, and then dried and sieved into a fine powder.

To prepare, you will need the following equipment as illustrated, including protective goggles, mask and gloves. When wood ash is washed, it produces soluble alkalis called lye (used in soap production) which is caustic, therefore take extra precautions when handling and preparing it.

Essential equipment when preparing ash glazes, including protective goggles and gloves.

Step by step

Collect the ashes, remove any lumps of charcoal and debris and decant into a large container of fresh water, give it a good mix and leave to settle for at least twenty-four hours (the longer the better).

Syphon off the water and repeat washing and settling process (this might take a couple of days) until the water runs clear.

Decant the ash into a sieve and rinse under running water. Leave to dry. Process through a coarse sieve, then through a 60-mesh sieve to make a fine powder.

HEALTH AND SAFETY

An awareness of good health and safety practices within ceramics cannot be emphasized enough. Much of this comes down to common sense, but there are a number of hazards to be aware of when handling ceramic materials and preparing glazes including:

Toxicity

Many raw materials we use to make glazes are toxic to varying degrees and extra caution should be taken when preparing glazes and handling materials that present hazards. These may be in the form of:

- Ingestion – entering the body and bloodstream through swallowing.
- Inhalation – breathing in airborne particles.
- Absorption – harmful toxins that are soluble in water and can be absorbed through the skin.
- Irritants – materials that cause discomfort and irritation to the skin, eyes or airways.

We also need to be mindful that some materials can give off extremely harmful fumes in the form of carbon monoxide (CO), carbon dioxide (CO_2), sulphur compounds and heavy metals during the firing and for this reason, you should avoid being in the same room as the kiln during the firing. Always refer to the manufacturer's safety data sheet (SDS) for specific guidance of each material.

Dust

Silica presents one of the biggest hazards in the form of free-silica dust, and is present in a number of ceramic materials, including quartz, flint, feldspars, talc, clays and frits. This is a known carcinogen and extra care must be taken to eliminate exposure to dust, including:

- Wear appropriate PPE (face respirator) when weighing and handling ceramic materials. Replace filters regularly.
- Ensure good ventilation and air flow in the studio.
- Wash cloth aprons and overalls regularly – consider wearing plastic or wipe-clean fabrics that do not hold dust. Avoid patting down overalls or shaking out fabric sheets that could make particles airborne.
- Never dry-sweep – benches, tools and surfaces should be cleaned regularly with a sponge and bucket of water. Vacuum and mop floors at the end of the day.
- Do not eat, drink or smoke in the studio.

Storing materials

Ceramics materials should be stored in secure, lidded containers in a dry location, away from moisture or direct sunlight. Make sure the contents are clearly labelled, ideally written with a permanent marker pen or sticker on the container which can't be easily wiped off. You should aim to keep printouts of safety data sheets in a ring binder for easy reference. Occasionally, the plastic containers and packaging can deteriorate over time, leading to spillages, so be mindful of this when handling materials that have been stored for long periods. Always wear a protective mask when decanting or handling materials.

Wear a protective mask with filters when handling materials to minimize exposure to hazardous dust.

Safe disposal of materials

Never dispose of ceramic materials down the sink as this will ultimately end up back in the water system. A water siphon trap fitted under the sink can help catch deposits of materials and should be emptied regularly. The waste material can be dried out on a plaster batt and bagged up for disposal. Refer to the manufacturer's safety data sheet for advice regarding appropriate disposal but a useful tip is to fire materials such as old dried-up test samples to a low temperature of 600°C (1112°F) which will render them solid and unable to break down. They can then be disposed of safely.

Leaching

Some glazes can leach harmful materials when exposed to acids (such as from foodstuffs) and bases (for example from detergents). The best course of action is to avoid using glazes that pose these risks, especially for items intended for use. For peace of mind, you can have glazes laboratory-tested, but you can initiate a home test as a starting point, which involves:

- Place a slice of lemon on the fired glaze surface and leave for twenty-four hours. Any discolouration of the glaze is an indication of leaching.
- Put a sample tile in a vinegar bath for three to four days and observe any colour changes in the glaze.
- Similarly, put a glaze tile in the dishwasher and leave for multiple cycles over the course of a few weeks. Observe if the glaze has any discolouration or surface abrasions as this is an indication the glaze is susceptible to attack from detergents.

GLAZE MATERIALS OF CONCERN

Take extra care when handling the following materials:

- Lead frits
- Barium carbonate
- Compounds of copper, cobalt, vanadium, lithium, manganese, chrome
- Silica – flint, quartz, feldspars, clays
- Sulphates (soluble in water)
- Wood ash – contains silica and soluble alkalis

PREPARING AND APPLYING GLAZE – METHODS AND TECHNIQUES

Preparing a glaze can be likened to the process of baking or cooking, whereby ingredients are carefully weighed and measured following a recipe, and then combined to create a mixture. In both instances, using appropriate equipment will make the task much easier and will lead to consistent, replicable results. Here is an overview of the essential items to get you started:

- A set of weighing scales – either triple beam scales or electronic digital scales that can weigh 0.1 of a gram
- Mixing bowls of various sizes from large to small for mixing and preparing glazes
- Containers to store small amounts – plastic yoghurt pots or deli containers are ideal
- Lidded buckets (2 litre, 5 litre, 10 litre) to store volumes of glaze liquid
- Wooden sieves (60, 80, 120 mesh) are an essential item for preparing and mixing a glaze
- Wooden slat lengths (approx. 30cm long or size of a standard ruler) to support the sieve when processing the glaze
- Selection of stainless-steel spoons and measuring scoops to transfer ceramic material from one container to another container or mixing bowl
- Glaze brushes for mixing and applying glaze. A 'lawn' brush with stiff nylon bristles for passing glaze through a sieve is particularly handy
- Rubber kidney or plastic spatula to aid the ceramic material through the sieve and remove excess glaze from the sides of the sieve and container

- Measuring jug selection of various capacity sizes (500ml, 1 litre, 2 litre) for decanting glaze and measuring specific amounts of liquid
- Respirator face mask that meets PPE (personal protective equipment) safety standards (suggested level: UK – FFP3 or equivalent)
- Latex/latex-free disposable gloves to protect your skin from absorbing glaze materials
- Large sponge to wipe down surfaces and clean away spillages
- Notebook and pen to record and document your results
- Calculator to aid mathematical sums – addition, subtraction, division or multiplication of glaze amounts

Desirable

- Glaze hydrometer – an instrument that measures the specific gravity weight of a glaze to ascertain the optimum consistency and enable replication of a batch (discussed later in the chapter)
- Power drill with mixing attachment – very useful for blending glaze materials and mixing the batch of glaze prior to application
- Rotary sieve – a type of sieve with a rotating arm which mills the glaze materials through the mesh
- Spray booth with extraction and/or 'wet back' panel (water flows over a back panel to trap and wash away airborne particles)
- Air compressor and gravity-feed spray gun

◀ Glazing the inside of a vessel using the pouring technique.

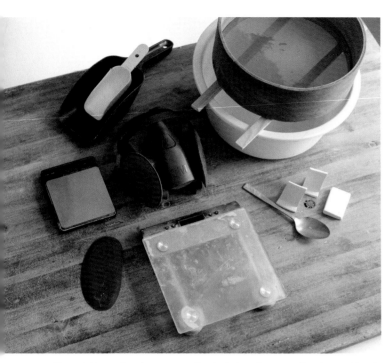

For example, here is a typical glaze recipe format:

Stoneware shiny transparent cone 8/9, Oxidized		
Base glaze	%	
Potash feldspar	45	- Primary flux, source of potassium oxide, silica & alumina
Quartz	25	- Silica, main glass former
Whiting	15	- Secondary flux, source of calcium oxide
China clay	15	- Alumina, stabilizes the glaze

Total = 100		

Additions	+	
Colourants		
Copper oxide	1	- Green colour in oxidization (depending on main flux)
Opacifier		
Tin oxide	4	- White (combined with copper, most likely a pastel green)

Essential items for glaze preparation include a sieve, wooden slats and bowl, selection of scoops and spoons, protective face mask, weighing scales, rubber kidney and bisque glaze tiles.

READING A GLAZE RECIPE

Glaze recipes can be researched from a wide range of sources – as discussed in Chapter 5, or you might be experimenting with your own recipes. The format of a glaze recipe constitutes a list of ingredients, with each individual amount expressed as a percentage, totalling 100 per cent. The benefit of using percentages is that it can be interpreted as a unit of measurement, for example, 40 per cent = 40 grams, and calculated to make a batch of glaze; from a small amount to fill a yoghurt pot-sized container, through to a 20-litre bucket and more. The main ingredient list that totals 100 per cent is usually referred to as the 'base' glaze recipe. These are the essential materials of the glaze that determine its characteristic traits, such as shiny, matt or textured qualities. A typical recipe will often list the ingredients from largest to smallest amounts – usually fluxes first, followed by silica and alumina/clay amounts. Any opacifiers and colourants are added to the recipe as separate additions. This allows for greater flexibility to adapt and expand the recipe as desired. Eventually, as you progress with experience you will be able to just look at a recipe and predict from its key ingredients how the glaze might behave and respond.

WEIGHING OUT INGREDIENTS

You don't need to spend a fortune on glazing equipment and you can be very resourceful with household items and recycled containers. Although, do invest in a decent set of weighing scales if you can, as this is the crucial element to getting it right. Choosing between a manual triple beam type or digital set is completely down to personal preference – both are very accurate and consistent means to weigh your materials. If you choose the digital route, it can be really useful to have two sets of scales – one for weighing large amounts and another more precise set for weighing small quantities. A specialist scientific set of electronic scales will come with a hefty price tag but if you seek high accuracy, particularly when weighing very small amounts, then consider it worth the investment. From experience, ordinary kitchen digital scales are perfectly acceptable means to weigh large quantities of glaze materials and do the job just fine. They are easy to clean and store away too. However, with digital scales you will need to ensure the scales are properly calibrated before you begin using them otherwise the weights might be incorrect. A word of caution when weighing out materials; do not be tempted to zero/tare the scales and add a different material on top of another. It may quicken the process, but it greatly increases the chance of error and potentially losing the whole batch.

Tip for weighing small amounts

Materials such as colouring metal oxides only require very small amounts to colour the glaze, for example 0.25 per cent of cobalt oxide will produce a strong blue colour. If you don't have a set of scales capable of weighing 0.01 of a gram, then a helpful tip is to weigh 1g of the material and place on a sheet of paper or card. With an old credit card or back of a spoon, compress the amount into a flat disk shape, about the size of a coin. Take the edge of the same card or spoon and divide the disk into quarters. This technique may not have the high accuracy of a weighed amount, but it is an efficient way to ascertain equal parts of 0.25 per cent which you can then add to your glaze.

Step by step

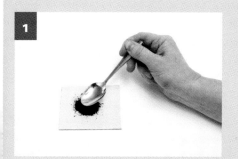

Weigh 1g of material and lightly press into a flat disk using the back of a spoon.

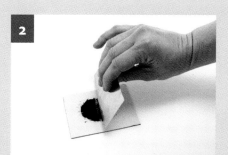

Using the edge of a card, carefully divide the amount into four equal quarters.

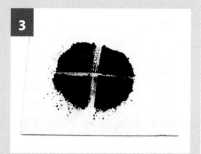

Each quarter part will weigh the equivalent of 0.25g and can then be transferred to the recipe amount.

WEIGHING METHOD

Before you start, select your glaze recipe and calculate the total batch amount you need. Make sure you have all the equipment and materials you need to hand, as well as wearing a protective dust mask. It can be useful to have a written list of your recipe ingredients to tick off as you go along. Work cleanly and wash and dry any utensils when interchanging materials to avoid cross-contamination.

Step by step

Place a sufficient size bowl on top of the scales. You will also need to have a secondary bowl or container to dispense your weighed materials into.

Continue to weigh your materials one by one and transfer into the container until you have completed your recipe.

Multiplying quantities of glaze

Here is a useful guide to calculate batch amounts of glaze:

Example: Typical stoneware base glaze 1280°C (2336°F/cone 9)

	%	Test amount	× 25 = 5 litres	× 50 = 10 litres
Cornish stone	70	= 70g	1750g	3500g
Whiting	20	= 20g	500g	1000g
China clay	10	= 10g	250g	500g
Total =	100%	100g	2500g	3000g
Addition +				
Cobalt oxide	0.5	= 0.5g	12.5g	25g

HOW MUCH WATER?

All glazes require a quantity of water added to the dry materials to make a liquid and hold the particles in suspension. When the glaze is applied to the wares, the water content is absorbed into the body, leaving behind a layer of glaze material. This aids the melt of the materials and ensures a consistent coating. However, when preparing a glaze, the tricky part is knowing how much water to add in the first place to make it the right consistency, as this is not always obvious. Much of this depends on the intended firing temperature and the type of materials used in the glaze because some materials, particularly from the clay-based group such as china clay or ball clay are thirstier than others and will absorb more water. We will discuss glaze consistency in greater depth later in the chapter but for the purpose of preparing a glaze, the main focus here is to add enough water to enable the glaze materials to be processed through a sieve. A general rule of thumb to gauge the amount of water you need to add at this stage is approximately 100ml for every 100g weight, for example 1000g = 1000ml water. However, this is only a guide, and you may need to add more or less water depending on your glaze materials and required consistency. You may wish to record how many millilitres of water you add so you can replicate the results later on. Through experience and familiarity of mixing your own glazes, you will be able to get a good sense of how much water to add and the process will eventually become instinctive.

PREPARING THE GLAZE

Once you have weighed your raw materials, you can proceed to mix the glaze. First you will need to add the desired amount of water to begin the process of slaking down the materials (such as 100ml for 100g). Always avoid pouring water into a bowl of dry materials, for two reasons; 1) the powder will puff into the air and create dust; 2) some glaze materials such as bentonite are prone to clumping, which can make it difficult to push through the sieve later on. Instead, pour the water content into a bowl and gently slide your materials into the water. You may see the materials bubble in the water as they absorb the liquid and slake down. It is beneficial to leave the materials to soak for a period of time before you sieve them; this could be ten to thirty minutes or so, but for best results, leave overnight. This will allow the particles to become fully saturated, making it much easier to process the materials through the sieve.

Sieves

If we simply take the glaze liquid as it is without refining it further, the fired glaze result will be very inconsistent and likely to have a whole host of technical issues from lumpy application

to poor fit with the clay body. Therefore, it is important that a glaze is sieved a number of times through a fine mesh to break down the material particle size and blend the ingredients together, leading to a homogenous, consistent mixture.

Sieves used for glazes are traditionally made from a wide strip of wood, bent into a cylindrical shape with a sheet of metal mesh lining the base. The grade of the mesh size corresponds to a number system ranging from 20–300; the larger the number, the finer the mesh (the number of holes per linear inch). The size of the mesh grade is important to the type of glaze you are making. Earthenware glazes require a fine mesh of 120–150. This refines the particles to a much smaller size and improves the melt at lower temperature ranges. On the contrary, the high temperature of stoneware will melt the particles regardless of size and the glaze can be processed through a lower-grade sieve mesh, 60–80. A useful tip; colourful stoneware glazes that contain oxide or stain benefit from processing through an extra-fine sieve of 120–150 on the final sieving to refine the particles even further and enhance the colour result.

Some materials, such as frits or bone ash, can be quite gritty or lumpy, making them difficult to process through the sieve. Therefore, it is beneficial to crush them into a finer powder first using a pestle and mortar or a ball mill (if you have access to one). Another useful tip is to try soaking materials in hot water rather than cold water, as this can speed up the saturation process particularly of fritted materials, making them easier to process later on.

Use a pestle and mortar to crush materials into a finer powder.

Jar mill

A jar mill (also referred to as a ball mill) is a mechanical piece of equipment used to grind ceramic materials. The materials are combined with water and poured into a ceramic jar which is filled with porcelain or flint balls. The jar is secured and placed onto rotating rollers which tumble the mixture over a period of time, anything from two to twenty-four hours, or more. The balls inside the jar crush the materials, thus producing a very refined glaze. Jar mills are more commonly

A selection of sieves used for the preparation of glazes.

associated with industrial use, but smaller versions are available for studio use.

Mixing

To mix the glaze, stir the materials that have been slaking in the water thoroughly and add more water if the mixture looks thick or paste-like. Wear protective gloves, particularly if the glaze contains any toxic or soluble materials.

Step by step

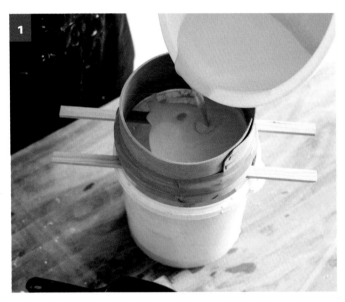

Place the sieve over the empty container, using the wooden slats for support. Pour the mixture into the sieve until it reaches halfway.

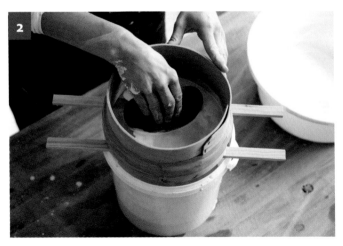

With a circular motion, use a rubber kidney or brush to compress the glaze mixture through the sieve, topping up with more glaze liquid as you go until all the glaze has passed through the sieve.

Repeat the process of sieving at least twice. When you are finished, pour the glaze into a lidded container and label the top and side using a permanent marker. It can be useful to attach a glaze tile sample to the container as a visual reference.

GLAZE THICKNESS AND CONSISTENCY

Gauging the correct consistency of a glaze is not an easy task and there are many variables to consider, including the type of glaze you are using – whether it requires a thick or thin coat of glaze; firing temperature – earthenware/stoneware; and kiln atmosphere – oxidization/reduction. It's not surprising that it causes so much anxiety! However, there are a number of techniques to help you achieve the correct consistency and enable you to replicate your results, as outlined below:

Glaze thickness 'Rule of thumb'

Here is a very simple way to remember the thickness of the glaze:

- **Earthenware glazes = consistency of milk**
 Earthenware glazes should be relatively thin but not watery. If there is any underglaze/slip detail, it should just be visible through the glaze once it is dried. As a guide, the dried glaze layer should be around 0.25–0.5mm thick.
- **Stoneware glazes = consistency of cream**
 Stoneware glazes are thicker in consistency compared to earthenware glazes; the dried layer should be around 0.5–1mm thick. Reduction glazes – particularly copper-red 'sang de boeuf' and Chun glazes benefit from a thicker application of 2–3mm thick.

Too much water?

If you have added too much water to your glaze, wait for the materials to settle (this may take a few hours) and then siphon off the excess before re-mixing the glaze.

Checking the thickness
By hand

A common way potters like to check the thickness is to dip a finger in the glaze and observe how the liquid sits between the lines and detail around the knuckle and skin folds. For

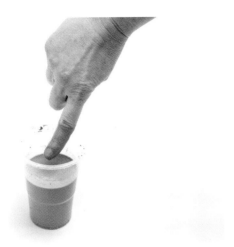
Check the thickness by dipping your finger in the glaze.

earthenware glazes the detail should be very clear, but less so for stoneware. Avoid using this method if you have any open cuts or wounds, and certainly not if the glaze contains any toxic or soluble materials that could irritate the skin. If in doubt, wear gloves or seek an alternative method.

Drag test

This is a particularly useful technique to gauge the thickness of sprayed glazes. Take a pottery needle tool or scalpel and scratch through the glaze in a discreet area of the piece. Look for a powdery ridge either side of the line, resembling a ploughed field. If the line feels scratchy, this is an indicator the glaze layer is too thin; if the glaze layer has a brittle, flaky quality, then it is likely to be too thick. Once satisfied, this mark can then be rubbed over with a fingertip.

Use a needle tool to help gauge the thickness of the glaze layer.

REPLICATION OF GLAZE THICKNESS PER BATCH

As you gain more experience with glazing, you will likely reach a point where you have an intuitive knowledge of the glaze thickness just by looking at the liquid or giving it a stir. However, you can be more precise with recording your glaze thicknesses so you can replicate your batches consistently, as discussed here:

Weigh your glaze

A straightforward and easy method is to simply weigh a sample of 100ml of your glaze and record the weight. Although quite rudimentary in approach, this method does allow you to compare the batches, particularly if you are new to glazing and looking to replicate the results without too much difficulty.

Specific gravity

One of the more scientific ways to replicate the glaze thickness is to calculate its specific gravity. Specific gravity is defined as the ratio of the density of a substance to the density of a reference substance. In this case the substance is glaze, and the reference substance is water. Water has a density of 1 gram per 1 millilitre. To gain the specific gravity of a glaze, divide the density of the glaze by the density of water. The method is as follows; you will need a set of scales and graduated cylinder (minimum 100ml):

1. Place the graduated cylinder on the scales and tare the weight to zero.
2. Make sure your glaze is thoroughly mixed and pour 100ml into the graduated cylinder.
3. Divide the weight of the glaze by 100, for example 150g ÷ 100 = specific weight **1.5**

Listed below are the approximate specific gravity ranges for guidance. Each glaze will differ so make sure you test first.

* Dipping or pouring glaze: 1.45 to 1.60
* Spraying glazes: 1.70 to 1.75
* Brushing glazes: 1.7 to 1.8

After doing your calculations you can check if the figures fall within the specified ranges, or simply make a note of the specific gravity when you are satisfied with a glaze. You can then check consecutive batches and adjust the water content accordingly.

Glaze hydrometer

A glaze hydrometer is an instrument that measures the specific gravity weight of a glaze. It resembles a thermometer and has a glass casing with a weighted bulb at the end. To use, stir your glaze thoroughly, wet the hydrometer and gently place, bulb end first, into the glaze slip where it will float like a fishing float and the scale can be read. You will be able to check the gauge readings against the specific gravity ranges as listed above.

Preparing the wares prior to application

Before you apply your glaze, you should first spend some time preparing the bisque ware. This includes lightly sanding rough edges and patches with wet and dry paper or checking for signs of cracks or splits. Wipe down the wares with a damp sponge to remove any surface dust and reduce the risk of crawling. Ensure the bisque is thoroughly dry before you attempt to glaze it, otherwise this will affect how it is absorbed into the body. Apply wax resist or latex to areas where you want to repel the glaze, for example the foot ring or lid gallery. The more time you devote to this task, the greater the chance you will achieve successful results.

A hydrometer tool for measuring specific gravity.

APPLICATION

The true success of a glaze often lies with appropriate, well-considered application. If done poorly, the application can seriously undermine the quality of the glaze and lead to very disappointing results. Before you begin, the most important consideration of all is to allow yourself enough time to complete the task, as it is surprising how long this can take. Rushing the process or applying the glaze on a whim is very risky indeed and may not yield a satisfactory outcome. Another factor to consider is to ensure you have tested your chosen glaze prior to application and understand the attributes and suitability of the glaze, such as correct thickness, or if it is a good fit with the clay body.

Glaze is best applied to dry bisque ware and should always be stirred and thoroughly mixed before you apply it to your work. There are a number of ways to apply glaze to the ceramic, including dipping, pouring and spraying the glaze. The approach you use is largely determined by the size of the object you intend to glaze, or quantity if glazing a batch, as well as how much glaze liquid you have. Dipping and pouring techniques are the most accessible skills to learn, and will typically yield the best results because the glaze layer is very consistent over the piece. Here is an overview of each technique.

Wax resist is applied to the foot on the piece to repel the glaze and speed up the cleaning process afterwards.

Pouring

The pouring technique is used for glazing the inside of vessels, containers and open forms, and can be extended as a practical method to cover flat tiles, plates, large items or used as a decorative technique in itself such as overlapping contrasting glazes. It can take a little practice to perfect, but it is a very effective method once you get the hang of it.

Pouring the inside

Grip the piece in one hand and use your other hand to pour the glaze from the jug until it reaches just below the rim. Avoid overfilling, otherwise the glaze might spill over the sides.

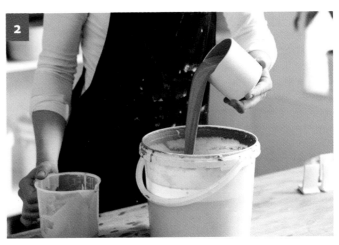

Tilt the piece to a 45-degree angle and swiftly tip out the glaze with a rotating motion to coat the whole interior. Hold the piece upside down until the glaze coating has been fully absorbed.

Pouring the outside

You can adapt the pouring method to cover the outside of larger items, or those that have no interior space, such as a sculpture. Place your object on slats over a bowl or tray to catch the glaze liquid. Pour the glaze from a jug, allowing the liquid to flow all over the surface area until it is fully covered. Leave for a few minutes to absorb the glaze before handling. Wipe away any drips and spills.

Dipping

To dip an object all over, you can grip the ware either by hand or with glaze tongs and submerge completely in the glaze. Here, the technique using tongs is explained.

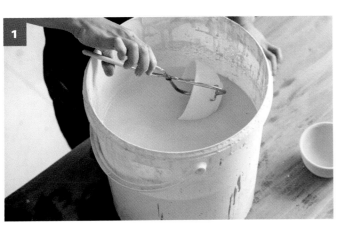

Use the tongs to grip the piece, either by the base or wall. Place into the glaze liquid.

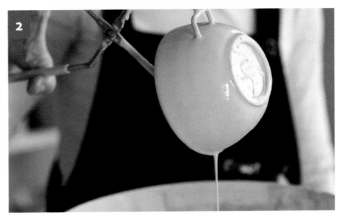

Remove after approximately three seconds, and lightly shake to remove any remaining drips of glaze.

To dip just the outside of a piece:

In both instances, wait until the glaze has been fully absorbed – it will look dry and be powdery to touch. Turn it back over and place back on the board and wipe clean the base or any areas that will make contact with the kiln shelf, to avoid sticking.

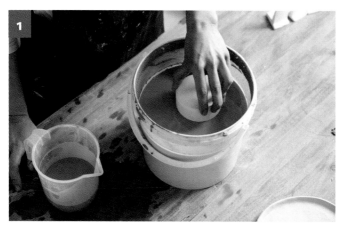

Grip the piece by the base and plunge it vertically into the container. The interior void will create a vacuum and prevent glaze from going inside.

Remove after approximately three seconds, twist, and flick off any remaining drips of glaze.

Dipping and pouring combination

More often than not, you will need to use a combination of the dipping and pouring technique, whereby the interior is poured first and the outside is dipped, for example, when glazing a mug, or a tall vase. In working practice, the interior of the piece is poured with glaze, tipped out and immediately dipped straight back into the bucket of glaze to coat the outside. This is a very efficient way of working, particularly when glazing a batch.

However, it is important to be guided by the type of work you are glazing. For example, thin-walled or slip-cast items are prone to damp patches whereby the water content in the glaze seeps through and renders the body too wet to accept glaze on the outside. In this scenario, the best course of action is to first glaze the interior and then leave it to completely dry, ideally overnight or in a warm spot before you attempt to glaze the outside. The process may take longer, but it will help prevent unsatisfactory results.

Spraying

Spraying glaze is advantageous for covering large surface areas with only a small amount of glaze, as well as complex items that would be too difficult to glaze using traditional means. It can also be used for decorative effect such as gradient colours, shading, highlighting and stencilling (*see* Chapter 7). It is more involved as a technique because it requires a spray booth with extraction, spray gun and compressor (a machine that

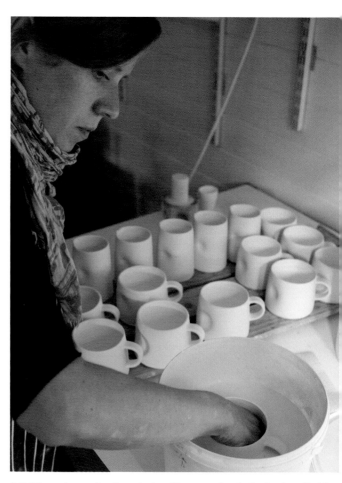

Artist Emma Lacey dips the exterior of her mugs by placing her hand inside to grip the piece and submerging it base-first into the glaze liquid.

Spraying glaze is advantageous for tricky or awkward work. Here the teapot spout and interior have been blocked so that a contrasting colour to the inside can be applied without risk of contamination of colours.

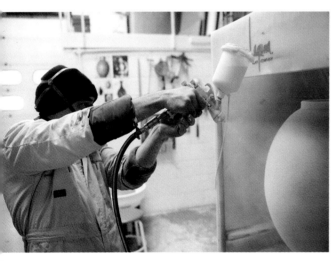

Artist Albert Montserrat applying glaze using the spraying technique. He builds up a number of layers to achieve unique interactions between the glazes.

pressurizes air and powers the spray gun) which are costly items compared to the other application methods. Be mindful of good health and safety practice, particularly when using compressed air (see health and safety at the end of this chapter). Never spray glazes that contain toxic or harmful materials, such as lead frits, barium carbonate, chrome oxide, nickel oxide, vanadium pentoxide, to name a few. Always wear appropriate personal protection equipment (PPE), including a dust respirator and eye protection to protect yourself from airborne particles.

Another consideration is that the thickness of the glaze required for spraying should not be too watery as this can saturate the bisque and result in a thin coating. Equally it should not be too thick either because this can block the nozzle of the spray gun. In general, you can use the glaze as you would if dipping or pouring, but do add a little more water to dilute the mix if you are having difficulty with application. If the piece has an interior space or is high-sided, it is recommended to pour the glaze inside first rather than spraying it because the space can be too narrow for the spray to cover evenly. Before you start, check the air pressure supplied to the spray gun from the compressor is set to the correct PSI (pound per square inch) for it to operate effectively. A guide amount is 40–60psi but refer to the manufacturer's operating manual for specific guidance. Also, the spray gun itself will have a series of adjustable valves and knobs which can change the width of the spray from narrow to wide, as well as the size of the droplets from large to a fine mist. It is wise to have a test run before you commit to the task to ensure you are happy with the set-up.

To prepare the piece to be sprayed, place it on a banding wheel so it can be rotated as you work. A few supports underneath will elevate it away from the banding wheel head and help prevent glaze pooling around the base. In order to achieve an even coating of glaze, aim the spray gun at a distance of between 20–30cm from the piece and sweep from left to right in an up-and-down motion as you rotate the banding wheel. You should allow each layer to dry before adding the next. The disadvantage of spraying is that it can be difficult to achieve a consistent layer of glaze. You can check the overall thickness by using the drag test (see glaze thickness).

Painting

Painting glaze with a brush to cover a surface area is not recommended unless you are using a specific brush-on or commercially prepared glaze. This is because glazes intended for dipping/pouring/spraying usually require a consistent coating and can appear patchy when applied with a brush. However, it is possible to adapt a dipping glaze into a brush-on glaze by adding a binder medium called CMC (carboxymethyl cellulose). CMC is an organic cellulose gum which functions as a thickener, binder and suspending agent in glazes. Follow the manufacturer's instructions for specific guidance, but general advice is to prepare the brush-on glaze as and when you need it, and in small batches because the organic nature of the product can cause it to rot when stored for long periods. To prepare the brush-on glaze, add one to two teaspoons of CMC to approximately 100ml of glaze – you might need to gauge

by eye and conduct a few test applications before you commit to going further. Adding CMC is also very useful if you plan to use stencils or stamps because it thickens up the glaze and can improve the transfer of the print. Another application of painting is as a method for expressive mark-making, decoration, or painterly effects.

STORING GLAZES

The majority of glazes will store for very long periods of time, indefinitely in most cases. A strong bucket with a secure lid will ensure the liquid does not dry out and maintains a good, workable state. Glazes usually settle into a separate glaze slurry layer and water content amount. Most will be quite straightforward to mix and use straight away, whilst others will need a bit more elbow grease to revive. Syphon off the water content (do not throw away), use an old fork or loop tool to drag through the glaze slurry and dislodge the lumps, then add it back to the water and mix. An electric blender or whisk is the ideal tool for speeding up this task.

Glazes that contain soluble alkali materials such as potassium, sodium and lithium can deflocculate the slurry over time causing it to thin out and form a dense, rock-solid layer in the bucket which is very difficult and laborious to mix. Deflocculation occurs when clay particles in the glaze repel one another, but can be improved with the addition of a flocculant such as Epsom salts (magnesium sulphate), calcium chloride or a few drops of white wine vinegar. This helps keep the particles in suspension and evenly dispersed. A teaspoon of Epsom salts dissolved in hot water, added to 1 litre of glaze is usually enough but you might have to add more or less depending on the individual glaze. Another tip is to add 1–2 per cent bentonite to the glaze recipe when you prepare the batch as this also has a flocculating effect and will improve adhesion and drying of the glaze when applied to bisque.

It is wise to fire a test sample of a glaze that has been stored for long periods before you commit to glazing the main work. Brush-on glazes can dry out over time, but can sometimes be revived with a little hot water and shake of the bottle. The same goes for dipping glazes where the water has evaporated away and resembles a block of powder – it can be reconstituted by soaking in water. Add more water to achieve the desired consistency and re-sieve the glaze before use.

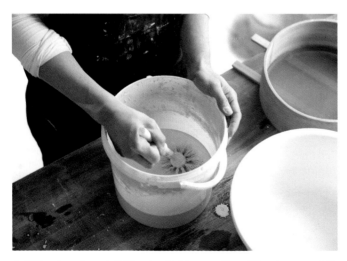

A stiff brush such as a toilet brush will aid preparation of the glaze, especially glazes that are heavily settled in the container.

Tips for preparing and applying glaze

- Take your time – don't rush!
- Prepare your bisque, sand away any rough areas. This will improve the final finish.
- Avoid drippy application (unless this is intentional). Some glazes are very unforgiving and will show up the drips after firing.
- Apply wax resist or latex to areas you do not want to glaze, for example the base or lid gallery.
- If you are glazing a white clay body with a white glaze, add a few drops of food colouring or vegetable dye to the glaze liquid to help see it and identify any missed areas.
- Thickness of glaze is key (approx. 0.25mm for earthenware, 0.5–1mm for stoneware).
- Plug and block areas you do not want glaze to run down, for example teapot spout.
- Dip your fingers in glaze first before you dip the pot to avoid bald spots.
- For thin-walled objects, glaze the inside first, leave in drying cupboard (or overnight) before glazing outside.
- Dipping and pouring will always give you the best results; try and master these techniques if you can.

- Ideally you should always glaze the inside and outside of the piece to avoid tension in the form and potential to crack. In most instances, you can get away with glazing the inside and leaving the outside unglazed, but less so the other way round.

- Some glazes will need sacrificial plates/trays to catch drips, particularly if they are prone to running, such as a crystalline glaze.

- Clean the bases, and make sure any areas that will have contact with the kiln shelf are free of glaze.

- If in doubt, wash it off! It is much better to start over rather than risk losing a piece to poor application.

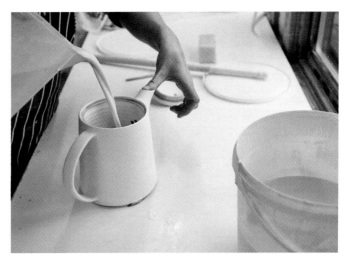

A thumb placed over the spout of a teapot will stop glaze flowing out and ensure the interior is cleanly glazed.

HEALTH AND SAFETY

In an ideal scenario, access to an extraction system when weighing out ceramic materials is beneficial to reduce the risk of dust inhalation. However, this is not always possible so therefore make sure you work in a well-ventilated room, and protect yourself from dust particles by wearing a good-quality half-facepiece respirator mask with filters (rather than just a thin paper mask). Lightly spray the air periodically with water as this will help dampen down any ambient dust. Always wear appropriate protective clothing including a wipeable apron and disposable gloves, particularly if you are going to be handling any toxic materials. Keep a bucket of water and large sponge on hand so you can wipe up spills and maintain a general tidy work area. If you are spraying glazes using compressed air, it is important you are a competent user and appropriately trained on using this equipment before you start. Make sure you are aware of the safety concerns such as flying debris causing injury, and never make direct contact with the skin or body because of the risk of air entering the body and bloodstream.

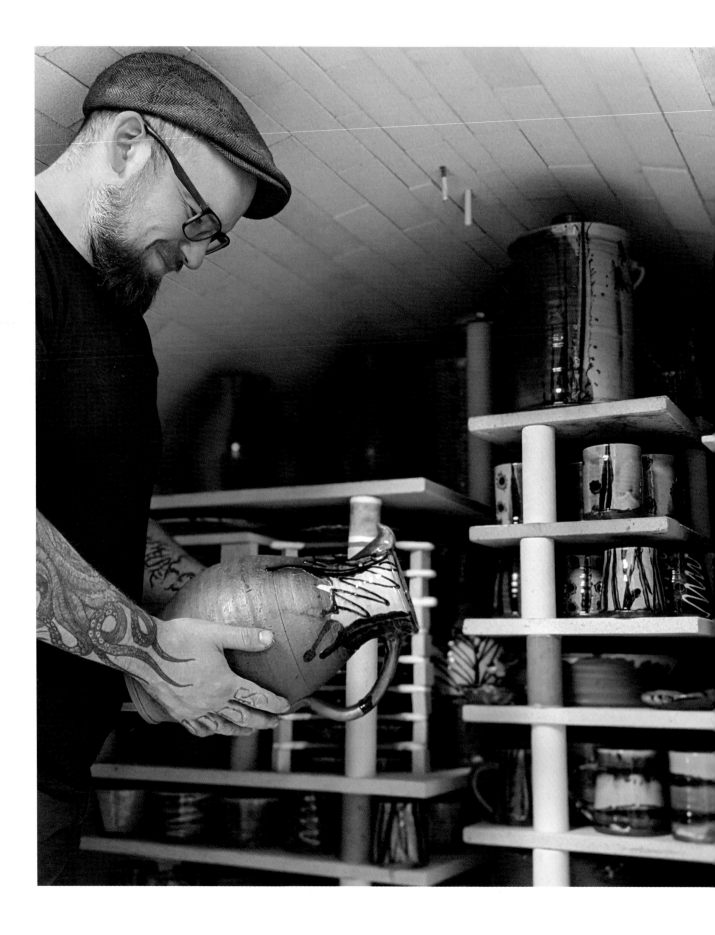

FIRING

Firing is the process of applying high-temperature heat to transform clay and ceramic materials into a permanent state. This is usually a two-part process, the first being the bisque firing, where raw, brittle clay converts to ceramic; followed by a glaze firing, used for decorative and functional application. The purpose of firing is to bring both the clay and glaze to a point of maturity, whereby the glaze material has fused on to the ceramic surface. From the perspective of the maker, the firing can feel like the riskiest stage. After all, the process is orchestrated by you but what happens in the kiln is not entirely within your control. However, like every aspect of ceramic practice – the more prepared you are, the more success you will have. The aim of this chapter is to provide a general overview and discuss all the different aspects to consider when firing your work, from preparation to end result.

BISQUE FIRING

In principle, it is possible to once-fire clay and glaze in a single firing but the purpose of the bisque (also referred to as 'biscuit') is to provide an in-between stage whereby the clay has become ceramic and is strong enough to be handled, but still remains porous enough to accept glaze. First, it is useful to understand the principles of firing and the

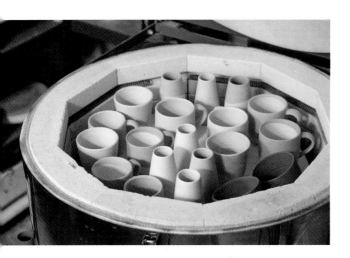 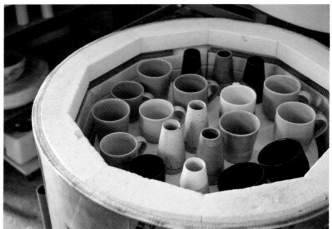

Glazed items before and after firing (left to right).

◄ Potter Russell Kingston inspecting his slip-decorated wares after glaze firing.

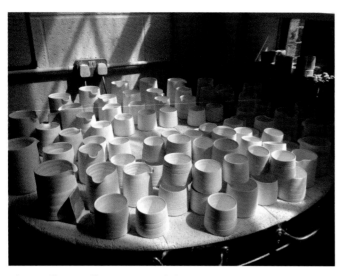

A large collection of bisque pots made by Louisa Taylor waiting in readiness to be glazed.

transformation from clay to ceramic as it progresses through the following stages:

- 80–200°C (176–392°F) – the water content held in the particles of the clay is driven off as steam (referred to as water smoking)
- 200°C–300°C (392–572°F) – organic matter present in the body disintegrates and burns away
- 573°C (1063°F) – silica quartz inversion. A critical temperature point whereby quartz molecules in the body undergo a sudden change in volume and expand by 3 per cent
- 600–700°C (1112–1292°F) – burning out of sulphates and carbon
- 800°C (1472°F) onwards – vitrification begins, the clay body becomes dense and less porous
- 900°C (1652°F) onwards – sintering, the clay particles within the body compact tighter and form a stronger matrix
- 1100°C (2012°F) onwards – cristobalite forms. Free silica in the clay body changes to cristobalite, a crystalline form of silica
- 220–280°C (428–536°F) cooling – cristobalite inversion. During cooling, crystallised silica particles in the clay body and glaze contract and shrink rapidly by 3 per cent. This is a sensitive temperature point at which wares can develop cracks – known as 'dunts' if cooled too quickly (see Chapter 7)

The temperature at which you fire the bisque is important to the final temperature of your glaze, as outlined below:

High bisque 1120–1180°C/2048–2156°F/ cone 02–4

The body of earthenware glazed ceramics remains porous after the firing and therefore it requires a high bisque firing that takes the temperature beyond the glaze firing to vitrify the clay body to make it less porous. Another reason to high bisque earthenware pottery is to reduce the potential for crazing in the glaze to occur. An example of a high bisque temperature is 1120°C/2048°F/cone 02, followed by a 1060°C/1940°F/cone 04 glaze firing.

Low bisque 1000–1060°C/1832–1904°F/ cone 06–04

Stoneware clay bodies and glazes will mature together during the firing and therefore it is only necessary to low bisque clay for stoneware firing. An example here would be 1000°C/1832°F/ cone 06 low bisque, followed by 1280°C/2336°F/cone 9/ glaze firing.

Bisque firing schedule

In general, for a bisque firing schedule, the first temperature rise from ambient room temperature up to 600°C/1112°F should be slow and gradual. This is to allow the water content in the clay body to be driven off as steam in a controlled manner, so it does not cause areas to blow out. Most kilns will have a vent at the top or side of the kiln to allow moisture to escape as the temperature climbs. Keep this open until at least 300°C/572°F. Once it gets to 600°C/1112°F, the firing can then proceed at a quicker rate until the final temperature has been reached. A typical bisque firing can take around ten to fourteen hours to complete depending on the size and thickness of the work, how densely packed the kiln is, and final temperature.

Unlike glaze firings, it is not as important to soak bisqueware (the term 'soak' is explained further on in the chapter). However, for porcelain clay bodies, it can be beneficial to soak the final temperature for thirty minutes to one hour to burn out carbon from remaining organic material in the body and reduce the risk of pin-holing of the glaze. A long soak of sixty to ninety minutes for bone china will help develop translucent properties. Another consideration is the thickness of the clay walls and overall size of your object. If the clay walls exceed 2cm/1in, or the piece is very large or wide you should reduce the first temperature climb to 20–40°C

(68–104°F) per hour, followed by 60–80°C (140°–176°F) per hour to ensure even heat distribution across the piece and minimise the risk of cracking. You may need to include more ramps (the rate at which the temperature increases) in the schedule to stagger the overall temperature climb, as well as include cooling ramps to steady the rate at which the temperature drops.

Example bisque firing schedules
High and low bisque
Ramp 1: 60°C/140°F per hour up to 600°C/1112°F
Ramp 2: 120°C/248°F up to 1000°C/1832°F/cone 06 (low bisque)
or 1120°C/2048°F/cone 02 (high bisque)

Porcelain
Ramp 1: 60°C/140°F per hour up to 600°C/1112°F
Ramp 2: 120°C/248°F up to 1000°C/1832°F/cone 06
Ramp 3: Soak thirty to sixty minutes

Bone china
Ramp 1: 60°C/140°F per hour up to 600°C/1112°F
Ramp 2: 120°C/248°F up to 1240°C/2264°F/cone 6
Ramp 3: Soak sixty to ninety minutes

GLAZE FIRING

The glaze firing follows on from the bisque firing and is the point where glaze materials are melted and fused to the ceramic body for decorative effect and/or functional purpose. The glaze firing cycle follows similar stages to clay-bisque as outlined earlier, but with some additional points:

- 100–250°C (212–482°F) – the water content in the glaze layer is driven off as steam
- 450–600°C (842–1112°F) – chemically bonded water is released from the glaze components
- 573°C (1063°F) – silica quartz inversion (same as bisque)
- 900–1000°C (1652–1832°F) – reduction is initiated (not relevant for oxidized firings)
- 700–1100°C (1292–2012°F) – melting range of glaze components including frits and feldspars
- 1100°C (2012°F) – mullite crystals begin forming in porcelain clays
- 1100°C (2012°F) onwards – cristobalite forms
- 1200–980°C (2192–1796°F) – crystalline glaze formation

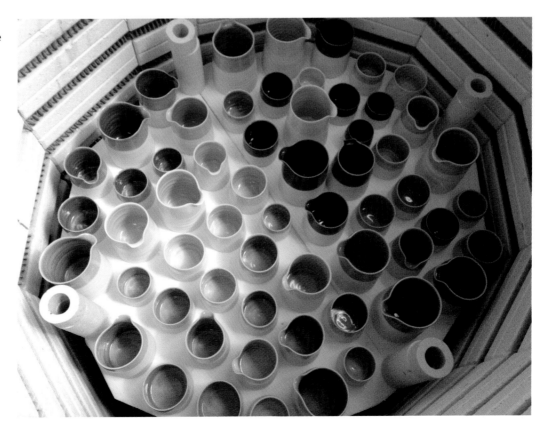

Colourful pots made by Louisa Taylor after a 1280°C (2336°F/cone 9) glaze firing.

- 750–650°C (1382–1202°F) – glaze surface hardens and is no longer molten
- 220–280°C (428°F–536°F) cooling – cristobalite inversion. High risk of dunting if cooled too quickly (same as bisque)

The firing schedule for a glaze firing can proceed at a quicker rate compared to bisque because the chemical changes within the ceramic body have already taken place. A glaze firing can take around eight to twelve hours depending on the type of work and final temperature point:

Example 1: firing schedule for glaze (general, steady pace)
Ramp 1: 80°C/176°F per hour up to 600°C/1112°F
Ramp 2: 150°C/300°F up to 1080°C/1976°F/cone 04 (earthenware) or 1280°C/2236°F/cone 9 (stoneware)
Ramp 3: Soak ten to fifteen minutes

Example 2: firing schedule for glaze (fast firing)
Ramp 1: 150°C/302°F per hour up to 600°C/1112°F
Ramp 2: 250°C/482°F up to 1080°C/1976°F/cone 04 (earthenware) or 1280°C/2236°F/cone 9 (stoneware)
Ramp 3: Soak fifteen to twenty minutes

There are a number of glaze temperature points used within ceramic practice. This is to accommodate the melting temperatures of the various different clays and glaze materials, as well as bring specific qualities and desirable attributes to your work. For example, red terracotta clay has a high iron content and therefore would begin to degrade and melt at temperatures exceeding 1200°C (2192°F), whereas porcelain requires a high temperature firing 1240°C–1350°C (2264°F–2462°F) to induce its beautiful translucent properties. Traditionally, earthenware glazes were favoured for their bright, glassy colours, compared to the more earthy tones of stoneware glazes. However, in recent times, there have been many advancements with ceramic materials and these assumed traits are less fixed now. In fact, it is possible to achieve a broad spectrum of colours and unique qualities that span across the temperature ranges. An overview of the attributes and considerations of the most commonly used temperature points is explained below to inform your choices when developing your glaze aesthetic.

Earthenware 1020–1180°C/1868°F–2156°F/Cone 06–4

The lower temperature range of earthenware can produce incredibly rich and vibrant glazes and is an excellent choice for slip-decorated ware and underglaze/on-glaze decoration. Earthenware glazes are famed for their brilliant shine which can beautifully enhance texture and detailed surfaces. There are a number of specific earthenware techniques that have evolved over the centuries including Maiolica (or Majolica) – a type of tin-glazed pottery decorated with colouring oxides, as well as traditional slipware glazed with rich lead glazes (although in recent times there is a shift away from using lead-based materials due to health and safety concerns). Another benefit of firing to earthenware is that it minimizes the strain and stresses the work is subjected to, particularly if it is very complex in construction. Thrown wares and thin-walled pots are less likely to warp and distort too. As for glaze colours, some ceramic stain pigments, such as pink, respond better to this temperature and are less likely to burn out or appear faded compared to stoneware firing.

At this lower temperature point, it is important to note that the clay body remains soft and less hardy compared to clay fired to higher temperatures. Earthenware is more susceptible to chipping, but can be improved by making the wares thicker on the rims and edges. The clay body also remains porous after firing (whereby it still accepts water) which can be problematic for a number of reasons; an increased risk of crazing and body/glaze expansion differences; wares intended for outdoor use are more prone to frost damage because moisture is absorbed into the body which then expands in freezing temperatures; and, functional wares can potentially seep liquid through the body and glaze over time.

However, it is possible to overcome these issues; earthenware ceramics, particularly for functional use can be glazed all over in order to seal the body entirely (*see* firing tips – stilts). Unglazed ceramics for outdoors should ideally be fired at very high bisque temperature (1180°C/2156°F) to reduce the porous nature of the clay body and extend the longevity of the piece

Mid temperature 1200–1220°C/2192°F–2228°F/Cone 5–6

The mid-temperature firing point offers the best attributes of bright earthenware with the hardy properties of high-fired stoneware. It is a popular choice because it is considered more economical than stoneware firing by saving energy and ultimately reducing the general wear and tear on the kiln. Mid-temperature firing can also help alleviate strain and stresses on complex works that might be susceptible to distortion or cracking at higher temperatures. Another benefit is that it can deepen the orange-red colour of terracotta clay without

running the risk of it melting or blistering. High-temperature stoneware glazes from 1260°C (2300°F/cone 8) and above can usually be adjusted to accommodate mid-fire temperature range by substituting the main fluxes for those with lower melting points; these include borate frits, soda feldspar and nepheline syenite. Refer to Chapter 8 for example recipes.

Stoneware 1220–1300°C/2228°F–2372°F/ Cone 6–10

Stoneware is the term given to high-temperature firings whereby the clay body has vitrified and can no longer accept water. Unlike the porous nature of earthenware, the integral strength of the high-fired clay body makes it an excellent choice for tableware, where hardy properties and general robustness are desirable. It can also improve the performance of outdoor pots and sculptures by increasing the resilience to frost and weathering. Stoneware glazes offer a broad palette of colours – depending on oxidization or reduction firing (explained further in the chapter). Stoneware colours are particularly good for expressing organic qualities and cool, earthy tones. Another application of this temperature range is for creating special effect glazes including lava crater glazes and very runny, gloopy textures.

In contrast to low-temperature firings, stoneware firings can put more strain on the work, increasing the risk of cracking and distortion. The shrinkage rate of the clay body will also be higher which you will need to account for when you produce your work in the making stage. Another factor to consider is that the exposure to higher-temperature firings over a period of time will take a harder toll on your kiln. Therefore, the running costs and maintenance will be more expensive in the long run.

Porcelain 1220°C–1350°C/2228°F–2462°F/ Cone 6–13

Porcelain requires a high-temperature firing to promote its seductive translucent qualities and enhance the glaze. This also helps strengthen the material and improves compatibility between the clay body and glaze layer. In principle, the higher the temperature, the glassier and more translucent porcelain becomes but this does however increase the risk of warping and distortion in the form.

KILN ATMOSPHERE

The results and appearance of your ceramic wares are largely determined by the type of atmosphere in the kiln chamber, specifically how much oxygen is present during the firing. This is influenced by the energy or fuel source used to fire the kiln, for example, electricity or natural gas. An explanation is given below:

Oxidization

An oxidizing atmosphere occurs when there is an unrestricted circulation of air and oxygen present at all times in the kiln chamber. Compounds, such as metal oxides and minerals within the glaze and clay volatilize or break away and recombine with oxygen in the kiln, creating carbon dioxide (CO_2) in the process. This chemical change determines the final colour and appearance of the oxides.

Two porcelain tiles were glazed with the same transparent shiny glaze (Chapter 8: Stoneware, glaze SW9). The tile on the left was fired in an oxidized atmosphere, and the tile on the right was fired in reduction. Note the blue tone of the porcelain from the reduction firing.

A copper oxide wash was applied to both tiles first and wiped back. The top half of the tile was then glazed in a transparent glaze and the bottom half in an opaque glaze. The middle section was left unglazed. The tile on the left was fired to earthenware and the tile on the right fired to stoneware (oxidized). As you can see the earthenware colours remain quite bright, whereas the stoneware colours are more muted in comparison.

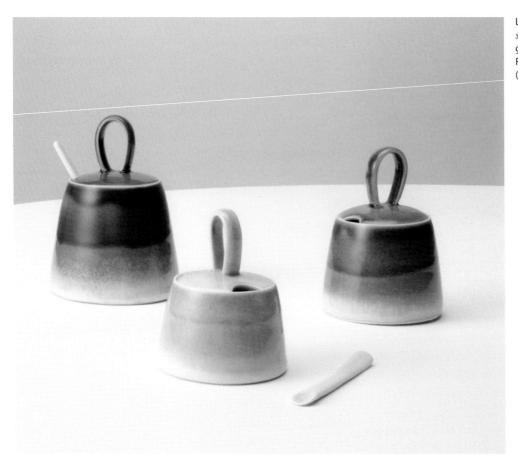

Louisa Taylor, *Tutone lidded pots and spoons* (H: 12cm). Thrown porcelain, glazes blended with stains and oxides. Fired in oxidization 1260°C/2330°F (cone 8).

An oxidizing atmosphere can be produced in all kilns regardless of energy or fuel type, as long as there is sufficient oxygen supply. However, it is more commonly associated with electric kilns which operate by passing an electrical current through coiled metal elements embedded into the kiln walls. This creates electrical resistance in the coil, causing it to radiate heat. The oxygen and air flow in the kiln is not disrupted by this process. Oxidized firings are generally reliable and straight-forward to carry out, which is very appealing for beginners through to professionals. Oxidized glaze results can appear brighter in contrast to reduction-fired glazes, and oxide colours range from greens, blues, browns, plum and reddish-brown tones, as well as the colour ranges of commercial pigments. Oxidization atmospheres are effective across the entire temperature range, from earthenware to stoneware.

Reduction

A reduction atmosphere is the opposite to oxidization, whereby oxygen in the kiln chamber is restricted or 'reduced'. This is achieved by firing the kiln using a combustible fuel source such as natural gas, bottled butane/propane, wood, oil or coal. Unlike electricity, the live flame requires oxygen to combust and continue burning. As the oxygen in the kiln chamber diminishes, the flame becomes starved and is not able to burn as effectively, and carbon monoxide (CO) is produced. The carbon atoms take oxygen from wherever they can to create carbon dioxide (CO_2), including oxygen molecules in the oxides present in the clay and glazes. This can have a dramatic effect on the final outcome. For example, copper oxide in an oxidized firing will result in a green colour, but in reduction it will become blood red. Any iron oxide in the clay body will become more prominent as flecks bleeding through the surface. Reduction is best conducted at stoneware temperatures above 1200°C/2192°F and not advisable to attempt using an electric kiln.

Reduction-fired glazes compared to oxidization can appear more muted in tone, but arguably have greater intensity and richness. The colour of porcelain body after an oxidized firing will remain a creamy white colour, but in reduction it will develop an alluring, icy hue.

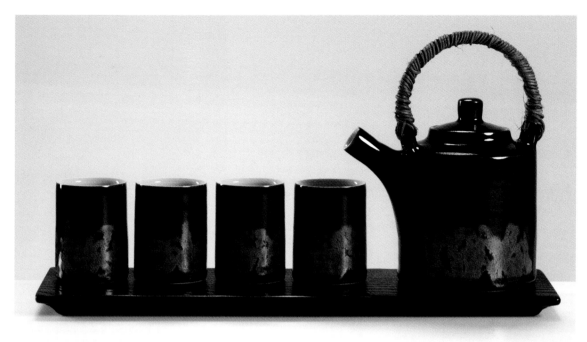

Chris Keenan, *Tenmoku and Celadon tea set with red 'writing'* (2021). H: 17cm. Thrown and turned Limoges porcelain – tenmoku, celadon and red glazes, reduction fired.

Both tiles glazed with a celadon glaze (Chapter 8: Reduction, glaze CE3). The one on the left was fired in reduction and the tile on the right was oxidised. The type of kiln atmosphere has a radical impact on the iron oxide that colours the glaze.

Many stoneware glazes will achieve similar results regardless of oxidized or reduction atmospheres, but there are glazes specific to reduction. These include glazes that originate from East Asia and are renowned for their beautiful colours, such as celadon – a light blue-green/grey colour; tenmoku – dark black to toffee-coloured browns; Chun – opalescent blues and sang de boeuf (oxblood) – an intense red glaze.

The results from a reduction firing can be less predictable compared to an oxidized firing, but many potters find the serendipitous nature of the process very appealing. Reduction firings can be more challenging to carry out and if the reduction atmosphere has not been consistent, this could cause pockets of oxidization or cool spots which will affect the glazes. Celadons are particularly sensitive to oxidation and will turn an insipid yellow-green colour if not fully reduced. Another consideration is the risk of carbon trapping, whereby reduction starts before carbon (soot) present in the chamber has fully burnt off and it becomes trapped in the glaze layer, leading to unsightly black spots and grey tones. However, this can also be an intentional desirable effect known as carbon-trapped shino glazes.

Reduction firing schedules

Reduction firing schedules depend very much on the nuances of every kiln and can widely differ. Contributing factors include:

- Kiln design
 - updraft kiln; heat and flames exhaust straight out of the top of the kiln
 - downdraft kiln; heat and flames are forced to circulate down and through the kiln
 - climbing kiln; for example a traditional anagama kiln built on a slope to encourage a natural air draw
 - size of kiln
- Fuel source
 - gas (natural or bottled)

- wood
- oil
- biofuels
- coal/coke (less common)
- burner system
 - atmospheric (combustion is provided from the atmosphere)
 - forced air burners (a mechanical blower forces air and improves efficiency)
- operation
 - manual
 - automatic (programmed and managed by a controller)

Potter Matthew Blakely loading wood into the kiln chamber to fuel the high temperature firing.

Therefore, the following firing schedule can only act as a guide and should be adapted to suit your own specific requirements. It can be beneficial to pre-warm the kiln for a few hours before you embark on the actual firing. When packing a reduction kiln, some potters like to position the shelves at staggered heights to allow good ventilation for the flames to swirl and flick around the chamber. A typical reduction firing cycle can take around ten to sixteen hours to complete, but in some instances, such as an anagama wood-fired kiln, the process is very labour intensive and can exceed forty-eight to seventy-two hours. With any type of reduction firing, it is wise to keep a record and chart the progression of the temperature climb in relation to hours, followed by notes about the quality of the firing results. This will help you replicate the results or improve your methods for future firings.

Example reduction schedule overview:

1. Ignite the fuel source and ensure the flue damper and vents are fully open and drawing air through. Adjust the air supply to begin the firing and continue to maintain an oxidizing atmosphere for the first segment of the firing to 850°C/1562°F.
2. The first climb to 600°C/1112°F is slow and steady at a rate of around 100°C/212°F per hour.
3. The second rate of the climb can be increased to 150°C/300°F–200°C/392°F per hour.
4. Once the kiln has reached between 850°C–1000°C/1562°F 1832°F, reduction can begin. This point will largely depend on the materials in the glazes. A rule of thumb is to begin reduction before the fluxes in the glazes start to melt.
5. The flue damper is partially closed approximately every twenty to thirty minutes and closely monitored (this will depend on the kiln design). The primary air supply and gas pressure should be carefully managed to continue the trajectory of the temperature rise and maintain reducing conditions. An indication that you have achieved a reduction atmosphere is when orange-red flames flare out from the spyhole and flue, searching for oxygen. The larger, and more intense the flame, the heavier the reduction.
6. As the firing reaches the final stages, the temperature climb will begin to slow down. Therefore, the damper flue might need to be opened slightly to increase air supply. Each adjustment can take ten minutes or more to make an impact so you need to be patient and allow the kiln to adjust. Continue to monitor the air and fuel ratio until the final temperature has been reached.
7. Once the kiln has reached temperature, soak the kiln for fifteen to thirty minutes to even out the heat distribution in the kiln and improve the glazes.
8. After the soaking period, the fuel supply can be switched off and the kiln left to cool. Alternatively, some potters like to apply a period of oxidization to promote brilliant shine and radiance in their glazes. This is achieved by crash-cooling the kiln to 1000°C/1832°F. The flue damper and vents are opened fully to allow a gush of air into the kiln. This can take around twenty to forty minutes to complete. When the temperature has dropped to 1000°C/1832°F, the flue damper and vents are closed fully, and the kiln is left to cool down gradually.

Neutral kiln atmosphere

In some circumstances, a kiln atmosphere can be referred to as 'neutral' – whereby the balance between oxidization and reduction is at the optimum ratio. Neutral firings are considered to be more economical and efficient for this reason.

OPERATING A KILN

The way a kiln is operated will depend on many factors, including;

- The energy or fuel source – electric, gas or other combustible fuel
- Kiln design – front loader, top loader, custom made
- Size of kiln – test kiln through to large kiln
- Type of firing – bisque, glaze, oxidized, reduction
- Firing temperature – earthenware, mid-fire, stoneware

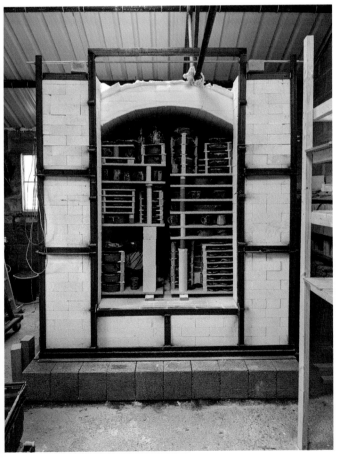

A large gas-fired kiln built on site by Russell Kingston at his workshop in Devon, UK.

In general, most modern electric kilns are operated by a programmable controller which manages the firing over a set period of time. This works in conjunction with a thermocouple – a probe that protrudes into the kiln chamber to sense the temperature and relay the information back to the controller. This is not exclusive to electric kilns, and some reduction kilns can also be managed by a controller system to monitor and adjust the gas and oxygen supply, close the flue damper/vent and dictate the temperature rise.

Older kilns, basic models, custom-made or site-specific kiln designs, for example anagama, are usually operated manually. With a manual electric kiln, it may consist of a simple dial on the front which is turned periodically to increase the power supply to the elements and heat the kiln. Other electric kilns rely on a sitter, whereby a small pyrometric bar is placed within a bracket inside the kiln. When the temperature is reached, the bar melts and this triggers the bracket to switch off the kiln.

Manual reduction kilns are better suited to more experienced users as they require careful management of the fuel supply and oxygen flow/restriction to achieve a successful reduction atmosphere. The temperature is gauged by a hand-held pyrometer – a type of remote sensing instrument connected to a thermocouple that is inserted manually into the kiln chamber when needed, or another non-contact device type that measures temperature by sensing infrared. They are commonly used in conjunction with a set of pyrometric cones to monitor the heat work so the user can ascertain the overall pace of the temperature climb and when the final temperature has been reached.

For wood, salt/soda kilns, a series of draw rings are placed within the kiln when it is packed. As the kiln reaches its final temperature, a ring is taken out using a rod. This allows the user to gauge the temperature and heat work of the kiln, and when the desired surface finish (from salt/soda or wood deposits) has been achieved.

Soak

Soaking a kiln refers to holding the temperature at a given point for a set period to help even out the temperature in the kiln and mature the glazes. Some kilns, particularly large models, can be susceptible to uneven temperature distribution whereby the top of the chamber will be at the correct temperature because of the heat rising up, but the bottom could have cool spots and glazed items in this area might not melt sufficiently.

A soak time of around ten to twenty minutes can improve the heat distribution in the kiln and ensure a good melt. It may be necessary to soak some glazes, particularly crystalline glazes, at specific points as they cool down to help stimulate crystal growth or achieve other unique effects.

PYROMETRIC CONES

Pyrometric cones are slim pyramids of ceramic material that are calibrated to melt at specific temperatures in relation to time. They have been used to monitor ceramic firings for over a century and can determine when a firing is complete, if enough heat has been provided or if there was a problem during the firing. Pyrometric cones operate on the principle of measuring heat work in the kiln, which can be explained as the amount of time exposed to heat during the firing. This is different to measuring temperature alone, which is not a true indication your glazes will melt sufficiently.

Pyrometric cones were initially developed by Hermann Seger in the late nineteenth century and today are produced by numerous manufacturers, including Orton cones, which we will refer to here. (A detailed Orton chart is referenced in the appendix of this book.) Orton cones, like most brands, operate on a numbered system which relates to a specific temperature point. The corresponding number will depend on the rate of temperature the kiln is fired, and the size of the cone used – either large, small, or a self-supporting type. For example, Cone 9 (150°C/300°F per/hour) = 1278°C/2232°F. During the firing, the cone will bend into a strong arch shape when sufficient heat work in relation to the corresponding temperature has been achieved. If the cone remains upright, this is an indication the temperature has not been reached; if the cone appears flattened and soft, then the temperature has been exceeded.

To prepare for the firing, you should include three pyrometric cones:

Guide cone – the first cone to melt and indicate the temperature point has been exceeded.
Firing cone – this is the desired temperature point. The cone will melt into a strong arch shape when the temperature has been reached.
Guard cone – temperature above the firing cone. A back-up cone which is above the desired temperature and there to indicate if the temperature has been exceeded.

A set of self-supporting cones pre-firing, in the order of left to right – guide cone, firing cone and guard cone.

Post firing, the cones have melted and the curve of the firing cone in the centre of the stack indicates that the correct temperature has been reached.

For example: Final temperature – 1280°C/2336°F at a rate of 150°C/302°F per hour = cone 9; below temperature – 1260°C/2300°F = cone 8; and above temperature 1300°C/2372°F = cone 10.

To prepare the pyrometric cones, you can use a cone sitter as illustrated here, or place them in a line and secure with a coil of clay wrapped around the three cones in a figure of eight formation. Allow for the clay coil to dry slightly before inserting into the kiln, or it could blow out from steam release. If the cones are not the self-supporting design, you will notice the base of the cone is cut at a slight angle. The purpose is to tilt the cone and encourage it to melt in a certain direction. Therefore, you will need to ensure the cones are all tilting away

from each other so they do not impede on themselves or the surrounding wares during the firing.

As kiln equipment has become more sophisticated with digital kiln controllers and pyrometric temperature readers, the use of cones as the primary method of reading temperature has become less common but this is not to say it is obsolete. In fact, using cones should still be incorporated into good practice, as a witness to record the firing and troubleshoot should something occur or go wrong. Similarly, cones are still very much used for manual firings such as wood firing, or raku, where observing the cones during the firing can indicate the temperature of the kiln as a back-up to a digital pyrometric reader (refer to health and safety at the end of chapter regarding safe observation of the kiln chamber). As with any methods of recording temperature, pyrometric cones are not infallible and can be affected by variables such as the kiln atmosphere, rate of climb or how long the kiln was soaked. However, they are a very simple and effective method of recording your firings and will allow you to understand how to consistently repeat your results.

PREPARING A KILN FOR A GLAZE FIRING

Before you pack the kiln, you will need to prepare the kiln shelves and make sure your glazes will not cause damage to the kiln itself, as well as ensuring longevity of your kiln furniture. To do this, you can either buy a commercially prepared batt wash mix, or it is just as easy (and cheaper) to make it yourself using the following recipe:

China clay 50%
Alumina powder 50%
Water

Mix to the consistency of double cream and apply at least two layers to your kiln shelves and furniture.

Wadding

For firings that involve salt or wood, the self-glazing nature of the process will require you to protect the wares and kiln furniture from sticking to the shelves, and each other. Wadding is a refractory material that acts as a barrier to glaze. After the firing, it becomes brittle and can be easily removed by hand or with a sanding tool, without damaging the wares. It is also useful if you need to custom-make any supports for specific works that might be vulnerable to sagging or cracking.

Alumina wadding recipe

Batt wash is applied to the kiln shelves and furniture to protect them from drips and spills during the firing.

China clay 40%
Alumina 40%
Plain flour 20%
PVA and water

In this recipe, the flour helps bind the material and will burn away in the firing. The glue makes it sticky and easier to shape when preparing the work for a firing.

Kiln furniture

Kiln furniture is made from refractory material and can withstand very high temperatures without distorting or breaking. You will need a number of shelves and supporting pillars to pack your kiln. They are available in various shapes, sizes, heights and component parts. Shelf spacers and tee cranks are a useful assembly for firing a stack of plates or tiles. Other useful kiln aids include stilts and bars – small supports which lift the glazed wares from the kiln shelf to prevent sticking, and allow for the glazed ware to be coated all over. Stilts are not recommended for temperatures exceeding 1200°C/2192°F because

A selection of different-sized posts used to support a stack of shelves in the kiln.

the clay body can soften at higher temperatures, causing it to sag over the stilt. Kanthal or nichrome wire are also resistant to high temperatures and useful if you need to suspend items away from the kiln shelf, for example – beads or spherical items.

Packing a kiln

When packing the kiln for a bisque firing, the items can touch, be stacked or placed next to each other to maximize the available space. The clay body should be completely dry – avoid putting damp or moist work in the kiln otherwise there is a risk it could blow out when the water content evaporates as steam. Unlike a bisque firing, the glazed items should not touch otherwise they will stick together. When loading the kiln, leave a small gap between each piece to avoid contact. The base of the work or any area that has contact with the kiln shelf should also be free of glaze or it could cause damage to both. You should not place items too close to the heating elements in an electric kiln as this can interfere with the heat distribution and result in blisters or cracks in the body and glazes. Finally, avoid firing freshly glazed work. Allow it to dry before you start the firing otherwise this will create too much moisture in the kiln which can impact the glazes. Excessive moisture can also shorten the lifespan of the kiln elements over time.

Step by step

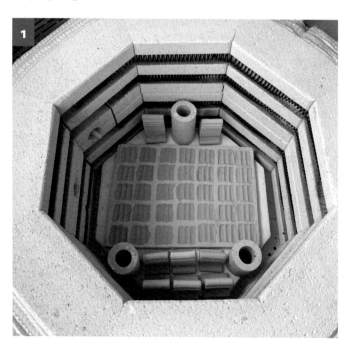

Insert three kiln posts in a triangular formation, one at the back and two at the front, and proceed to load your items into the kiln chamber. Make use of all available space by placing items of similar size and height together.

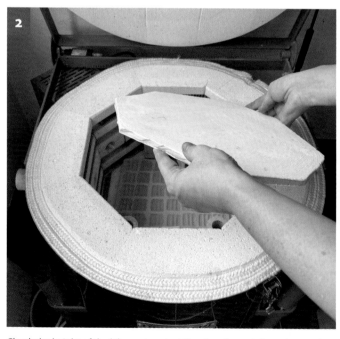

Check the height of the kiln post against the size of your tallest piece and then position the kiln shelf on top. When loading kiln shelves, make sure to align the kiln posts in the same position each time to support the stack.

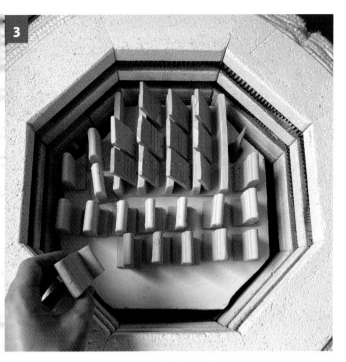

Repeat the steps until you have fully loaded the kiln. Secure the door and proceed with programming the controller. Remove the bung from the vent on the side or top of the kiln to allow moisture to escape during the early stages of the firing.

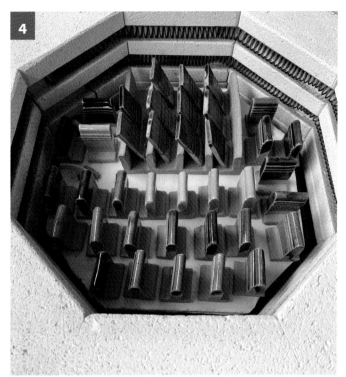

Once the kiln has cooled down sufficiently after the firing, it can be unpacked and prepared for the next firing.

Before you load the kiln, prepare the chamber; vacuum and clean any debris from the previous firing and position three spacers around the floor of the kiln before loading the first shelf on top. This promotes good air flow and heat distribution around the kiln. It is good practice to include a pyrometric cone in the chamber to act as a record of the firing and check the kiln has reached temperature. Leave ample space around the cone for it to melt and so it doesn't touch your work. Be careful not to knock the thermocouple (a gauge that protrudes into the chamber to monitor the temperature) as you load shelves into the kiln. Ensure the kiln area is free of any combustible materials such as paper or fabric before you start the firing.

FIRING COMPLEX AND AWKWARD WORK

At the very start of a project, you should always consider how you are going to fire your object. Firstly, by making sure it will fit in the kiln chamber, followed by the application and positioning of the glaze. It is easy to fall into the trap of making a piece without full consideration of how to fire it, which can lead to

Tips for firing

Here are some tips to help you achieve a successful firing:

- Plan ahead and make sure you can make efficient use of the kiln space.
- Protect your kiln shelves and furniture with a coat of batt wash prior to firing.
- Ensure bottoms of glazed objects are free of glaze (unless placed on a stilt).
- Don't mix raw clay items in with your glaze firing because the moisture driven off from unfired clay during the firing can get trapped between the body and glaze layer of the neighbouring pieces, resulting in blisters and blebs.
- If you are using glazes that are very runny and unpredictable, consider placing a sacrificial bisque plate underneath the item to protect the kiln shelves from damage.
- Items for earthenware can be glazed all over and fired on stilts to seal the body and protect it from moisture and crazing.
- A layer of alumina hydrate powder spread across the kiln shelf can help with shrinkage of large items during the firing by allowing it to move as it shrinks. It is also useful for protecting shelves from drips and spills.

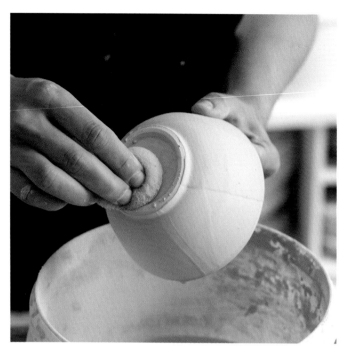

Be sure to wipe away any areas of glaze that will make contact with the kiln shelf otherwise your piece could stick and cause damage to itself and the kiln furniture.

A frame like this example is used to suspend beads for glaze firing, and can be purchased from a pottery supplier.

compromises further down the line. Here are some useful tips to help you overcome some of these challenges.

Beads and round objects

When first learning about ceramics, it is drummed into us that anything that makes contact with glaze will fuse to it in the firing, which highlights the importance of making sure these areas are glaze-free. The downside is that this can cause unsightly bald areas which can disrupt the overall quality of the work. This is particularly challenging when making beads or spherical items as there is no obvious area to sacrifice glaze from. There are a number of ways to overcome this; firstly, earthenware glazed items can be placed on a stilt and lifted away from the kiln shelf. Stoneware items are more difficult to accommodate but you could puncture a small hole (when the item is in the raw making stage) and once bisque, support it using thick, kanthal wire. Similarly, you can make holes in your beads so they can be threaded with thin kanthal wire and suspended in a frame system (as illustrated). If you do not want a hole in your work, you can embed thin loops of kanthal wire into the piece to hang from the frame instead. The wire can then be snipped off after the firing or remain if it is intended to be part of the design.

Lids

Lids are generally best fired together with the pot as this protects both from distortion during the firing (make sure the points of contact on the gallery ridge and lid base are free of glaze). A light tap with a tool (the wooden end of a chisel or hammer is ideal) after the firing is usually enough to release the lid without damaging the pot. However, some clay bodies do not respond so well to this method and might break, such as porcelain, which is slightly self-glazing by nature and therefore it is helpful to fire the lid separate to the pot. A tip here is to fire both the pot and lid separately on a slab of bisque made from the same clay body and painted with a layer of batt wash. This will allow the clay body to shrink and move without distorting the shape. Another important consideration when making a lid is that you need to accommodate the thickness of the glaze layer, otherwise a lid that fits well at bisque might become too tight after glaze firing. Therefore, allow a tolerance of 0.5mm or the depth of your thumbnail to account for this layer. It may look like it is too loose in the gallery area at this point without a glaze, but once fired, it will be a perfect fit.

Plates, tiles and flat items

Firing individual plates and flat objects commands a lot of kiln space and furniture, which can make it difficult to fit everything in. A tee-crank is a very useful piece of kiln furniture which

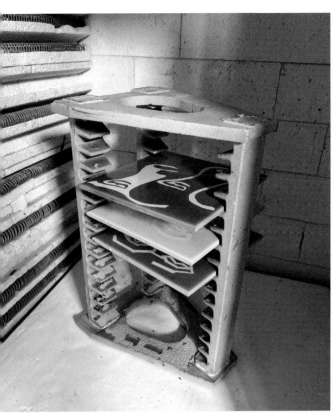

A tee crank is used to stack flat items or plates to form a stable and secure assembly to support the ware during firing.

enables the user to stack the plates or tiles and make full use of the space. If a piece is very flat and wide, for example a platter, there is an increased risk of cracking due to uneven heat distribution with the edges of the piece being closer to the kiln elements than the centre. In this case, fire the kiln at a much slower rate, 30–40°C/86–104°F per hour up to 600°C/1112°F, followed by 80–100°C/176–212°F to top temperature, to ensure even heat distribution across the piece and avoid cool spots, particularly in vulnerable areas such as the centre compared to the outer walls. Electric kilns that have elements fitted into the kiln bed and/or door as well as the side walls are beneficial and improve overall heat distribution. Soaking the wares at top temperature can also minimize the risk of cracking and splits. Allow the kiln to cool gradually and slowly. You may need to include an extra cooling ramp in your programme to minimize the risk of dunting on very wide items.

Awkward shapes

Unconventional shapes and forms can pose a conundrum when packing the kiln. To accommodate the work, you could fire it upside-down on the rim, or incorporate an edge in the design that will make minimal contact with the kiln shelf. Think ahead; you can be very clever with the design in the making stage to make full use of the surface area without compromising on unglazed areas.

Supporting structures

Some objects will require a series of supporting structures that are positioned in such a way as to prevent the work from sagging or cracking during the firing. These can be made from the same clay body as the piece, wadding material or ceramic fibre paper/blanket (wear a mask and gloves when handling this material). After the firing, any contact marks can be sanded away and made good.

Crystalline and extremely runny glazes

Some glazes, such as crystalline glazes, can become incredibly fluid during the firing which can spill off the wares and damage the kiln furniture and kiln itself in the process. You can overcome this by using a sacrificial tray or saucer underneath and propping your work up on wadding or stilts. The point of contact can then be sanded away and tidied up post firing. Another useful trick is placing the work on ceramic fibre paper, which is very fine and can be cut to size to accommodate the space. It can be removed and sanded away after the firing.

Bone china

Bone china is prone to warping and distortion, and will require a 'setter' – a type of support to maintain the shape of the item during the firing of the bisque and in some instances, the glaze firing too. The setter can be specifically made out of bone china and a custom fit for the item, a ready-made piece of kiln furniture or refractory clay ring. A coat of alumina wash is applied to the setter to prevent sticking of the wares. Depending on the design of the item, the piece is typically placed upside-down on its rim and supported by the setter during the firing. The rim can be polished smooth after the firing using a diamond pad sanding tool.

Multiple firings

A glaze surface does not have to end with one firing. In fact, some glazes might need multiple firings to achieve the desired effect. However, it can be difficult to apply another coat of glaze onto a glazed surface. The way to overcome this is to heat the work a little so the glaze will evaporate quickly on

It is possible to refire a glazed item multiple times and is particularly useful for re-touching minor glaze flaws.

A rotary tool with an abrasive bit is useful for removing rough areas of glaze or any debris from the firing.

contact. Or you can add binder to the glaze to thicken it up and make it sticky; this could be wallpaper paste, PVA glue or CMC. This can also be beneficial if there is a minor glaze flaw to rectify or the glaze feels a bit lack-lustre and needs more work (*see* Chapter 7 for more information). Be mindful though; the more times you refire the work, the greater the risk of the piece cracking or developing a fault – but sometimes it is worth taking that risk if it makes the difference between a piece looking mediocre, or fantastic!

FINISHING

There are some simple techniques you can apply to improve the overall finish and quality of your work and bring it to a professional standard. These include sanding any rough edges and making the base smooth so it will not scratch the surface underneath. This can be done using either a hand-held electric rotary tool or by using diamond sanding pads. Diamond pads are available in different graded grit mesh from coarse upwards. It is useful to have a few of the grades, starting with the coarse pad – rotate the pad over the rough area and then swap to the next pad and so on. This will create a smooth, marble-like finish which is incredibly tactile.

HEALTH AND SAFETY

Ceramic kilns in general are very safe to use but there are a number of important health and safety points to consider before you embark on your firing:

- Make sure the kiln area is free from any combustible material such as paper, wood or fabric that could ignite and cause a fire.
- Ensure good ventilation and avoid working in the same room as the kiln when it is firing because harmful gases and sulphates can be released during the firing.

- In any situation that requires looking through a spyhole into a glowing kiln, this must be done with extreme caution and always wearing appropriate eye protection (PPE). This is due to the risk of significant eye damage from harmful infrared and ultraviolet light omitted at high temperatures.
- Keep on top of your kiln maintenance and general wear and tear.
- Be mindful of hot surfaces, particularly the outside of the kiln during the firing. Always handle hot items with heat-resistant gloves and wear appropriate clothing to cover your skin and reduce the risk of burns.
- Use caution when manoeuvring heavy work or kiln furniture into the kiln to avoid injury to your back and joints.
- Wear a dust respirator when handling ceramic fibre material or powders that contain free silica, for example alumina.
- Never dry sweep. Always vacuum dust and wipe down surfaces with a damp cloth.

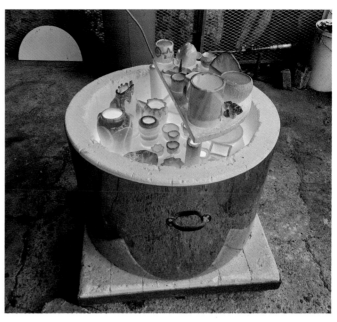

A raku kiln is opened when the temperature reaches 1000°C (1832°F), exposing the red-hot ceramic wares inside. The objects are then handled with tongs and placed in sawdust to smoulder. Ensuring good health and safety practices is vital when conducting this type of firing.

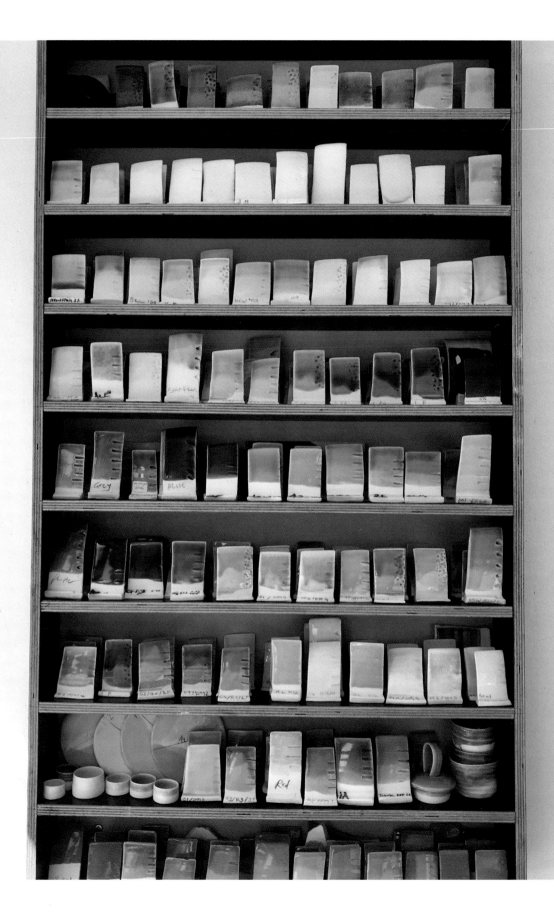

GLAZE TESTING

G laze is unlike any other creative medium. Its true identity is only revealed when transformed by heat. For this reason, experimenting with your own glazes can feel like a guessing game at times, especially if you are new to the subject. This underlines the importance of glaze testing to arm you with the knowledge to make confident decisions about your glaze aesthetic. There are numerous ways to approach glaze development. You can be very scientific and methodical, or you may prefer to work intuitively and embrace the offerings of the kiln. Through practice, glaze testing will enable you to identify the most suitable glazes for your work and gain familiarity with the process to instigate your own glaze journey.

As an introduction to glaze testing, conduct a button test whereby you take a small sample of each raw material, place on a prepared tile, and fire it to stoneware temperature of 1280°C/2336°F/cone 9. This is a useful exercise to provide an overview of how each material responds to heat and indicate its behaviour within a glaze recipe. You can expand this further with a series of melt tests by isolating groups of materials, such as frits – borax frit, high alkaline frit, calcium borate frit and so on. Line up a small sample amount (for example 1g) of each material on a tile, and position at a slight angle in the kiln by propping it up against a piece of kiln furniture. Fire the tile to the corresponding temperature and compare the melt of the frits – such as how runny, shiny or crazed they are. From here you can expand your knowledge by trying out the glaze-testing methods outlined within this chapter.

Recording your results

Before you begin you will need to consider how you are going to record your results, either using a pen and notebook, or typed and digitally recorded. Another option is to sign up to an online glaze-sharing database such as Glazy.org and create a profile to store all your results, as well as build a community with others.

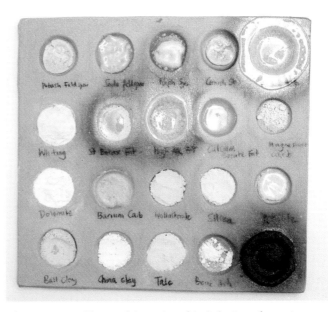

A button test provides a useful overview of the behaviour of ceramic materials when fired to high temperatures. Here you can see flashes of orange from materials that contain sodium. The raised brown disk in the bottom right corner is common table salt which is highly volatile when fired and not recommended for glazes.

◀ The glaze reference board in Louisa Taylor's studio. Glaze tiles are displayed as a useful resource and record of samples accumulated during a practice spanning twenty years.

An online database such as Glazy.org is an excellent resource and allows you to collate your recipes and research new recipes from its vast database.

GETTING STARTED

The easiest way to get started is to research a few glaze recipes which can be found using a wide range of sources including the internet, books, articles and recommendations. You can also create your own glazes from scratch or adapt a current recipe to suit your needs (*see* Chapter 4 for more guidance on how to understand a recipe). From my own experience, I use a base recipe that was given to me as a student and over the years I have tweaked the percentage weights and swapped ingredients around to achieve desirable effects in the glaze. This recipe forms the foundation of my entire glaze collection, from which I then blend and intermix glazes together to create new colours.

If you are keen to experiment and learn how to create your own glazes, the first thing to do is conduct further reading into the specific properties of each material and the role they play within a glaze. The information in Chapter 2 can help you with this, but on a practical level a useful tip is to research different glaze recipes and compare the types of materials used, percentage weights, firing temperature and how this dictates the characteristics of the glaze, such as shiny, matt, crackle, mottled or translucent. As you progress to a more advanced level, you may wish to learn about the unity molecular formula (UMF) so you can instigate and develop your own recipes.

There are a number of excellent glaze calculators available online that can do the sums for you, including glazy.org, glaz-esimulator.com, and online-glaze-calculator.com, to name a few. The bibliography can support you with this area of glaze development.

Test tiles

Much like reviewing a paint chart before committing to a wall colour, glaze tests impart valuable information and offer

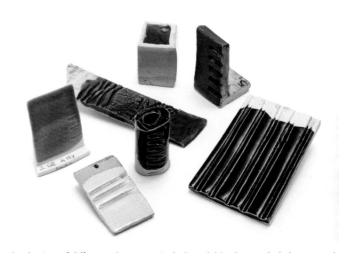

A selection of different glaze tests, including slabbed, extruded, thrown and slip cast examples.

a unique glimpse into the potential of a glaze, such as how it might behave at a specific temperature point and on the clay body; any notable characteristic traits, for example, shiny, matt, iridescence, dryness; and ultimately, its suitability for the intended work. Test tiles form an integral part of successful glaze practice and act as a visual record that can be referred to again and again.

There are numerous ways to make test tiles and they can be as precise or rudimentary as you like. However, they should always be relevant to your work in order to gather the most insightful information to take forward into application. This includes making them out of the same clay body, following the same construction process if possible (for example, thrown, slabbed, pinched), and include texture, especially if your work has any embossed details or decorative patterns. Another consideration is whether your work is upright such as a vessel, or flat like a decorative tile or panel. Your tiles should reflect this, either as freestanding or slab tile fired upright in a rack, to allow glaze to run and behave as if it was on the vertical of a pot, or for flat work, laid horizontally so the glaze will pool rather than run. You should also consider the application of the glaze, whether you intend to dip, pour, spray or paint. For instance, there is not much to be gained by painting your glaze tiles with a brush if you are going to dip the main work because the results will not offer a true representation.

Choosing the right clay body

The clay body you use to make your work can have a huge impact on the results of the glaze. So much so, you might need to test the clay body and glaze together before you even make your work. This will allow you to make an informed choice about the suitability of your clay body in relation to your glaze aesthetic. For example, a buff fired clay body will darken a glaze, and you might notice flecks of iron come through, especially if the work is reduction fired. This can be considered a desirable effect though, so it all depends on what you are seeking from the glaze. Other clays like red terracotta can interfere with the colour of the glaze (which is not always a bad thing!) but it may benefit from a coating of white slip in the leather-hard stage, which will act as a white canvas when you come to glaze later on. If your aim is to showcase the true colour of the glaze, it is best to choose a very white clay body such as porcelain or white earthenware/stoneware. Be mindful though, not all glazes will fit the body well and you might have some issues with crazing or shivering caused by incompatible expansion of

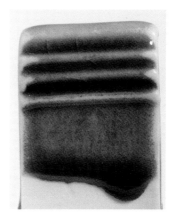

The same copper green glaze (SWG7) is applied to a smooth stoneware and a grogged clay body. The colour response is quite matt and textured on the grogged body (right) in comparison to the glossy outcome on the smooth body (left).

the body or glaze (*see* Chapter 7). Therefore try a few different base glazes so you can opt for the most appropriate glaze for your clay body.

MAKING TEST TILES – METHODS

Here are some examples of different approaches to make your test tiles. A good size for a test tile is around 8cm high × 4cm wide × 1cm thick. You can add texture, marks or any relief details if needed. Remember to put a hole in the top of the tile if you intend to display your tiles on a board or string together. Make the hole big enough to account for shrinkage in the drying and firing stage, so the tile will fit its mount later on. It is always useful to keep a stock of tiles or redundant bisque samples to hand, so you always have something to glaze if you need to conduct a test before committing to a final piece.

Slabbed

Roll a sheet of clay to the same thickness as your work (for example 1cm). Cut the slab into equal strips of approximately 10cm long × 4cm wide. When the clay has firmed a little but remains flexible, fold back the bottom end of the strip to create a free-standing tile. You can also make flat tiles from the slab instead if you prefer.

Thrown

Tiles can be made from cut and sliced thrown pots, or you could throw a batch of small individual sample bowls or

A batch of thrown test tiles can be made from a wide bottomless cylinder, cut into equal segments.

cylinders. You can also make freestanding tiles by throwing a wide bottomless cylinder with a ridge at the base. When the cylinder is leather-hard it can be sliced into individual tiles.

Pinched

Squeeze or manipulate a coil of clay into a free-standing or flat shape to emulate the qualities of hand-built surfaces. You could make individual tiles or small bowls too.

Extruded

Extruding is a good method for batch-producing large quantities of test tiles, as well as ensuring a consistent size and shape. Your extruder might already come with a pre-made die for

Clay is put into the barrel of the extruder and pressure is applied with the handle which forces the clay through the die and into an extruded shape.

making test tiles or you can make one to your own design. Extruded tiles can be made as hollow tubes or in the traditional 'T' shaped profile as used to make the tiles in this book. Here, a template was drawn on to a blank steel disc (cut to the size of the extruder) using a marker pen. A series of holes were drilled through the section and the profile was cut with a saw and filed afterwards. You could also get the die professionally laser cut to your own specifications.

Slip-cast

If your work is slip-cast then you can make tiles using a mould either as disks, shallow bowls, cylinders, tiles. Cast the items the same thickness as your main forms. Carve lines into the mould if you require embossed texture on your tiles.

Extruding enables you to make a large quantity of tiles with relative ease.

FREESTANDING VS FLAT TEST TILES

	Pros	Cons
Freestanding	Upright tiles indicate how glazes behave on the vertical surface of a pot. Easy to dip into a container and reduce the need to wipe the base afterwards.	Not as easy to display and take up more storage space. More time-consuming to make. Ensure the tile is wide enough at the base so it does not tip over.
Flat	Easy to make. Represent how glazes behave on horizontal surfaces. Easy to store and display on a wall or board.	Occupy more kiln shelf space in the firing when laid flat. The back of the tile has to be free of glaze, which can add more time to the process.

Tile rack for flat tiles

A test rack is a useful tool for supporting flat tiles in an upright position to represent how the glaze will behave on a vertical surface. They are very easy to make as outlined in the following step-by-step sequence. Make sure you choose a very coarse or robust clay body to construct the rack as this will be more hardwearing and will last for many years. Apply batt wash to the inside ledges to protect them from drips and spills of glaze.

Preparing the tiles for firing

Once your tiles have been made, smooth any rough edges and lightly wipe with a damp sponge. When the tiles are dry, fire them to bisque temperature – either high bisque for earthenware, or low bisque for stoneware (refer to Chapter 4).

Preparing the glaze test

Once you have selected a recipe to test, you can proceed to weigh out the ingredients– 100g of the glaze is usually a sufficient amount to make for a test (1 × the glaze recipe). If you are planning to conduct a biaxial or triaxial blend (outlined later in the chapter), these tests require more glaze and therefore a suggested amount of 500g (5 × the glaze recipe) should be

Step by step

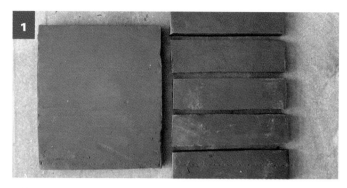

Roll a large slab of clay to a thickness of 1cm and allow it to firm to leather-hard stage. Cut the slab to a size of 20cm long × 15cm wide. This is the base of the tile rack. To create the uprights of the rack, cut five pieces from the slab to an equal size of 15cm long × 2cm wide.

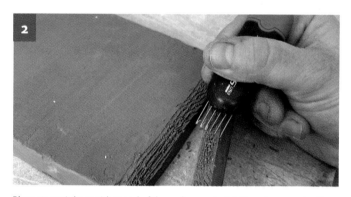

Place an upright at either end of the rack, cross hatch the edges, apply slip and attach to the slab. Evenly space the remaining uprights across the base and attach as before.

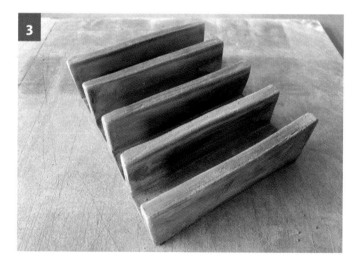

After the clay has firmed, tidy up the joins and dry carefully. Bisque fire before use.

enough. For the batch-testing method, you will need 1000g (10 × the glaze recipe).

Example	× 1	× 5	× 10
Recipe %			
Feldspar	65g	325g	650g
Whiting	15g	75g	150g
Flint	10g	50g	100g
China clay	10g	50g	100g

You can prepare the glaze test using the same method outlined in Chapter 3, whereby you add water to the powder and process the glaze through a sieve. A small sieve is the ideal size for preparing test amounts of glaze.

When you have prepared your glaze tests, store the liquid in a lidded container and use a permanent marker to write the reference code on the side and lid of the container or by attaching a sticker. This will make it much easier to reunite the two and avoid confusion later on.

Methods for glazing the tile

How you glaze your glaze tile largely depends on the design and shape, either free-standing upright or a flat tile. Free-standing tiles have the advantage when it comes to this because they can be held at the base and dipped into a cup of the test glaze without too much trouble. Flat tiles and other larger pieces can be covered by pouring the glaze across the surface. Be sure to clean away any spills or areas that will have contact with the kiln shelf. Another tip is to dip or pour a corner of the tile with a second coat of glaze. After the firing, this will indicate if the glaze benefits from a thicker or thinner application. Two layers of glaze are usually sufficient for a test.

Example:

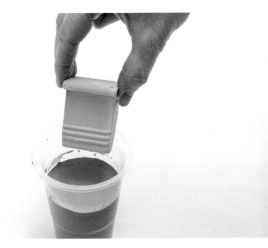

Decant the test glaze into a beaker. Hold the tile by the base.

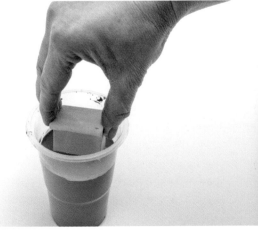

Dip the tile into the glaze and hold for around two to three seconds.

Preparing the test amount of glaze using a small sieve.

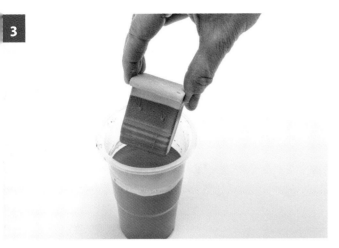

Remove and give the tile a gentle flick to shake off any excess glaze. Re-dip the corner or top half of the tile to indicate a thicker application.

Glaze referencing

Write on your tiles using either an underglaze pencil or with red/black iron oxide mixed with water into a strong solution so there is no chance it will burn out in the firing. Make sure the area is free from glaze otherwise the writing might get lost underneath. On the tiles themselves there is often not a lot of space, so think about a referencing system that will allow you to cross-reference the details with your notes. For example, you could abbreviate the name of the glaze, the initials of the person who gave it to you, or the source of the recipe. For example, SGR.1 (Satin Grey 1). You could also draw a triangle symbol followed by a number to indicate the corresponding cone and firing temperature.

Firing the tests

Individual glaze tests can fit into empty gaps and spaces whenever you fire the kiln, and you will soon generate a substantial number of fired tests. If you are regularly making glaze tests, consider investing in a small test kiln as they are economical to fire and offer a quick turnaround. This is beneficial if you want to conduct a sample test before committing to the main work without having to wait to fill a large kiln. If you are unsure how the glaze will respond, fire the tile on a sacrificial plate to protect the kiln shelves from drips.

Analysing your glaze results

There is much anticipation when opening a kiln filled with new glaze tests as we can only imagine up to that point how they might turn out. We all hope our efforts are rewarded with a successful collection of exciting results, but this is not always the

A small front-loader test kiln is the ideal size for a batch of glaze tests.

case. Firstly, it is important not to be dismissive of your results, even if you don't like specific things about them such as the colour, texture or quality. Think of your tests as building blocks that can be tweaked and improved into something really special.

To establish desirable characteristics within a glaze, you need to take a closer look at your results and analyse them in greater detail. This includes:

- How does the glaze respond on the tile? A desirable trait in a glaze is the way it 'breaks' over texture. This is a decorative effect that exploits the change in colour and texture of the glaze when the thickness varies. Particularly when a glaze flows over ridges and edges, it will highlight these features.
- Does the glaze fit the clay body? Are there any signs of crazing (desirable or not)? If the glaze is a good fit but you don't like the colour, change the colourant to a different one and see if this improves it further.

Inspect the tile for desirable attributes such as how it breaks over edges and details, the quality of the melt, colour response and overall appearance.

- Is the glaze runny or stable? Runny glazes can be beneficial for accentuating textural details. If the glaze is too runny, you can adjust the alumina/clay content of the recipe (increase by 2–5 per cent) to stiffen it and reduce the fluidity.
- Colour response? Some base recipes, especially those that contain sources of lithium (lithium carbonate, spodumene, petalite) will enhance colour and bring a wonderful brilliance to the glaze. Colourful glazes that contain zinc oxide on the other hand might appear duller and milky in comparison because zinc can inhibit the colour response of some colourants including chrome, such as chrome-based stains – turning them brown. (Although zinc can enhance cobalt blues.)
- Finally, is the glaze appealing and can it be adapted further? You may not like the colour, but perhaps there are some interesting qualities in the glaze you like, such as crystallization or iridescence. Pull out these traits, isolate other parts of the glaze. Be curious and continue to experiment to achieve the full potential.

Storing test tiles

As you build up a collection of glazes, you will need to consider how to store and present your tiles as a reference system that

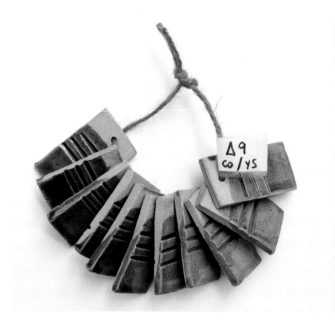

A group of tiles are strung together and a label attached for easy reference.

works for you. This will depend on how much space you have available, but common approaches are to construct a display unit with shelves that can store upright/freestanding tiles. This can be mounted on the wall or stand alone. If your tiles have a hole in them, this will allow you to string groups of related tiles together such as glazes made with the same base recipe, firing temperature, or variants of colourant. With flat tiles, you could hang or mount them directly on to a board and display on the wall. In some studios and educational environments, tiles are fixed onto a series of hinged boards which can then be flicked through and referred to. You may even prefer to catalogue and store your tiles in labelled boxes, although this approach is less accessible when it comes to finding a glaze. Here, you could document and photograph each glaze digitally for quick reference or store your results using an online glaze-sharing site.

GLAZE TESTING METHODS

The focus of this next part of the chapter is to introduce a number of different glaze testing methods that will help build and expand on your knowledge. Glaze testing has a reputation of being a slightly laborious task, which underlines the importance of finding a method that works well for you and is enjoyable. From experience, my advice would be to keep it simple and manageable – don't overload yourself by setting overambitious targets of glazes you need to prepare and test

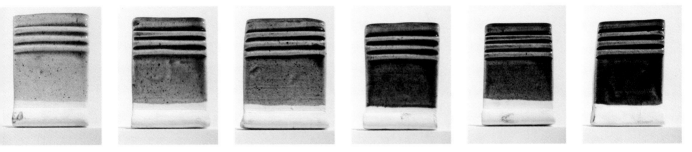

Cobalt oxide was added to the base glaze in increments of 0.25 per cent (0.25, 0.5, 0.75, 1, 1.25, 1.50 per cent).

in a set period. This is a sure way to evaporate any enthusiasm you have! Be realistic and aim to complete a smaller batch of glaze tests in an achievable timeframe. You will soon find your rhythm. Take regular breaks and come back to it another time if you reach your patience limit.

Blend additions

This simple method of adding repeat amounts of oxide or stain to a base glaze provides a visual progression of the increasing strength of the addition and how this can influence the glaze. For this following example, cobalt oxide was added to the base glaze (stoneware transparent shiny) in six increments of 0.25 per cent. For example 0.25 per cent, 0.5 per cent, 0.75 per cent, 1 per cent, 1.25, 1.5 per cent.

To conduct the test, prepare 100g of a base glaze recipe and glaze one tile without any additions. Make sure to write the reference number on the tile. Add your first addition of 0.25g to the glaze liquid. Mix, sieve and apply to a glaze tile. Add the same quantity again and repeat the process until you have completed all your tests.

Guidance amounts to try

Strong oxides, for example cobalt, copper = 0.25%, 0.50%, 0.75%, 1%, 1.25%, 1.5%

Weaker oxides, for example iron (black, red, ochre), manganese = 0.5%, 1%, 1.5%, 2%, 2.5%, 3%

Commercial stain colours = 2%, 4%, 6%, 8%, 10%, 12%

Opacifiers, for example tin oxide, zirconium, titanium dioxide = 1%, 2%, 3%, 4%, 5%, 6%

Batch testing

This technical exercise is intended to establish the principles of experimentation and development, and the integration required in producing a broader collection of ceramic glazes. The purpose is to familiarize yourself with developing colour

Emma Lacey, *Blue Scale Collection*. These striking mugs explore a tonal gradient working down from 1 per cent inclusion of cobalt oxide in the glaze.

and tonal ranges that can be achieved using one glaze, in a controlled and logical manner. Another benefit of this technique is that it is very time effective and generates a substantial batch of different glazes with relative ease.

Method:

For this exercise, you will need ten empty containers, a jug, sieve and a marker pen. Select a base glaze recipe and prepare a quantity of 1000g (10 × the recipe %).

For example:

	%	× 10 =
Cornish stone	60	600
Whiting	20	200
Dolomite	10	100
China clay	10	100

Total		1000g

Increments of additional material. Row 1: cobalt oxide, 0.25, 0.5, 1 per cent; row 2: copper oxide, 0.25, 0.5, 1per cent; row 3: yellow stain, 2, 4, 6 per cent.

Add 1 litre of water to the glaze powder (note; some materials are thirstier than others so you might need to add more water if your glaze liquid is too thick – record the total amount) and proceed to sieve and prepare the glaze in the usual manner (refer to Chapter 3). To make the tests, divide the overall volume of the glaze equally amongst the ten containers. For example, if the total volume is 1500 millilitres, when divided by ten, each container will have 150ml of glaze liquid.

To start, apply the base glaze as it is to one test tile without any additions and put aside. Configure the nine remaining containers as a grid of three by three, as illustrated above. For each row, experiment with increments of an additional material of your choice. As each container essentially represents 10 per cent of the overall total, you can simply weigh out the addition amount without multiplying it, such as 0.25 per cent = 0.25g.

Use a reference system that works for you. Here, the rows are referred to as 1, 2, 3, and the columns are A, B, C. Therefore, when referring to this chart, for example: 1A = Base glaze + 0.25 per cent cobalt oxide; 1B = Base glaze + 0.5 per cent cobalt oxide; 1C = Base glaze + 1 per cent cobalt oxide.

To prepare each test, weigh out the specified amount of colourant, such as 0.25g cobalt oxide. Add the amount to the glaze test, mix and sieve twice. It is very important to sieve the test, especially if it contains a colouring oxide, before you apply it to the tile because otherwise it will appear speckly rather than

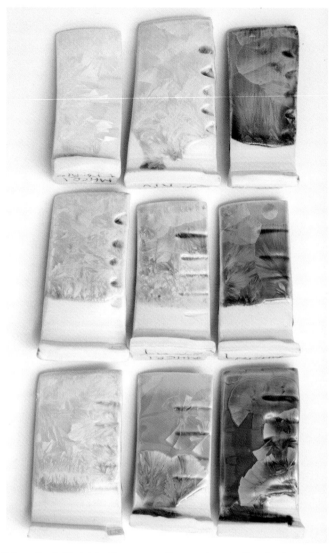

This method of batch testing was used to experiment with colouring oxides in a crystalline base recipe (SWCR1). Increments of 1, 2 and 3 percent. Row 1: iron oxide; row 2: manganese dioxide; row 3: copper oxide.

blended. Write the reference number on each test so you can correspond the information with your notes. Fire the tests at the desired temperature point, and then compare your results.

Additions to try:
1. Oxides – select from copper, cobalt, manganese dioxide, iron oxide (black, red, yellow, ochre) or rutile and experiment with adding different percentages to your tests – refer to the chart in Chapter 8 for specific guidance amounts.
2. Texturing oxides – create textural, volcanic qualities within your glaze by experimenting with additions of 1, 2, 3 per cent vanadium pentoxide or silicon carbide.

3. Select three glaze stains of your choice and test percentages of 2, 4, 6 per cent (light-medium) or 6, 8, 10 per cent (medium-strong).
4. Choose a colourful glaze or special effect glaze you like (such as lava glaze) and experiment with adding colouring oxides and stains to broaden the palette further.
5. Test opacifiers in percentages of 2, 4, 6 per cent to see how this can alter the opacity of a transparent base glaze such as tin oxide, titanium dioxide or zirconium. Compare the different tones of whiteness, from bright to creamy. You can take this further by adding glaze stains or oxides to the tests to create sugary pastel tones.
6. Have a go at experimenting with materials that will make the glaze matt, in percentages of 6, 8, 10 per cent,

for example dolomite, magnesium carbonate or talc. Compare how dry or smooth the glaze becomes depending on which material you used.

For stoneware glazes: If you have access to both oxidized and reduction kiln firings, glaze two batches of tiles and put a set in each firing. Compare how the type of kiln atmosphere affects the glaze results. You might even discover some glazes are more effective in one type of firing over another.

Glaze intermixing

A very simple but effective test that follows on well from the batch testing method is to choose five glazes from within the same firing range (such as earthenware) and atmosphere

Example of the glaze intermixing technique in practice. Glazes can be intermixed in liquid form in equal parts of 50/50 to create new colours.

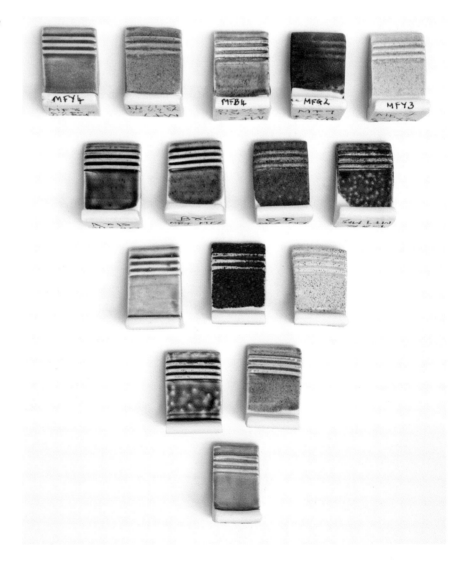

(oxidized/reduction) and intermix in equal parts of 50:50. This is a wet-blend method whereby the glazes are intermixed in their liquid state rather than as dry materials. You can use a teaspoon or volumetric syringe to measure the parts, so for example 1 part A, 1 part B. Make sure you thoroughly mix the glazes (no need to sieve) before applying to a test tile and firing at the desired temperature.

Example:

```
A       B       C       D       E
   A+B     B+C     C+D     D+E
      A+C     B+D     C+E
         A+D     B+E
            A+E
```

Biaxial blend

A biaxial blend is a wet blend method and involves combining two different glazes or colourants in varying proportions to make a hybrid glaze that offers the best attributes of both. To get started, select two glazes from within the same firing range and kiln atmosphere (oxidized/reduction) and make sure you have at least 500ml of glaze available for each. It is useful for this test to blend two opposing glazes that offer something different to each other. For example, one glaze could be a shiny blue glaze, and the other a yellow-brown glaze. For the purpose of this explanation, we shall refer to them as glaze A (blue glaze) and glaze B (yellow-brown glaze).

Method:

Line up a row of nine empty containers, imagine that there is a dividing line; the top row of numbers ascend from 1 to 9, while on the bottom row they descend from 9 to 1. This refers to the parts ratio A:B as follows:

	Test 1	Test 2	Test 3	Test 4	Test 5	Test 6	Test 7	Test 8	Test 9
Glaze A 100%	1	2	3	4	5	6	7	8	9
Glaze B 100%	9	8	7	6	5	4	3	2	1

Use a fixed unit of measurement, such as a teaspoon, or volumetric syringe to measure a part. Add the relevant amount to a container, for example two parts glaze A, eight parts glaze B, mix and apply to a test tile, and then label the test tile. Continue in this way until all nine tests are completed. When the tiles are fired, you will see a progression of the glaze blend and amalgamation of the two. From here you can identify a glaze blend to take forward into further development. If you like the glaze and would like to make a larger quantity, you could remake 5 litres of each glaze (A & B) and use a larger measurement such as 500ml or a cup to represent the part. As long as you keep the ratios the same, the results should replicate. This is the method I use in my own studio as I mix many of my glazes together and it makes sense to keep a large batch of each glaze on hand. However, if you just want to make up what you need, then you can do this by taking your chosen ratio, such as Glaze A:2 and Glaze B:8, and calculate each recipe as percentage parts, for example Glaze A = 20 per cent, Glaze B = 80 per cent and combine the recipe to total 100.

Tip for mixing a biaxial blend

A smaller 5-point biaxial blend is a condensed version of the 9-point blend and is useful for providing a general overview of how two opposing glazes might interact when blended together.

	Test 1	Test 2	Test 3	Test 4	Test 5
GLAZE A 100%	1	2	3	4	5
GLAZE B 100%	5	4	3	2	1

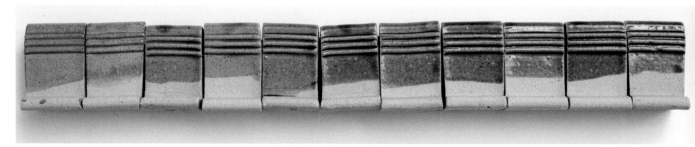

An example of a biaxial blend in practice. The blend of two contrasting colours has produced a broad scope of results.

Triaxial blend

A triaxial blend is a method of testing three variants on a 3-point axis. This method of testing allows you to identify how specific materials behave in a glaze and the numerous possibilities that can be achieved to broaden your palette further. At first glance, a triaxial blend can seem very intimidating, but don't be put off as it is fairly straightforward to implement once you get going. Triaxial blends can be applied in many ways to gain insightful information. Traditionally, they were used to test isolated materials from the silica, flux and alumina groups, but they can also be used to blend three different glazes together, as well as test the effects of colourants and modifiers in a base glaze.

In a triaxial grid, each point is assigned to a material, colourant or glaze, referred to as A, B or C. For the purposes of this example, three different colourants added to the same base glaze have been used to represent the variants. From each corner point, A, B and C; the base glaze and selected colourant are wet blended sequentially with another in even increments. As you can see, the triaxial blend demonstrates the progression of colour and the interaction between the relative parts.

A triaxial blend is a method of testing three variants on a three-point axis.

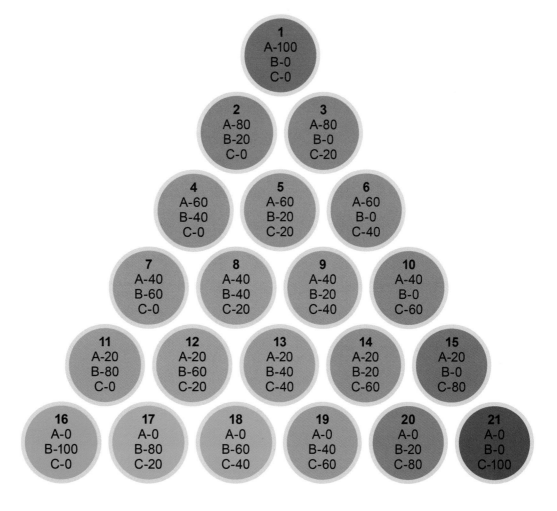

The size of the triaxial blend is up to you, and can include as many rows as you like within a triangular formation. To give you some idea where to start, the minimum amount is three rows which configures a 6-point grid. More commonly five rows give a 15-point grid, and six rows a 21-point grid as illustrated, which allow the user to create a broad selection of results and identify the nuances between each one. Advanced triaxial blend grids can total up to eleven rows giving a 66-point grid, and beyond, but this does reach a limit eventually when the differences between the results are so minimal that there is little reason to conduct the tests this extensively. A way round this is to only mix the inner parts of the triaxial blend, as this is usually where the most interesting results occur in the glaze.

Example:

Step by step

To complete a 21-point grid as illustrated, you will need twenty-one empty plastic containers, a volumetric syringe and at least 500ml of three test glazes which we will refer to as glaze A, B, and C. Follow the chart above and use a volumetric syringe to represent each proportional part. 100ml = 100 per cent, 80ml = 80 per cent and so on.

You can experiment further by:

- Using the same base glaze throughout and adding two colourants to each point and blend.
- Try two colourants with an opacifier on the third point.
- Try a texturising oxide to one point such as silicon carbide or vanadium pentoxide.

Extract the liquid and decant into the container. Complete the amounts of each glaze first before moving on to the next.

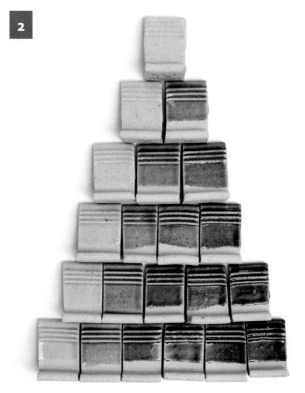

Mix together, apply to a test tile and label the back with the glaze reference number. After firing, put the tiles back in a triangular formation and select your favourite results.

- Using the three components of the glaze, glass former, flux and alumina on each point, the test should reveal in what proportions a proper glaze melt is achieved.
- If you have tried the batch testing method as explained previously, select three glazes from your results and blend together.

Quadaxial blend

A quadaxial blend is a testing method using 4-point axis. This exercise is slightly more challenging to undertake compared to other methods but is very useful as a way to make your own glazes from scratch as well as blend glazes together to create new glazes. Quadaxial blends can vary in size and complexity, but the most common and accessible grid to try is a 25-point grid, as illustrated below.

If you are interested in creating your own glaze, you can use the quadaxial grid to test four isolated materials from the flux, silica and alumina groups, such as feldspar, whiting, flint and china clay. Assign a material to each corner, A, B, C & D (you will need 500g of material and approx. 400ml of water) then sieve the mixture, and sequentially blend with another following the amounts as shown in the diagram below. This is a wet blending method, and the liquid can be measured in millilitres using a volumetric syringe for ease. Apply the mixture to a tile and fire to the desired temperature (this example – 1280°C/2336°F, cone 9). Usually around the middle point of the grid, the materials will start to interact with each other and will indicate the point where they become a glaze. You can then translate the proportional parts as percentage weights and recreate the glaze. Alternatively, you can blend four opposing glazes together, or test colourants and modifiers on each corner point to diversify your results further.

A quadaxial blend is a testing method using 4-point axis.

Currie grid method

The Currie grid developed by the late Australian potter, Ian Currie, consists of thirty-five tests arranged as 7 × 5 biaxial grid. The format is not dissimilar to a quadaxial blend, the difference being that silica and alumina (clay) are varied in separate amounts from the fluxes and colourants, which remain constant. This systematic approach of testing allows us to examine the influence of silica and alumina on the glaze as a whole and understand the relationship between the thirty-five glazes.

The tests are blended via a volumetric syringe from the four corner glazes at A, B, C & D.

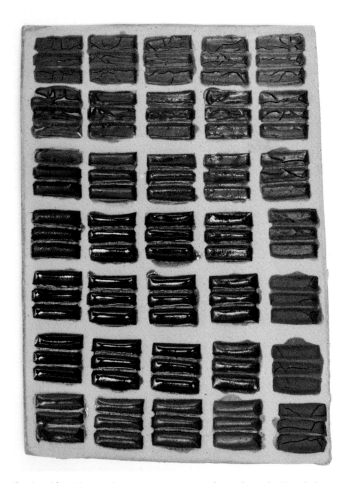

Currie grid test in practice, using a stoneware glaze coloured with cobalt oxide. Here, silica increases in sequential amounts from left to right, and similarly, alumina (clay) increases from the bottom to the top. The fluxes and colourants remain constant throughout. The test allows us to understand glaze behaviour and pinpoint desirable qualities, for example the high gloss glaze in the third row from bottom (left side).

A High Alumina

B Low Flux

Increasing alumina

C High Flux

D High Silica

Increasing silica ▷

Standard grid format (diagram reference, Ian Currie).

Corner A: High alumina
Corner B: Low flux
Corner C: High flux
Corner D: High silica

See ian.currie.to for further reading and a useful calculator which will formulate your glaze ratios and alumina/silica proportions to carry out this test successfully.

UNEXPECTED GLAZE RESULTS

Even with the best intentions, there are times where our glaze tests and final pieces are widely different after the firing, bearing no resemblance to each other. This can be perplexing

to understand, especially if you have been very careful with preparing your tests and replicating the results. There are usually a number of factors at play and you might have to conduct a bit of detective work. First, check the thickness of the glaze application – any slight difference here could alter the glaze appearance significantly. Similarly, how the piece was fired, either upright or flat could influence the outcome. Another consideration is the scale of the piece, texture, clay body and firing temperature (underfired/overfired) which will all impact the glaze in some way. Also, glaze materials differ from batch to batch from their origin sources, as well as equivalents sold around the world. The best course of action is to retrace your steps and try and find out the root of the cause to avoid any further disappointment. Finally, sometimes a glaze test will offer the most exciting results but when applied to the actual work, it can look underwhelming, or the opposite and be too dominating! As frustrating as this is, try not to be too disheartened as it is all part of the learning experience and you will soon gain familiarity with the process.

Tips for glaze testing

- When making your tiles, stamp the side of the tile with a mark to indicate the bisque temperature (high/low bisque), clay type or group. This will help you identify the tile later on when you come to use it. Some makers like to stamp a numerical reference into the tile itself to record the test without the need for writing on the tile.

- Protect your kiln shelves when firing new and unknown glazes. Place a sacrificial bisque tray or alumina powder underneath them to catch any drips and spills.

- A collection of glaze tiles can be a thing of beauty in itself; consider the permanent display of your tiles so you can feel inspired every time you look at them.

- Use a permanent marker on your tiles after the firing to mark the glaze recipe, especially if the initial writing is difficult to read.

- An underglaze pencil is one of the most useful tools for writing on a test tile and is suitable for oxidized and reduction firing, across the temperature ranges.

- Consider a double back-up when writing on your tiles; write the reference twice – just in case you are unsure how the glaze will respond and don't want to risk losing the glaze reference.

GLAZE EXPERIMENTATION AND DECORATIVE TECHNIQUES

Glaze exploration has no boundaries, from the many different types of surface effects through to application and decorative techniques. However, when new to glaze, there is a tendency to approach it with caution and apprehension – but don't be afraid to tear up the rule book! After all, historically, much of what we know today about ceramics and glaze was discovered by trial and error, so just have a go and enjoy experimenting!

With this in mind, how do we get creative with our glazes? Firstly, consider the aesthetic you are striving for in your work as this will help you make the most appropriate choices with glaze – refer to Chapter 1 to help develop this area of your practice. Likewise, so much can be learnt by simply researching other artists and gaining an understanding of their processes and techniques. There are many fantastic videos and short films available online and via social media, often made by the artists themselves, that offer a unique perspective into their practice. The focus of this chapter is to discuss key techniques and offer suggestions of things to try out for yourself. This is further supported by images and useful insight by some of the leading practitioners working within the field.

SLIP DECORATION

Decorative slip is essentially liquid clay made from water and dry clay powder, coloured with ceramic pigments such as oxides or commercial stains. It is not the same as casting slip which is used for mould making. The benefit of using slip is that it enables the artist to decorate the work in the raw, leather-hard stage, followed by a glaze firing to enhance the colours further. Traditionally, slip-decorated wares were earthenware and glazed with rich, lead-based glazes such as copper green and honey yellows. The glazes featured in this book are predominately lead free, but there are a number of suitable glazes that can rival lead glazes (refer

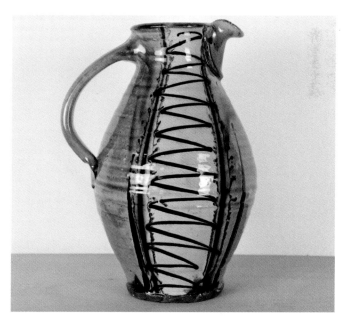

Russell Kingston, *Slipware Jug* (2022). H: 28 cm. Thrown vessel with attached spout and pulled handle, slip decorated, fired in a gas-fuelled kiln to 1120°C.

◀ Anna Barlow, *C'est ne pas du tart* (2018). H: 53cm. Interested in the rituals of food, Anna Barlow creates hyper-realistic sculptures that portray magnificent desserts and indulgent sugary treats. She uses an array of sumptuous ceramic glaze colours and life-like textures to mimic indulgent food items.

Leadless commercial glaze, coloured with 0.5 per cent copper oxide, applied over a slip-decorated terracotta tile.

Decoration is applied to a glazed surface using a soft-tipped paint brush.

Tessa Eastman takes inspiration for her lively, hand-built sculptures from curious organic shapes viewed through a microscope, as well as cloud formations up in the sky. She likes to explore the strangeness of growth of natural phenomena in which systems flow and digress from an intended pattern.

Glaze is an integral part of Tessa's practice. As she explains, 'the glazes are often considered at the start of making a work and I aim for the glaze to enhance the character and personality of a piece, bringing harmony and discord. Without glaze, the sculptures wouldn't be animated and have the perfect balance of surface and form.'

Through her work, Eastman is not afraid to take risks and is highly experimental with her glaze application. Her practice seamlessly combines rich and textural surfaces with expressive forms. To develop tactile surfaces within your own work, try layer and combine opposing glazes, such as frothy lava glaze or crawled surfaces with shiny, colourful glazes (*see* example recipes in Chapter 8). You could also fire the work multiple times, adding more layers of glaze until you are satisfied with the result.

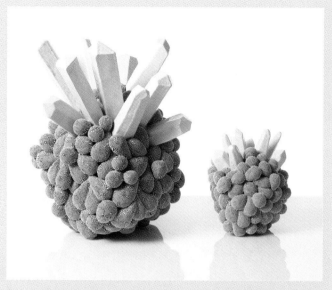

Tessa Eastman, *Raining Crystalline Meteorites* (2023). Large black: L32 x W32 x H36cm. Small coloured: L18 x W18 x H21cm. Hand-built, multiple glazed stoneware, fired to 1240°C (2264°F).

to recipes EW1 and EW3 in Chapter 8 – Earthenware). Slip decoration is also suitable for stoneware – oxidized and reduced. A list of slip recipes is included in Chapter 8. If slip decoration is an area that interests you, refer to the bibliography for further reading on this subject.

MAIOLICA

As discussed earlier in Chapter 1, Maiolica is the term given to decorated tin-glaze earthenware. Maiolica is characterized by an opaque, white (tin) glaze, typically applied to red-earthenware pottery and hand painted with ornate patterns and motifs. Traditionally these glazes were made from lead, but safer alternatives are given in Chapter 8 for you to try. It is true that leadless glazes are not always as effective as the original lead glazes when it comes to the quality of the melt and blend of the oxide and stain decoration. However, a good tip is to add a small amount of borax frit – around 10 per cent (standard borax frit is fine) to the colouring pigment before you begin as this can improve the melt and enable a softer blend into the glaze. Some artists like to sketch out their designs first with a

pencil onto the glaze surface before they start painting. When ready, use a soft brush to apply the pigment onto the unfired glaze. Try watering down the strength of the oxides or stain to gain tonal effects and depth within your compositions. A light spray of clear transparent glaze over the top of the decoration can improve the melt of the pigments further and enhance the colours. Another tip is to spray the decoration with hairspray to fix it in place and prevent smudging. The techniques used for traditional Maiolica are not limited to earthenware and can be applied in conjunction with mid-fire and stoneware oxidized glazes with the addition of 6–8 per cent tin oxide in a transparent base glaze.

Glaze sintering

As discussed by Lisa Katzenstein, the technique of glaze sintering is very useful for applying and layering up decoration on a white background. Begin by applying a layer of white glaze and low fire to a temperature of 700°C (1292°F). This will 'fix' the background so it becomes like a canvas – and much easier to apply decorative work on top. After the decoration has been applied, the piece can be fired to the required temperature and resolved.

Artist insight: Lisa Katzenstein

The distinctive, illustrated ceramics made by Lisa Katzenstein are a superb example of traditional Maiolica techniques combined with contemporary application. Here the artist explains her processes and the methods she employs to achieve her lively, decorative surfaces.

'All my work is slip-cast in moulds from models that I carve on a lathe. I spray the glaze on to give me an even finish, and then I fire the piece to 700°C [1292°F] in a "sintering" firing which fixes the glaze to the pot but does not melt it. This enables me to apply washes of colour and use resist techniques, which otherwise would result in the glaze flaking off the pot.

'When I paint my vase, I sketch out the outline of the design then paint the foreground motifs, such as the leaves and the white areas of hydrangea blossom, and then I paint a latex resist on top. The background colours are then painted with a hake brush. After this I scratch into the latex to form lines in which I inlay oxide colour which will form the black lines. When all the black lines are completed, I lay a paper towel on to the latex and gently rub, and then peel off the paper which takes most of the wax with it. I then touch up a few of the lines with a small brush. All my work is bisque fired to 1130°C [2066°F/cone 01], followed by a glaze firing to 1030°C [1886°F/cone 05] with an hour and fifteen minutes soak at top temperature.'

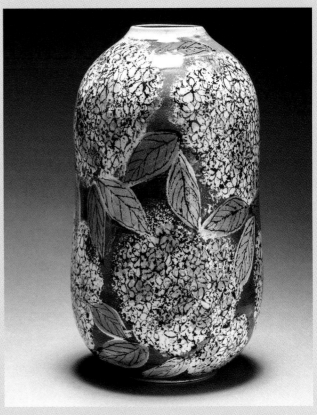

Lisa Katzenstein, *Hydrangea Vase* (2022). H: 26cm. Slip-cast earthenware, hand-painted Maiolica, with latex resist and sgraffito decoration.

Brush work

If your aim is to create very illustrated decorative works, then follow the methods as discussed for Maiolica. You can also paint underglaze decoration on to a bisque surface and apply a transparent glaze over the top. Here we are focusing on using brushes to bring visual interest to a glaze surface by using other glazes or pigments. First apply a coat of your chosen base colour to your bisque item. Take a soft brush, such as a hake brush, and dip it in another colour glaze and paint over the top. Sometimes it can be difficult to get a good spread of glaze when decorating on top of another glaze because it can get quickly absorbed and become dry on the brush. To overcome this, you can water down the pigment and build up the decoration in layers. Another technique is to add a binder medium or gum to the glaze such as CMC, which can help

slow down the drying and give the glaze a more paint-like consistency. It can also prevent smudging because it improves the hardness of the dry glaze and its adherence to the surface. With the decoration, you can be as gestural or delicate as you like. Repeat as desired using the colours of your choice. The more you layer and overlap, the greater the interaction between glazes. You can also paint over fired glaze and refire multiple times.

Pouring/overlap

A very simple technique is to overlap contrasting glazes with each other. This can be done either by pouring glaze with a jug over areas of the piece or by dipping a section of the piece into a container of glaze. You can also spray layers using a spray gun. The two glazes can create a unique interaction where they

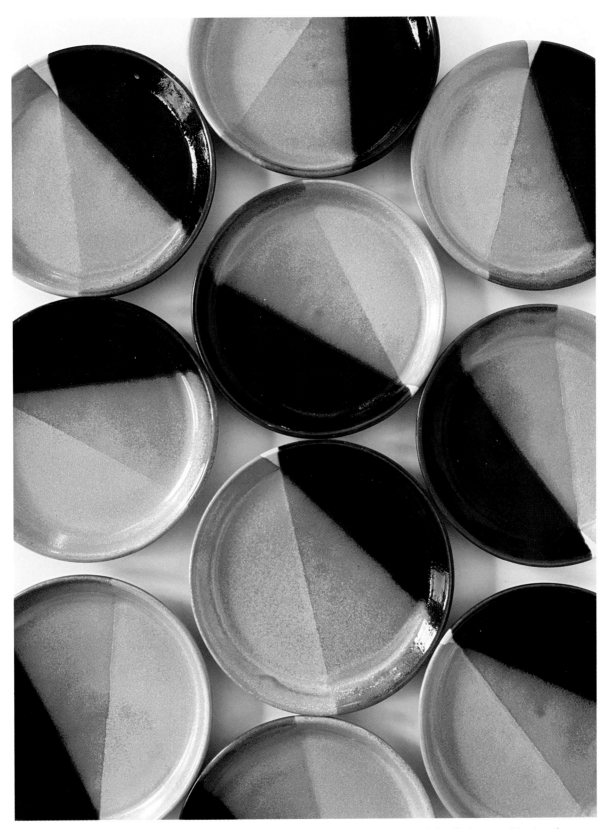

Melisa Dora, *Hand thrown saucers* (2022). Dia: 14cm. Hand thrown with white stoneware clay and glazed using a combination of two glazes overlapped to create the middle colour. Fired to 1240°C (2264°F/cone 6).

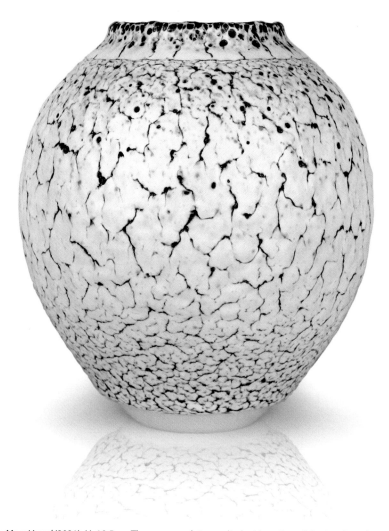

Albert Montserrat, *Green Moss Vessel* (2021). H: 18.5cm. Thrown porcelain, applied with an iron-rich glaze base layer, then over-sprayed with an opaque satin-matt coloured glaze. Fired in oxidization to 1300°C (2372°F/cone 10).

overlap. You can push this technique further by overlapping multiple glazes, or leaving areas of exposed clay body to bring an extra contrast.

Layering glazes

In a similar way to pouring or overlapping areas of glazes, you can push this further by layering glazes one on top of another. Let the glazes dry before you apply the next layer.

As you apply more layers of glaze this can cause the materials in the glaze to form a eutectic with other glazes as they melt in the firing, which means the glaze is more likely to run. Therefore, allow a tolerance gap to accommodate the glaze flow, for example wipe 1–2cm of glaze away from the base. It is also wise to put a sacrificial tray under the work to prevent damage to the work itself and the kiln shelf, should the glaze run off the pot.

Trailing

Some of the techniques used for slip decoration are interchangeable and can be used in glaze decoration. This includes trailing. You will need a slip-trailer tool – which consists of a rubber bulb with interchangeable nozzles. The bulb is squeezed to push out the air and the vacuum draws up the liquid. It is also possible to buy very precise trailers that consist of a plastic bottle with a fine metal needle-like tip. With a variety of tools to hand, you can then trail glaze as expressive marks, writing or intricate patterns.

Resist techniques

You can build visual interest in your work by using resist techniques. This involves masking or covering specific areas to repel glaze as a form of decoration. The easiest way to achieve this is to use liquid wax or latex which is applied directly to the

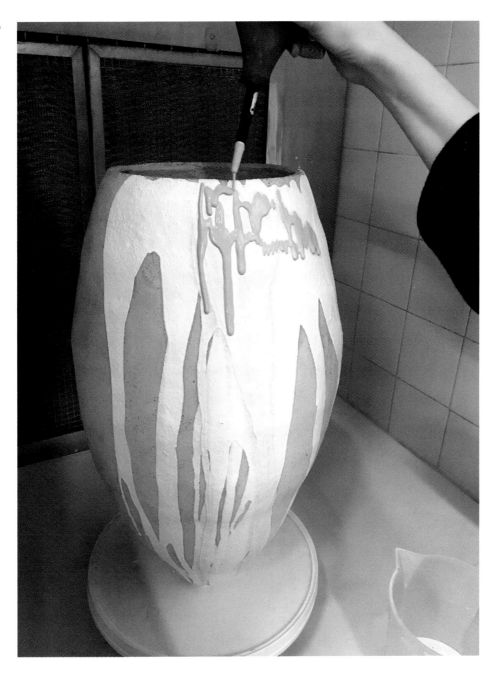

Use a slip trailer tool to drip and layer glazes to create lively surface interactions.

surface, either on to bisque or on top of another glaze. Both methods have their benefits; liquid wax remains on the surface and burns away during the firing. Latex can be pulled off once it has dried, allowing for a build-up of layers. Resist is also useful when applied to foot rings and inside of lid galleries to help speed up the glazing and cleaning process when preparing for a firing. Resist mediums can take a heavy toll on brushes, so don't use your best brushes for this task. A tip is to rub a little liquid soap or washing-up liquid into the brush head to make it easier to clean afterwards and prolong its longevity.

Step by step

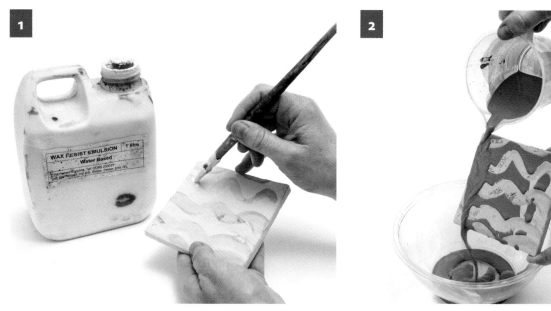

1 Dip the brush into the wax and paint your pattern or detail on to your work.

2 When the wax is dry, apply your glaze, either dip, pour or spray method.

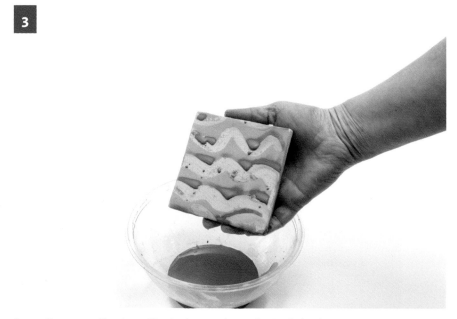

3 Repeat if necessary. The glaze will resist the waxed areas, leaving behind an interesting contrast.

Stencils

Similar to using other resist techniques, stencilling is a way of applying decoration to a surface by masking or applying medium through a hole or defined shape. This can be done in any stage from leather-hard to glaze. Stencils can be made from paper, card or thin plastic; however, from experience, newspaper offers the best attributes for this technique. This is due to the slightly absorbent nature of newspaper which makes it less susceptible to wrinkling as it dries. Stencils are best applied on top of an unfired glaze layer, followed by other glazes or colourants applied on top.

Step by step

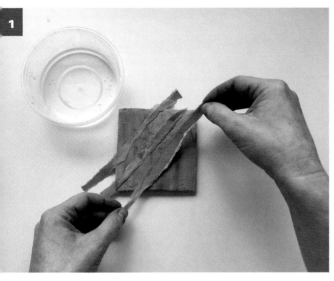

To make a stencil, first cut your shape out of newspaper. Damp the paper in water, and lightly stick it to the surface of your piece.

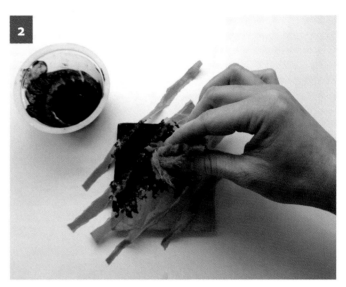

Proceed to apply your glaze or colourant over the top of the stencil and wait for it to dry to a matt sheen.

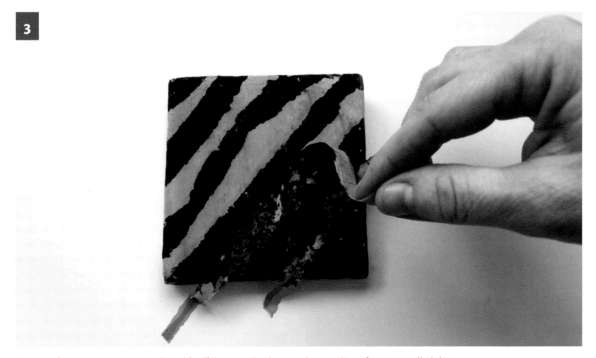

Use your fingers or a pottery needle to lift off the stencil to leave a clean outline of your stencilled shape.

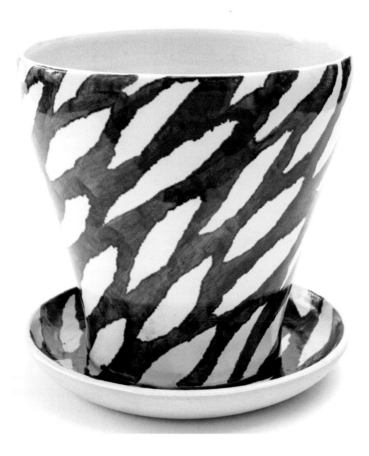

Alma Boyes, *Stencilled Planter and Plate*. H: 22cm. Tin glaze, stencilled cobalt decoration, coated with a layer of clear glaze and fired to 1260°C (2300°F/cone 8).

Stamping

You can create repeat patterns or striking decoration simply by using a stamp made from a sponge dipped in glaze, oxides or stains. A natural sponge will give a softer texture compared to a synthetic sponge. Simply dab the sponge into an oxide water mix or a contrasting glaze colour and apply directly to bisque or on top of an unfired glaze layer.

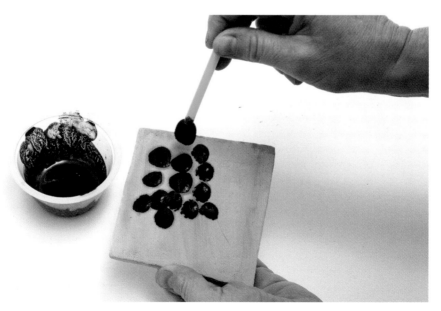

Stamping is a great way to create dynamic surfaces.

Mono printing

This technique involves the direct transfer of one medium on to another, as outlined below. A tip is to first draw your design on to the newspaper before you begin so you can trace your line as you go along.

Step by step

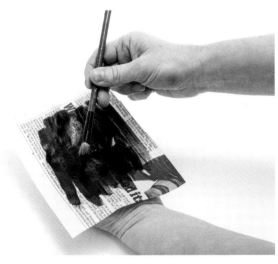

Mix oxide or stain with water and coat a layer onto a sheet of newspaper. Wait until it dries from wet to a matt sheen.

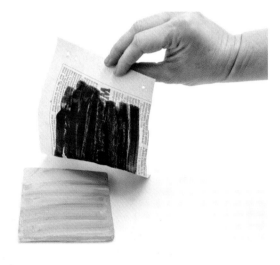

Turn the paper face-down on to an unfired glazed surface (or directly onto bisque).

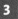

Draw on the paper with a fine nibbed tool to transfer the medium on to the surface of the piece.

Peel back the paper to reveal the printed pattern underneath.

Crayons and underglaze pencils

Ceramic crayons and pencils can be purchased from a pottery supplier and are very useful for a variety of tasks, from writing on the base of test tiles, to creating illustrative decoration. It is also possible to make your own crayons by mixing 15–20 per cent stain colour or 5–10 per cent oxide into 100g of any white ball clay; for example, Hyplas 71 ball clay. Combine with a little water until the mixture forms a thick paste. Roll into thin coils and then fire to 800°C/1472°F/cone 016. Apply to bisque and on top of unfired glaze.

To make a wax crayon, melt 100g of paraffin wax pellets (same wax used for candle making) and add 10–15 per cent stain or 5–10 per cent oxide to the mix. Stir until everything has combined. As illustrated below, the artist Katharina Klug

Artist Katharina Klug makes her own crayons by pouring hot wax into carved channels.

The wax crayons are applied to bisqueware and repel the glaze, leaving behind a striking contrast between the drawn line and glaze surface.

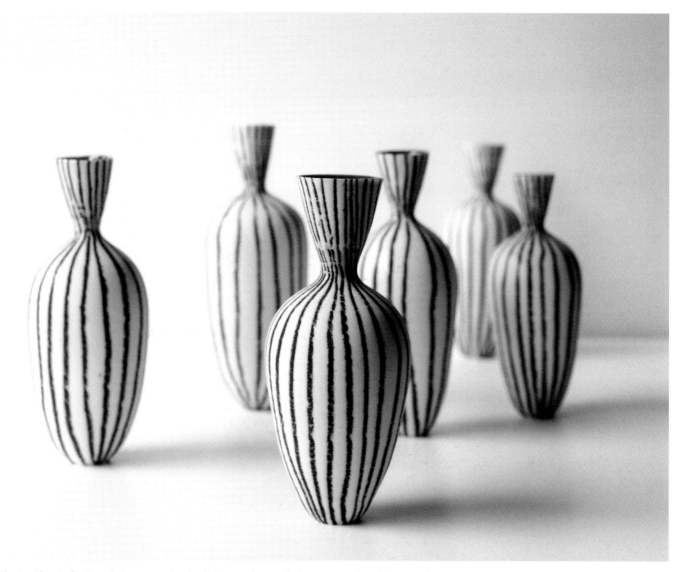

Katharina Klug, *Ladies* (2020). H: 20cm each. Wheel-thrown, glossy red glaze interior – hand-drawn dark pastel lines on exterior matte white glaze, fired to 1260°C (2300°F/cone 8).

pours her wax mix directly into channels she has carved into a block of clay. This makes removal of the crayon much easier without risk of breaking it. You can also make a cone out of baking parchment or a coffee filter paper and sit it inside a cup or beaker. Make sure the cone is sealed and then pour the liquid wax inside and leave to cool. The paper can then be peeled off afterwards. The benefit of using wax crayons is that the wax will act as a resist and when it burns away in the kiln, the colour of the stain or oxide will be left behind, creating an interesting contrast with the glaze.

Sgraffito

Sgraffito – an Italian word meaning 'to scratch', is a technique that involves scratching through a decorative layer to expose the clay body underneath. The technique is commonly used for slip decoration, but can also be applied to glaze. Sgraffito is particularly effective on a coloured clay body, such as red terracotta, in combination with a white glaze. A tip is to draw your design on to the glaze with a pencil so you can trace the line if you find this easier. The pencil mark will burn away in the firing. Be mindful of dust and protect yourself by wearing a mask.

Step by step

To get started, first apply a coat of glaze to your piece. Once it has dried, take a sharp, pointed tool such as a pottery needle and scratch your design through the glaze layer.

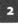

Lightly brush away any surface dust, to reveal the crisp line underneath.

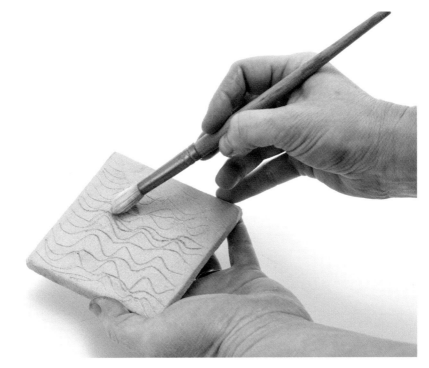

Enhancing texture

Some glazes by themselves will do a very good job at enhancing texture. Particularly glazes that contain barium carbonate (or strontium carbonate, a safer alternative). These glazes uniquely 'break' (a term given to exploit colour changes) over edges, as well as produce distinctive mottled textures. When glaze testing, seek out these qualities if you have a surface you want to exploit and showcase.

You can also enhance texture with oxides applied underneath the surface and wiped back.

Paul Briggs, *Windflower Vase* (2022). H: 19.5cm. Pinch-formed from one ball of black clay, 1200°C (2192°F/cone 6) oxidation, white glaze, primarily nepheline syenite with 1 per cent iron. The combination of a white glaze over a black clay body delicately highlights the ivy-styled pinched textures that oscillate around the piece.

Step by step

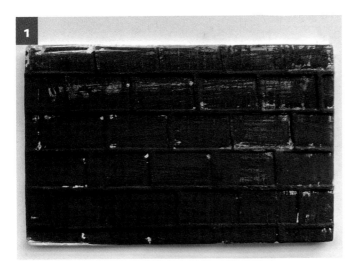

Coat the piece all over with a mixture of oxide and water (cobalt oxide is used here). Add more water if you prefer a washy effect, or less if you want a strong colour.

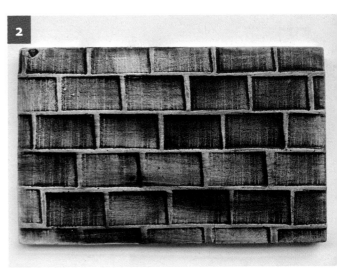

Take a damp sponge and wipe back the oxide, making sure the residue remains in the crevices and texture.

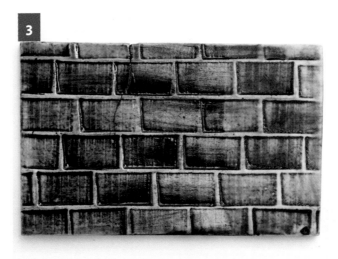

Apply a glaze on top or leave exposed. This example is half dipped in shiny transparent and the other half in opaque glaze. The centre is unglazed.

Oxide wrap

Take a piece of string and soak it in a mixture of oxide and water. Wrap the string around your unfired glaze piece. As the string burns away, the residue and print from the string will leave behind interesting patterns within the surfaces. You can also try wrapping thin copper wire around the piece which will partially melt and deteriorate, leaving behind a green metallic imprint. Good ventilation or extraction in the kiln area is essential when burning away any organic matter or embedded items.

Speckling effect

To create a speckling effect on glazes, take an old toothbrush and dip it into a washy mix of oxide or stain colour of your choice. Use your thumb to flick against the brush head and spray the pigment onto the glaze surface (or you can apply directly on bisque and then cover with a transparent glaze). Repeat until you reach the desired effect. You can even try combining this technique with stencils and resists to create further visual interest. Another technique to try is to add a

small amount of iron spangles to the glaze (around 2 per cent). This can create a mottled texture and is particularly effective in reduction glazes.

Contrasting the clay body with glaze

Simply dip or pour glaze over your piece and deliberately leave areas of the clay body exposed. This can create a strong dynamic between the surfaces, especially if your piece is made out of a coloured clay body or porcelain. You can apply an oxide wash underneath to enhance texture further. This technique is only really effective with mid-fire to stoneware temperature ranges, because when the earthenware clay body is left exposed, it can still look like bisqueware and feel unfinished.

Post firing techniques

Once you are satisfied with your glaze results, you can embellish the surface further with low-firing techniques including enamels, transfers/decals, metallic and decorative lustres. You can even apply paint or mixed media elements if you so wish. Another technique is to make separate component parts and then either glue together with a strong epoxy adhesive or apply glaze, refire and fuse the parts into one composition.

Iron spangles were added to a celadon glaze in percentages of 1, 2, 3 per cent (left to right) and fired in a reduction atmosphere to 1280°C (2336°F/cone 9).

Detail of *C'est ne pas du tart* by Anna Barlow. This decadent piece incorporates a combination of porcelain, Parian, bone china and earthenware clay elements. The whole assemblage is then glazed and refired multiple times to a temperature of 1080°C (1976°F/cone 04).

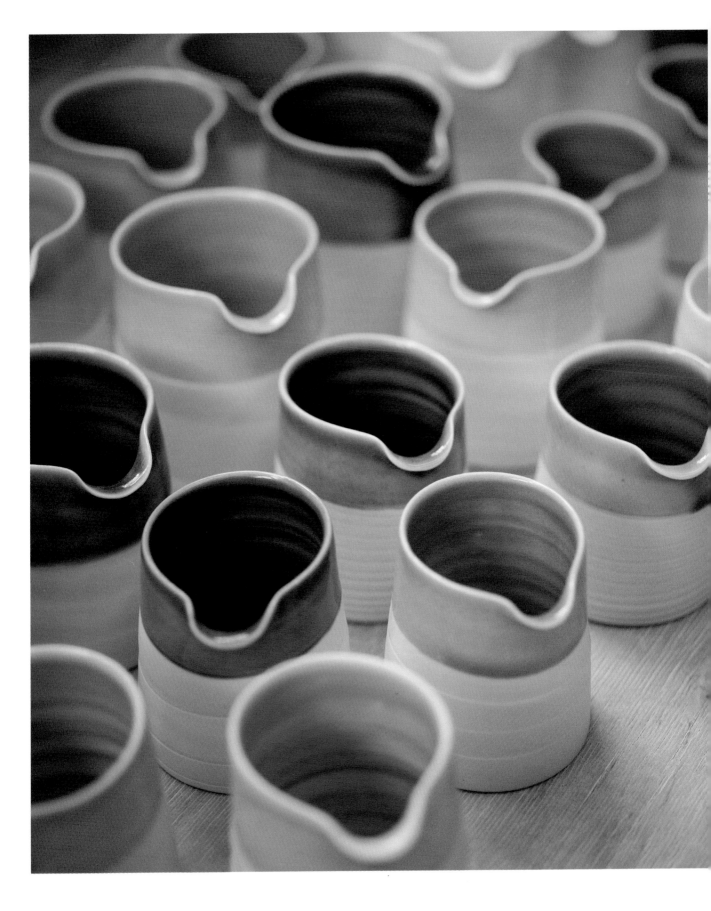

COMMON GLAZE FAULTS AND REMEDIES

Glaze faults and defects are unfortunately an inevitable part of ceramics practice and can lead to huge disappointment, especially if a lot of time and effort has been invested in a piece. However, many common defects can be avoided through good preparation and planning. First and foremost, always allow enough time to glaze your work and pack the kiln. It is quite surprising how long this process can take – at least a few hours to a whole day, if not more, so try not to rush as this will almost certainly lead to mistakes or an oversight that could jeopardize the outcome of your work. One of the most common errors to make, particularly when you are new to glazing, is misjudging the thickness of the glaze application. If the glaze layer is applied too thickly or too thinly, this could significantly impact the result and not represent the true colour or quality of the glaze. Therefore, always test your glazes first on a sample or tile before you apply it to your final work. If you are having issues with patchy results or unsightly drips, you may need to practise your application techniques further to improve your skills (*see* Chapter 3).

Occasionally the fault will be completely out of your control and the result of a kiln misfire, or piece of debris falling on the ware during the firing. In the case of any glaze fault, as frustrating as it is, try to retrace your steps and uncover the reason for the failure so you can avoid a repeat of the incident. Including a set of pyrometric cones in the firing can act as a kiln record and enable you to identify the temperature, which is a good place to start. The following information outlines the most common glaze faults and how to identify and remedy them.

CRACKING

From the very beginning of making a work in clay, until the moment it is fired and finished, the risk of cracking awaits. There are a number of reasons why this happens. Most commonly, a crack will start in the making stage caused by either clay drying too quickly or unevenly, tension in the form, inconsistent making (thick/thin walls), poor construction and joining methods. Cracks are likely to return in the glaze firing and could open up and worsen at higher temperatures. The reason for this is because of 'clay memory'. This refers to the alignment of the particles in the clay structure that return to their initial positioning after being manipulated by forming techniques.

Before you start glazing, first check for any signs of hairline cracks in the bisque. Give the piece a gentle tap with the knuckle and listen for a dull ringing noise. If the noise sounds more like a thud, then this could be an indication the piece has a serious fault.

Cracks are notoriously difficult to eradicate but superficial cracks can be remedied by the following recipe:

Crack filler recipe
1-part alumina
1-part china clay (kaolin)
1-part clay powder (the same clay body you used to make the piece)
Add a little water and mix to a thick paste.

◀ Louisa Taylor, *Jug Pots*, H: 10cm (tallest). Thrown porcelain, colourful oxidized glazes, half dipped and exposed against the clay body. Fired to 1280°C (2336°F/cone 9).

This is a very versatile recipe and can be used when the clay is raw, bisque and even after it is glazed. For best results, apply it before and after bisque, and then re-bisque to completely 'heal' the crack. Sand back any rough areas and then proceed to glaze the piece. If there is a crack in the clay body that appears after the glaze firing, you can fill the crack with the paste, dab glaze on top and refire. Although be aware that with any refire, there is always an element of risk with getting the piece successfully through. Also, this technique is only suitable for minor cracks. For more severe cracks you could fill the crack with a two-part epoxy putty (such as Milliputt) post firing, and conceal with paint/enamel if need be – although arguably this does compromise the overall quality of the work and should only be done on non-functional work or for light repairs. The ancient Japanese art of kintsugi repair is an excellent example of celebrating the flaws in a piece by embellishing and mending it with lacquer mixed with gold dust or other precious metals.

Good practice throughout will help eliminate issues when you come to glaze your work. Of course, there will be some cracks which become irreparable, and you will have to accept the fate of the piece. However, to enable your work to make it through the firing you should ensure you have done everything you can in the making and construction stage when the clay is in its unfired state. The more time and effort you spend here will greatly reduce the issues later on.

DUNTING

Dunting can be identified as a hairline crack or sharp-edged split that runs through the glaze and clay body, often resulting in the fired ware breaking into fragments. Dunting is not always immediate, and a piece can spontaneously shatter weeks or months later after the firing. The main cause of dunting can be attributed to the kiln cooling too quickly or unevenly around two critical temperature points when important silica inversions take place and particles experience a sudden volume change. These are the quartz inversion – 573°C (1067°F), and cristobalite inversion – 226°C (437°F). Extra care should be taken around these temperatures when cooling as this is when the ware is under excessive stresses and strains, and most vulnerable to fracture. Therefore, always cool your kiln slowly and avoid opening the kiln vent/bung or allowing a draft to flow through the kiln. Resist the temptation to open the kiln door/lid to have a quick look inside, particularly at temperatures above 150°C–200°C (302°F–392°F) as this can significantly

This piece has a number of faults, including a serious dunting crack in the rim and crawled glazes, most likely caused by the glaze application being too thick, leading to increased tension in the form.

increase the risk of thermal shock (wares cracking due to sudden temperature change).

There are other factors that contribute to dunting, including inconsistent thickness in the cross section, such as a thrown pot that has thin walls but a thick base. This is straightforward to remedy through improved making and consideration for the cross-section. When loading an electric kiln, avoid placing the wares too closely to the heating elements as this can lead to uneven heat distribution and increase the risk of cracking (see Chapter 4). Another factor is poor glaze fit, whereby the glaze layer is too tight and does not accommodate the expansion of the clay body during firing. In this case you will need to adjust either the glaze or the clay body to improve the compatability between the two (see 'Crazing'). Dunting can also occur when the kiln has been fired too rapidly at the silica inversion points. This can be identified as a split/crack which does not align back neatly, and the edge of the crack is slightly rounded and softer compared to the sharp, crisp edge of a cooling crack.

CRAZING

Crazing is one of the most common faults to occur in a glaze and is recognized as a series of fine hairline cracks that spread across the glaze surface like an intricate web after firing. I

Crazing causes fine cracks in the glaze surface and can undermine the structural integrity of the ware.

occurs when the glaze is under tension and contracts more than the clay body. A tale-tale sign of crazing is a 'pinging' sound which starts from the removal of the wares from the kiln, and can still be heard days, months or even years later. Crazing can greatly reduce the inherent strength of the piece, and make it less hygienic for functional ware.

Crazing can occur across all temperature ranges but is more problematic in earthenware pottery intended for use, because a crazed surface can cause liquid to seep through the porous body. Crazing can be remedied by substituting or reducing materials with high expansion and contraction rates, such as soda or potash feldspars for those with lower expansion rates, for example lithium carbonate or talc (magnesium oxide). Increasing the silica amount in the glaze recipe by 5 per cent or adding a small amount of low-expansion frit, such as calcium borate frit, can benefit the glaze and improve craze resistance. Occasionally crazing is not caused by the glaze fit itself, but the variables during the firing such as too rapid cooling (thermal shock), or thick application of glaze. Therefore, it is worth eliminating these issues before you start to adjust the glaze formula.

On the flip side, crazing can be perceived as a desirable effect, especially in raku. In this instance, the crackle can be enhanced further by rubbing Indian ink or pigment into the lines. Crazing is less of an issue if the work is not intended for functional ware.

SHIVERING (SHELLING)

Shivering is the opposite fault to crawling, but both share the same underlying issue of poor glaze fit. In this instance the glaze layer is under extreme compression and too loose against the clay body. The glaze has a lower expansion and contraction rate than the clay body which prevents the two from bonding compatibly as they cool. Shivering can be identified as a fine network of cracks across the glazed surface, with some areas flaking or peeling away from the body entirely. It is more noticeable around sharp edges and rims, or areas of underglaze or slip decoration. In severe cases, stresses in the shivered glaze can cause the piece to crack and split.

Glazes that contain low expansion materials such as lithium can be more susceptible to shivering fault, where the glaze layer flakes away from the body.

Shivering can occur in all temperature ranges, but is more common in stoneware (oxidized and reduction). It is not exclusively a glaze issue, and the cause can be attributed to the clay body. Therefore, the composition of the glaze, clay body or both, will need to be reviewed and adjusted in order to remedy the problem. To improve the glaze fit, try additions of 5–15 per cent of feldspar, alkaline or high expansion materials to the recipe. You could also decrease the amount of silica (which has a low expansion rate) by 5–10 per cent to correct shivering. If you have identified the clay body as the cause, then you might need to change to a different one. For clays made following a recipe, try reducing the amount of silica by 5–10 per cent to improve the contraction rate of the clay body.

CRAWLING

Crawling is caused by high surface tension in the glaze, and is characterized by globules, beads or droplets of glaze that pull away from the surface exposing the clay body underneath. In some instances, crawling can be considered a desirable effect (*see* Chapter 8 for recipes). It typically occurs during the melting stage of the glaze material. If the molten glaze is too viscous or stiff, this inhibits the flow and overall melt of the glaze. Glazes can be prone to crawling if they are high in alumina, clay-based materials, zirconium, tin (or other opacifiers). Matt glazes are particularly susceptible to crawling because of their high alumina content. The addition of extra flux (5–10 per cent, such as borax frit) can help remedy this issue. A useful tip from experience is to add a small amount of transparent glaze to a matt glaze to improve the melt and reduce the dryness of the surface; an example quantity ratio would be 100ml of transparent glaze to 1000ml of matt glaze.

One of the main causes of crawling is dust or grease on the bisque ware which repels the glaze during the firing. Therefore, always wash your hands clean and avoid applying hand-cream or any greasy substance before you handle the ware. Wipe down the surface with a damp sponge to clean away any dust and dirt. If a bisque piece has been on the shelf for some time, it can be beneficial to re-bisque the ware to burn away surface dust. Crawling can also occur if the glaze has been applied too thickly, particularly inside the base of a pot or in tight corners. This destabilizes the tension in the glaze and can cause it to pull apart. When pouring glaze inside a vessel, the base is where the glaze resides for the longest before it is tipped out and this can

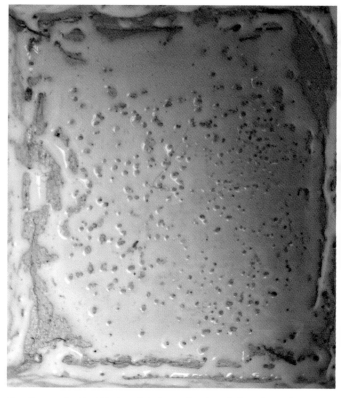

Crawling can be identified as globules or droplets of glaze that pull away and expose the clay body underneath.

cause the overall glaze application to be too thick and uneven. A useful tip to avoid this issue is to first swill a little water in the base and allow it to soak into the bisque prior to glazing. This acts as a barrier and prevents too much glaze from being absorbed in the base.

Be mindful of thick glaze application, overlaps or multiple layers of glaze. The thicker the application, the more likely it will crawl. An indication the glaze application is too thick can be seen after it has been applied to the bisque ware. The surface may resemble a dried-out river bed, with a series of cracks across the surface. Chunks of glaze might even fall off when handled. If this is the case, the best course of action is to scrape or wash off the glaze and start again, otherwise you could end up with patchy results. Avoid firing freshly glazed work, allow it to dry out thoroughly first. If the glaze is too wet, as the water content evaporates into steam it can lift and loosen the glaze away from the clay body. Thankfully, it is usually fairly straightforward to remedy a crawled glaze after it has been fired (as long as it is not too severe). The best course of action is to simply reapply glaze into the affected area and refire to settle the glaze back to a smooth, consistent layer. You

may need to repeat this action a couple of times to completely heal the fault.

PINHOLES AND PITTING

Pinholes and pitting of the glaze can appear as small holes in the glaze surface and are caused by bubbles of gas released during the firing when the glaze is in its molten state. These tiny bubbles burst through the glaze layer and leave behind a crater that does not heal over. Heavily grogged clays and viscous glazes are usually the cause of the issue, as well as poorly deflocculated casting slips, underfired bisque and the firing cycle being too short – not allowing enough time for the clay body and glaze to fully mature. It can be a difficult fault to remedy and depending on the severity, you may not fully achieve satisfactory results. However, a longer soak in the glaze (ten to fifteen minutes) can help to mature the glaze and heal over the craters. Likewise, porcelain can benefit from a longer soak of thirty minutes to one hour in the bisque to burn away organic material that remains in the body prior to being glazed. Post firing, pinholes can be filled with glaze and refired. For best results, apply the glaze to the affected areas and when it is dry, wipe away the excess with your finger or sponge so the glaze remains just in the holes.

BLOATING

Bloating can be identified as blisters or blebs that appear either between the glaze layer and clay body, or within the clay body itself. The fault is caused by trapped gases that do not escape during the firing. Underfired bisque ware is the common root of the problem because excessive carbon present in the clay body is not burnt away effectively and is then released as carbon dioxide which interferes with the maturing glaze layer. Poor preparation of the clay body in the making stage can lead to pockets of trapped air which then expand when the clay is fired, leaving an unsightly raised bump on the surface.

BLISTERS

Blisters within a glaze surface appear as rough, crater-like blemishes and can occur if the glaze has overfired or has been applied too thickly. Some materials, such as bone ash, omit gases during the firing which can interfere with the glaze melt. The solution here is to alter the glaze recipe by increasing the flux, or you can reduce the firing temperature by 10°C or more. A blistered surface can be improved by grinding off the blemishes using a sanding tool, followed by a coat of glaze and refire.

PATCHY APPLICATION AND DRIPS

The correct application of a glaze is critical in gaining a successful, blemish-free outcome. If done well, dipping and pouring techniques will generally offer consistent results. Where it can go wrong is when a piece is glazed in a rush or without due diligence and the glaze coating may show drips or uneven areas as a result. Similarly, when using a spray gun to apply glaze it is very easy to miss areas, which can lead to patchy results. It is, of course, always easier to address these issues before the piece has been fired rather than rectify afterwards. If the glaze drips down the sides or spills over when you are dipping/pouring the piece, allow the glaze to dry and use a scalpel to lightly scrape off the drip or try rubbing it down with a fingertip. A light brush or

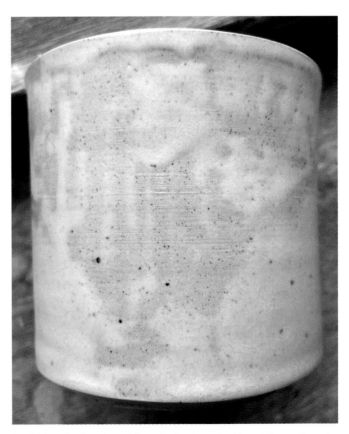

Applying a dipping glaze with a paint brush can lead to patchy results.

spray of glaze over the top will help the drip blend into the rest of the glaze. Some glazes, such as a special effect lava glaze, are more forgiving than others and will not show up the drips. In contrast, other glazes will look very unsightly and will ruin the overall success of the piece if not dealt with correctly. Always trust your judgement. If you think the piece looks badly glazed, then it might be wise to scrape or wash it off and start again rather than risk losing the piece entirely due to poor application.

Occasionally, patchy results are caused by the glaze application being too thin or watery. This can affect all glazes if too much water has been added to the glaze when it was prepared (*see* Chapter 3 for tips regarding correct glaze thickness). However, earthenware glazes that have had a high bisque are particularly susceptible because unlike the porous nature of low bisque, high bisque does not accept glaze as easily. This is true for pieces made from bone china whereby the bisque is taken to a point of vitrification (1200°C–1220°C/2192°F–2228°F) followed by a low-temperature earthenware glaze. Here, it can be beneficial to warm the bisque prior to glazing (for example, leave in a warm kiln – but avoid using a heat gun as this can risk cracking from inconsistent heat distribution). Be mindful that you need to be able to handle the work so don't heat it to the point where it is too hot. In principle, the glaze will evaporate more effectively from a warm bisque surface and soak in a thicker amount.

Post firing, patchy areas can be treated by gently warming the piece, followed by brushing over the area with more glaze and refiring. However, this does not always yield satisfactory results, and the piece might require another refire. Some useful tips to overcome this issue; it is possible to thicken glaze with a few drops of gum arabic or CMC to help adhere it to the glazed surface. Alternatively, mix your glaze with a small amount of wallpaper paste to make it sticky and easier to apply to the area. These binder materials are organic by nature and will burn out during the firing without interfering with the overall quality of the glaze. In the worst-case scenario, it is possible to remove fired glaze back to bisque with a sandblaster, but this is only suitable for earthenware or low-fired pottery where the body remains porous.

ROUGH EDGES/INCONSISTENT SURFACE

Glaze, in most cases, will cover a surface and hide a lot of sins. Stoneware glazes in particular are very forgiving and robust. However, some glazes benefit from being applied to a prepared surface in order to achieve the best results. For example, consider the edges on rims or any seams – if it feels rough to the touch when bisque, then it could become very sharp when glazed. Take time to sand away rough spots with wet and dry paper (a type of abrasive paper) and remove scratchy marks as these could show up through the glaze (glassy glazes are susceptible to showing up marks). Make sure you wash away any sandpaper residue and dry the bisque before applying the glaze.

STAINS/RUST SPOTS

Occasionally your work will have a blemish or surface fault which is hard to decipher where it came from. This could be down to a number of reasons, but a common culprit is a contaminant in the glaze, such as a rogue speck of cobalt oxide or copper oxide. Be careful when you handle raw glazed work

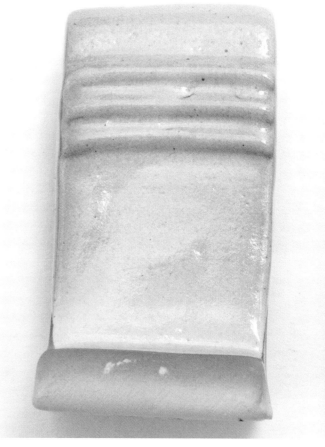

Glazes containing volatile oxides can pollute neighbouring wares. Here, a tile coated in tin glaze has absorbed the fumes from chrome oxide, resulting in a grey-green tint.

and wash your hands if you pick up another piece glazed in lots of oxides or strong colour as you may accidently transfer some of the residue in the process. Never dip or pour a piece of work coated in oxide back into the main bucket of glaze; take out what you need and glaze it separately.

If your work has debris or rust spots, this can come from the kiln itself. Some kilns over time can corrode around the burners (gas-fuelled kiln) or around the top of the kiln bung and door. This can flake off and land on the work during the firing. Other times, glaze or debris from the work itself can damage other work in the kiln. Glazes containing chrome oxide or vanadium omit vapours during the firing which can affect other oxides – such as tin oxide (*see* Chapter 2). To treat the affected areas, use a piece of abrasive sanding paper (wet and dry) or use a rotary multi tool (such as a Dremel) to remove the glaze, followed by a dab of glaze and refire.

UNDERFIRED

You can usually establish if a glaze has underfired by the surface texture appearing very dry and grainy. If the piece is decorated with underglazes, the glaze might look hazy and it is difficult to see the decoration underneath. Check for any kiln issues (faulty elements in electric kilns are usually the culprit). Refer to pyrometric cones (if used in the firing) or check your kiln controller in case it has an error code. An underfired glaze is usually simple to rectify by refiring the piece. If it is not a direct kiln issue, you might have to take the temperature higher by a few degrees to melt the glaze, or try adding a soak (*see* Chapter 4) for ten minutes to even out any cool spots in the kiln.

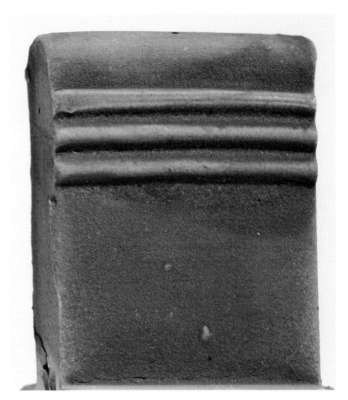

Underfired glazes usually appear dry and feel rough to the touch.

which can boil when they exceed their melt limits. In stoneware firings, an overfired glaze might appear very glassy and runny, or stick to the kiln shelf. Any surface decoration may appear blurred and distorted. Matt glazes are overfired if they look shiny. Soaking the top temperature for too long can also have this effect. If the kiln is not the cause of the overfire, reduce the top temperature by 10–20°C for future firings and hopefully this will prevent further mishaps. Occasionally, an overfire can be beneficial and bring a new quality to your work that you might have never discovered otherwise.

OVERFIRED

Earthenware glazes that have been overfired can look boiled, with glassy bubbles that spoil the surface. Unfortunately, this is very difficult to recover from as it can become worse when refired. A kiln defect might be the cause of the problem in this scenario, or the firing temperature is too high for the limits of the glaze. Again, pyrometric cones are a useful way to record a firing or refer to your kiln controller. Overfiring a glaze is more common with low-temperature/earthenware glazes with strong fluxing agents such as high alkaline frit and lead/leadless frits

LEACHING

Careful considerations about the toxicity of a glaze and its potential to leach have to be made when producing work intended for functional use. This is explained in more depth in Chapter 2. However, in the context of a glaze defect, leaching can be characterized by subtle changes in the colour and appearance of the glaze after it has been in contact with acidic or alkali bases. For this reason, avoid using glazes that contain highly toxic materials such as lead (including in its fritted form) and barium carbonate for functional wares.

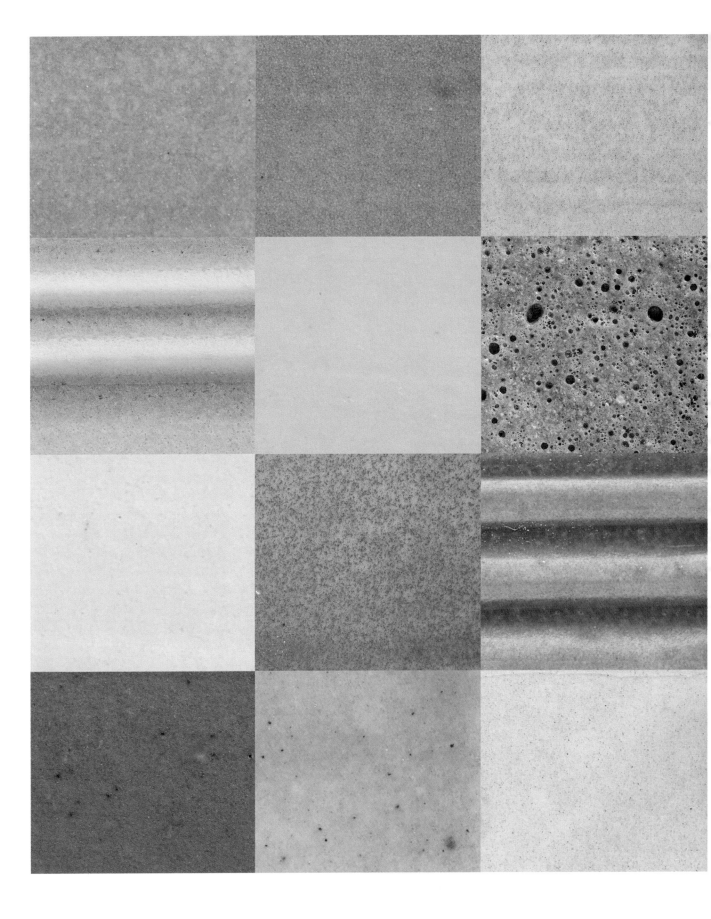

GLAZE RECIPES

This chapter offers a wide resource of appealing glaze recipes that are here to inspire and be put into application. Many are from my own glaze records that I have compiled over the years, others are handed down or researched from established ceramic artists and potters. The featured recipes span across the firing temperature ranges and are organized into sections for ease of reference, including earthenware, mid-fire and stoneware (oxidized and reduction). There are also a few extra recipes at the end of the chapter for raku, Egyptian paste and slips for wood, salt and soda glaze.

All the recipes are expressed as percentages which can be interpreted as weight – for example 100 per cent=100g. The majority of glaze recipes here list the base glaze as 100 per cent and any additions such as colouring oxides, stains or opacifiers as a separate amount. This allows for greater flexibility and opportunity to change and experiment, if you so wish. In some instances, you will see the colourants are included in the total amount of 100 per cent as this is specific to how the glaze was originally formulated by the creator.

The raw materials that were used to make the recipes are readily available from pottery suppliers, apart from local materials such as wood ash which was collected and processed at source. Materials are listed from UK suppliers, but a full list of equivalents and direct substitutes for the USA is given in the Resources section.

Finally, although every care has been taken to produce and document the glaze tests in this book, no recipe can fully guarantee replicable results. There are too many factors at play, such as the clay body, raw materials used, application of glaze, texture of surfaces, firing conditions, and so on. Therefore, make sure to test your batch first before applying to your main work and adjust or modify the recipe accordingly to suit your requirements.

IS IT FOOD SAFE?

There is much awareness around the harmful dangers of lead-based glazes and the potential to leach when exposed to acidic foodstuffs and liquids. Even lead in its fritted form can still pose a risk if the glaze is not carefully formulated. In combination with colouring oxides such as copper, this can greatly increase the solubility of the lead further. For this reason, lead glazes have been omitted from this book. Glazes containing barium carbonate also have the danger of barium release and therefore should not be used on surfaces that will come into contact with food (*see* Chapter 2 regarding substitution of barium with strontium carbonate).

Although many of the featured glazes are likely to be deemed suitable for food use, the only sure way to guarantee this is to have them certified by a ceramic testing laboratory. This is a legal requirement in many countries, especially if the item is intended for the commercial market. Details of testing labs are given in the Resource section. From a practical point of view, a well-formulated glaze fired to maturity on a suitable clay body will always offer the most hygienic surface. If in doubt, a good

◀ A selection of stoneware oxidised glazes demonstrating the broad variety of colours and effects that can be achieved in this temperature range.

tip is to apply a leadless shiny transparent or white glaze on the area that will make contact with food and keep any colourful/feature glazes to the outside. Glazes that are highly crazed, very dry/matt or have another special effect should be avoided for functional wares due to the risk of harmful bacteria that can harbour on these surfaces and potentially cause illness.

DEVELOPING GLAZES

If you find a glaze here you like and it works well for you, have a go at experimenting with colouring additions and opacifiers; you might generate a whole new glaze palette in the process. You will see that a number of base glazes featured in this chapter are repeated with different colourant additions. As this demonstrates, you don't need to have a vast array of recipes, but instead focus on a small collection of essential recipes that you can continue to develop and expand. The knock-on of this method is that you will only need to stock the key materials to make the base glaze, which is more efficient and cost-effective in the long run.

Start by taking your chosen base recipe and refer to these charts to create your own colours. There are a number of factors to consider, such as the colour response (particularly of oxides) is largely determined by the kiln atmosphere (oxidized or reduction) and the flux used in the glaze. For example, if the base contains zinc oxide (a flux), this can inhibit certain colours (chrome will turn brown), but it can promote cobalt blues and copper greens. In oxidization, copper oxide will produce a range of deep green colours, and rich turquoise-blue in low alumina, alkaline glazes. In reduction, copper oxide can achieve beautiful blood-red and purple colours.

Suggested amounts for oxidized glazes as follows:

OXIDE	AMOUNT %	COLOUR
Cobalt	1	Strong blue
Cobalt	0.5	Medium blue
Cobalt carbonate	0.25	Pale blue
Copper oxide	3	Strong green-turquoise
Copper oxide	1	Medium green-turquoise
Copper carbonate	0.5	Light green-turquoise
Black iron oxide	6	Strong brown

OXIDE	AMOUNT %	COLOUR
Black iron oxide	4	Medium brown
Red iron oxide	2	Light brown
Manganese dioxide	6	Dark brown-plum
Manganese dioxide	4	Light brown-plum
Chrome oxide	2	Green-brown-yellow
Rutile	4	Tan brown
Nickel oxide	2	Grey-brown
Vanadium pentoxide	6	Medium yellow-textured
Tin oxide	8	Bright white
Titanium dioxide	6	Cream

You can combine oxides to achieve a variety of different colours:

OXIDE	AMOUNT +	OXIDE	AMOUNT	=
Cobalt oxide	0.5	Black iron oxide	2	Grey-blue
Cobalt oxide	0.5	Manganese dioxide	5	Purple-blue
Cobalt oxide	0.5	Rutile	3	Warm blue
Cobalt oxide	2	Copper oxide	2	Blue-green
Copper oxide	2	Black iron oxide	2	Warm green
Copper oxide	3	Vanadium pentoxide	3	Yellow-green
Copper oxide	3	Rutile	2	Warm tan-green
Rutile	4	Vanadium pentoxide	5	Warm ochre
Chrome oxide	1	Black iron oxide	2	Dark green

It is also possible to combine stain and oxide additions to create unique blends:

STAIN	AMOUNT +	OXIDE	AMOUNT	=
High temperature Red	6	Cobalt carbonate	0.5	Purple
High temperature Red	6	Manganese dioxide	3	Red brown
Sun yellow	6	Copper carbonate	1	Acid yellow-lime
Sun yellow	6	Red iron oxide	1	Warm yellow
Lime green	4	Cobalt oxide	1	Blue green
Lime green	4	Manganese dioxide	2	Mottle green
Azure blue	6	Manganese dioxide	3	Deep blue-brown
Azure blue	8	Copper oxide	1	Turquoise-green
Bright orange	8	Copper carbonate	0.5	Burnt orange
Bright orange	6	Red iron oxide	1	Rust orange
Chrome tin pink	8	Cobalt carbonate	0.25	Lavender

Stains can be intermixed with each other in the following amounts:

STAIN	AMOUNT +	STAIN	AMOUNT	=
High temperature Red	3	Orange stain	3	Burnt red
High temperature Red	6	Turquoise blue	3	Warm purple
Sun yellow	4	Lime green	4	Green-yellow
Lilac	4	Crimson pink	3	Pink-purple
Persian green	3	Royal blue	3	Deep blue-green
Chrome tin pink	6	Azure blue	1	Lilac

Suggested amounts for reduction glazes as follows:

OXIDE	AMOUNT %	COLOUR
Cobalt	1	Strong blue
Cobalt	0.5	Medium blue
Cobalt carbonate	0.25	Pale blue
Copper oxide	3	Deep copper red to black
Copper oxide	1	Deep copper red
Copper oxide	0.5	Copper red
Copper carbonate	0.5	Pale pink to red
Ilmenite	3	Speckled brown
Rutile	4	Tan-opalescent
Manganese dioxide	4	Brown-plum
Nickel oxide	1	Grey-brown
Red iron oxide	12	Tenmoku rust red-brown
Red iron oxide	8–10	Tenmoku black-brown
Red iron oxide	4	Mottled green-brown
Red iron oxide	2	Dark olive celadon
Red iron oxide	1	Celadon
Red iron oxide	0.25	Pale grey-green celadon

Oxide combinations for reduction glazes:

OXIDE	AMOUNT +	OXIDE	AMOUNT	=
Cobalt oxide	0.5	Red iron oxide	2	Blue-grey
Cobalt oxide	0.5	Manganese dioxide	5	Blue-purple-brown
Cobalt oxide	0.5	Rutile	3	Warm blue
Cobalt oxide	2	Copper oxide	2	Blue-green
Cobalt carbonate	0.5	Chrome oxide	1	Turquoise-green
Cobalt carbonate	0.5	Nickel oxide	1	Grey-blue
Manganese dioxide	4	Rutile	3	Textured brown
Ilmenite	2	Rutile	2	Textured yellow-brown

Stain additions for reduction

It is possible to use stains in reduction atmosphere, although some colours will respond better than others. For example, blues, browns, greens, yellows, reds and oranges in most instances will be comparable to an oxidised firing, however shades of pinks and purples can burn out and appear faded. Refer to the manufacturer's reference sheets or website for specific guidance.

EARTHENWARE GLAZE RECIPES

1050°C−1120°C/1922°F−2048°F/Cone 05−02

Earthenware glazes offer a broad scope of vivid colours and alluring effects. The rich, shiny qualities of earthenware can enhance texture as well as any slip decoration and underglaze decoration painted underneath. All the glazes featured below were fired on a smooth white earthenware body that was high bisque to 1120°C/2048°F/cone 02. This was followed by a 1080°C/1976°F/cone 04−03 glaze firing, with a ten-minute soak. The majority of glazes featured here will fire quite comfortably between 1050°C−1100°C/1922°F−2048°F, unless specified differently. Also, note that some glazes were made using a commercial glaze powder as a base. This was Potterycrafts P2027 leadless shiny transparent glaze, but you can use an equivalent commercial version for similar effect or replace this with recipe EW1 as the base if you prefer to make your own glaze from scratch.

Neutrals

EW1: Shiny Transparent		EW2: Shiny Transparent Crackle		EW3: Satin Semi-Transparent		EW4: Pearl White Shiny	
Standard borax frit	30	Standard borate frit	80	Standard borax frit	30	Calcium borate frit	75
Calcium borate frit	30	Zirconium silicate	11	Calcium borate frit	15	Potash feldspar	15
Soda feldspar	20	Ball clay	9	Feldspar	10	Ball clay	10
China clay	10			China clay	25		
Flint	10			Zinc	12		
				Flint	8		
Notes: Good all-rounder, excellent craze resistance Add + 8% tin for Maiolica glaze		Notes: Highly crackled surface, for decorative use only					

EW5: Smooth Satin White		EW6: Smooth Matt White		EW7: Satin Matt White		EW8: Silky Matt White	
Potash feldspar	28	Nepheline syenite	78	Calcium borate frit	30	Nepheline syenite	50
Calcium borate frit	22	Barium carbonate	12	Lithium carbonate	8	Barium carbonate	21
Whiting	11	Lithium carbonate	8	Barium carbonate	23	Lithium carbonate	18
Flint	23	Bentonite	2	China clay	25	Flint	6
China clay	14			Flint	14	China clay	5
Bentonite	2						
		Notes: For decorative use only		Notes: For decorative use only		Notes: For decorative use only	

Browns and blacks

EWB1: Blue-Black Mirror

Commercial glaze	100
+	
Copper oxide	3
Cobalt oxide	2
Manganese dioxide	6
Red clay	6
China clay	5
Pitch black stain	6

Notes: Commercial glaze can be substituted for base EW1

EWB2: Black-Brown Mirror

Commercial glaze	100
+	
Manganese dioxide	8
Red iron oxide	3
Copper oxide	3
China clay	5
Pitch black stain	8

Notes: For jet black – 8% black stain only

EWB3: Black Mirror

Standard borax frit	45
Calcium borate frit	31
Whiting	8
Flint	16
+	
Cobalt oxide	3
Red iron oxide	3
Manganese dioxide	3
Pitch black stain	5

EWB4: Slate-Black Mirror

Standard borax frit	45
Calcium borate frit	31
Whiting	8
Flint	16
+	
Cobalt oxide	3
Red iron oxide	3
Manganese dioxide	3

EWB5: Bronze Shiny

Commercial glaze	100
+	
Manganese dioxide	8
Red iron oxide	3
Copper oxide	3
China clay	5

EWB6: Rust Brown-Green Dry Matt (Bath Spa recipe)

Nepheline syenite	78
Barium carbonate	12
Lithium carbonate	8
Bentonite	2
+	
Red iron oxide	6
Copper oxide	0.25

Notes: For decorative use only

EWB7: Rust Dry Matt

Nepheline syenite	78
Barium carbonate	12
Lithium carbonate	8
Bentonite	2
+	
Red iron oxide	6

Notes: For decorative use only

EWB8: Honey Brown Glossy

Commercial glaze	100
+	
Red iron oxide	6

Notes: Good alternative to lead-based honey glaze to enhance colours of decorative slips underneath

Yellows, oranges and reds

EWY1: Bright Yellow Shiny

Standard borax frit	30
Calcium borate frit	30
Soda feldspar	20
China clay	10
Flint	10
+	
Sun yellow stain	8

EWY2: Pale Yellow Shiny

Calcium borate frit	75
Potash feldspar	15
Ball clay	10
+	
Sun yellow stain	6

Notes: Add 0.25% copper oxide to make acid yellow green colour

EWY3: Dry Matt Yellow

Nepheline syenite	45
Barium carbonate	17
Lithium carbonate	3
Whiting	14
Flint	16
Zinc	5
+	
Sun yellow stain	8

Notes: For decorative use only

EWY4: White-Yellow Satin Matt

Nepheline syenite	50
Barium carbonate	21
Lithium carbonate	18
Flint	6
China clay	5
+	
Sun yellow stain	6

Notes: For decorative use only

EWY5: Shiny Red

Standard borax frit	30
Calcium borate frit	30
Soda feldspar	20
China clay	10
Flint	10
+	
High temperature red stain	6

EWY6: Shiny Orange

Calcium borate frit	75
Potash feldspar	15
Ball clay	10
+	
Orange stain	6

EWY7: Burnt Orange Shiny

Calcium borate frit	75
Potash feldspar	15
Ball clay	10
+	
Orange stain	6
Copper oxide	0.25

EWY8: Pale Brown-Orange

Commercial glaze	100
+	
Rutile	3

Greens and turquoise

EWG1: Antique Green (Emmanuel Copper)

Standard borax frit	80
Zinc oxide	10
Ball clay	10
+	
Zirconium silicate	10
Ilmenite	10
Copper carbonate	5

Notes: Will create a matt green glaze at 1040°C/1904°F/cone 05

EWG2: Chrome Green Shiny

High alkaline frit	75
Whiting	5
China clay	10
Flint	10
+	
Chrome oxide	1.5

Notes: For decorative use only

EWG3: Matt Acid Yellow

Nepheline syenite	45
Barium carbonate	17
Lithium carbonate	3
Whiting	14
Flint	16
Zinc	5
+	
Sun yellow	6
Copper oxide	0.5

Notes: For decorative use only

EWG4: Textured Green Brown Matt

Nepheline syenite	78
Barium carbonate	12
Lithium carbonate	8
Bentonite	2
+	
Chrome oxide	0.75

Notes: For decorative use only

EWG5: Shiny Turquoise Blue

Standard borax frit	30
Calcium borate frit	30
Soda feldspar	20
China clay	10
Flint	10
+	
Copper oxide	1.5

EWG6: Crackle Turquoise Blue

Standard borax frit	45
Calcium borax frit	25
Cornish stone	20
China clay	10
+	
Copper oxide	0.75

EWG7: Pale Blue Shiny

Calcium borate frit	75
Potash feldspar	15
Ball clay	10
+	
Copper oxide	0.75

EWG8: Mottled Turquoise Matt

Nepheline syenite	78
Barium carbonate	12
Lithium carbonate	8
Bentonite	2
+	
Copper oxide	1.5

Notes: For decorative use only

Blues and purples

EWP1: Royal Blue Shiny

High alkaline frit	85
Whiting	5
China clay	10
+	
Copper carbonate	2

Notes: Highly crackled surface, for decorative use only. Quite runny

EWP2: Matt Blue-Green

Nepheline syenite	50
Barium carbonate	21
Lithium carbonate	18
Flint	6
China clay	5
+	
Copper oxide	0.5
Cobalt oxide	0.5

Notes: For decorative use only

EWP3: Creamy Turquoise Green-Blue

Standard borax frit	42
Calcium borate frit	22
Whiting	7
Potash feldspar	20
Bentonite	5
Flint	4
+	
Copper oxide	3
Cobalt oxide	0.5

EWP4: Deep Navy Black

Commercial glaze	100
+	
Copper oxide	3
Cobalt oxide	2
Manganese dioxide	6
Red clay	6
China clay	5

EWP5: Rich Purple Shiny

High alkaline frit	85
Whiting	5
China clay	10
+	
Cobalt oxide	0.5
Manganese dioxide	3

EWP6: Matt Violet

Potash feldspar	38
Barium carbonate	30
Lithium carbonate	2
Zinc oxide	6
Whiting	8
Flint	16
+	
Nickel	2

Notes: Firing range up to 1120°C/2048°F/cone 02. For decorative use only

EWP7: Violet Shiny

Standard borax frit	30
Calcium borate frit	30
Soda feldspar	20
China clay	10
Flint	10
+	
High temperature red stain	8
Cobalt oxide	1

EWP8: Parma Violet

Calcium borate frit	75
Potash feldspar	15
Ball clay	10
+	
Lilac stain	6

Pastels

Commercial stains combined with a tin-glaze base will give you the best colour response when producing pastel colours, but you could try swapping the main colourant with cobalt carbonate in 0.25 per cent for a light blue colour, or copper carbonate in 0.25 per cent for a light green colour.

EWPA1: Pastel Yellow		**EWPA2: Pastel Green/Blue**		**EWPA3:**		**EWPA4: Pastel Turquoise**	
EW1 base +		EW1 base +		EW1 base +		EW1 base +	
Tin oxide	8	Tin oxide	8	Tin oxide	8	Tin oxide	8
Sun yellow stain	6	Bramley green stain	6	Chrome pink stain	6	Turquoise stain	6

MID-FIRE GLAZES

1200°C–1220°C/2192°F–2228°F/Cone 5–6

Mid-temperature firing glazes are becoming increasingly popular because they offer the bright, colourful tones of earthenware glazes combined with the hardy properties of stoneware. The tiles used here are made from porcelain and smooth white stoneware clay. They were low bisque to 1000°C/1832°F/cone 06, followed by a 1220°C/2228°F/cone 6 firing and ten-minute soak. The glazes fit both bodies very comfortably and have good craze resistance. Here are some recipes to get you started – experiment with the proportions of oxides and stains to broaden your palette further.

Neutrals

MF1: Transparent Shiny		MF2: Transparent Shiny		MF3: Transparent Shiny	
Nepheline syenite	55	Nepheline syenite	40	Cornish stone	30
Whiting	15	Calcium borate frit	15	Calcium borate frit	33
Flint	10	Whiting	15	Whiting	12
Dolomite	15	China clay	10	China clay	10
China clay	5	Silica	20	Silica	15
Notes: Example on porcelain		Notes: Example on porcelain		Notes: Example on porcelain	

MF4: White Tin Glaze (Adapted from Emmanuel Cooper base recipe)		MF5: Cream Satin		MF6: Dry Matt White	
Potash feldspar	40	Nepheline syenite	35	Nepheline syenite	60
Cornish stone	13	Talc	40	Barium carbonate	25
Whiting	23	Petalite	15	China clay	10
Zinc oxide	7	Whiting	5	Flint	5
Ball clay	10	China clay	5		
China clay	7				
+					
Tin oxide	8				
Notes: Suitable for on-glaze decoration/Maiolica				Notes: Best results fire to 1220°C/2228°F/ cone 6 with fifteen-minute soak. Decorative use only. Example on porcelain	

Blacks, browns, grey

MFB1: Jet Black Shiny
(Emmanuel Cooper base recipe)

Potash feldspar	40
Calcium borate frit	35
Ball clay	15
Flint	10
+	
Black stain	6
Cobalt oxide	1

MFB2: Mottled Antique Brown
(Emmanuel Cooper base recipe)

Potash feldspar	40
Calcium borate frit	35
Ball clay	15
Flint	10
+	
Copper oxide	3
Cobalt oxide	1
Vanadium pentoxide	6

Notes: Decorative use only

MFB3: Dry Grey

Nepheline syenite	60
Barium carbonate	25
China clay	10
Flint	5
+	
Nickel oxide	2

Notes: Best results fire to 1220°C/
Cone 6 with fifteen-minute soak.
Decorative use only

MFB4: Iridescent Brown

Nepheline syenite	40
Calcium borate frit	15
Whiting	15
China clay	10
Silica	20
+	
Rutile	6
Red iron oxide	3

Notes: Remove iron oxide for lighter
colour. Example on porcelain

MFB5: Warm Honey Brown

Nepheline syenite	30
Borax frit	35
Calcium borate frit	20
Whiting	5
China clay	5
Talc	5
+	
Red iron oxide	6
Manganese dioxide	4

Notes: A little runny, do not apply too
thick. Best results fire to 1200°C/2192°F/
cone 5. Example on porcelain

MFB6: Mottled Blue-Brown Semi-Matt
(Emmanuel Cooper base recipe)

Potash feldspar	40
Cornish stone	13
Whiting	23
Zinc oxide	7
Ball clay	10
China clay	7
+	
Copper oxide	2
Cobalt oxide	2
Vanadium pentoxide	4

Notes: Pitted texture, very similar to
salt-glaze effect. Decorative use only.
Example on porcelain

Yellows, oranges and reds

MFY1: Cool Yellow Satin

Nepheline syenite	55
Whiting	15
Flint	10
Dolomite	15
China clay	5
+	
Sun yellow stain	8

MFY2: Butter Yellow Smooth Satin (MF7)

Nepheline syenite	35
Talc	40
Petalite	15
Whiting	5
China clay	5
+	
Sun yellow stain	6

Notes: Example on porcelain

MFY3: Speckle Yellow Satin

Nepheline syenite	35
Talc	40
Petalite	15
Whiting	5
China clay	5
+	
Sun yellow stain	6
Manganese dioxide	3

Notes: Example on porcelain

MFY4: Red Orange Blush Shiny

Nepheline syenite	30
Borax frit	35
Calcium borate frit	20
Whiting	5
China clay	5
Talc	5
+	
High temperature red stain	4
Orange stain	6

Notes: Example on porcelain

MFY5: Pale Red Shiny

Cornish stone	30
Calcium borate frit	33
Whiting	12
China clay	10
Silica	15
+	
High temperature red stain	8

Notes: Example on porcelain

MFY6: Iridescent Peach Shiny

Nepheline syenite	40
Calcium borate frit	15
Whiting	15
China clay	10
Silica	20
+	
Rutile	6

Notes: Apply over the top of other glazes for Chun-like effects. Example on porcelain

Greens

MFG1: Copper Green Shiny
(Emmanuel Cooper base recipe)

Potash feldspar	40
Calcium borate frit	35
Ball clay	15
Flint	10
+	
Copper oxide	3

MFG2: Dry Rust-Green

Nepheline syenite	60
Barium carbonate	25
China clay	10
Flint	5
+	
Copper oxide	2
Vanadium pentoxide	6

Notes: Decorative use only. Example on porcelain

MFG3: Pale Green Shiny

Nepheline syenite	30
Whiting	12
Calcium borate frit	33
Flint	15
China clay	8
+	
Lime green stain	6

Notes: Swap the stain for 0.25 copper carbonate for similar colour. Example on porcelain

MFG4: Metallic Copper Satin

Nepheline syenite	55
Whiting	15
Flint	10
Dolomite	15
China clay	5
+	
Sun yellow stain	8
Copper oxide	3

Notes: Example on porcelain

MFG5: Pale Blue-Green Shiny

Nepheline syenite	30
Calcium borate frit	33
Whiting	12
Flint	15
China clay	10
+	
Lime green stain	6
Copper carbonate	1

Notes: Example on porcelain

MFG6: Warm Yellow-Green Shiny

Nepheline syenite	40
Calcium borate frit	15
Whiting	15
China clay	10
Silica	20
+	
Chrome oxide	0.5

Notes: Decorative use only

Blues and turquoise

MFBT1: Royal Blue Shiny
(Emmanuel Cooper base recipe)

Feldspar	40
Cornish stone	13
Whiting	23
Zinc oxide	7
Ball clay	10
China clay	7
+	
Cobalt oxide	1.5

Notes: Example on porcelain

MFBT2: Powder Blue Shiny

Cornish stone	30
Calcium borate frit	33
Whiting	12
Flint	15
China clay	10
+	
Tin oxide	8
Azure blue stain	6

MFBT3: Dry Navy Blue

Nepheline syenite	60
Barium carbonate	25
China clay	10
Flint	5
+	
Nickel oxide	2
Cobalt oxide	0.5

Notes: Best results fire to 1220°C/ Cone 6 with fifteen-minute soak. Decorative use only

MFBT4: Mottled Turquoise Satin-Matt

Nepheline syenite	78
Barium carbonate	12
Lithium carbonate	8
Bentonite	2
+	
Copper oxide	1.5
Vanadium pentoxide	3

Notes: Thicker application (3mm) will give a stronger colour. Best results fire to 1220°C/2228°F/cone 5–6 with fifteen-minute soak. Decorative use only

MFBT5: Deep Turquoise Satin

Cornish stone	30
Calcium borate frit	33
Whiting	12
China clay	10
Flint	15
+	
Turquoise stain	6
Cobalt oxide	0.5

Notes: Example on porcelain

MFBT6: Turquoise Satin-Matt

Nepheline syenite	60
Barium carbonate	25
China clay	10
Flint	5
+	
Copper oxide	2

Notes: Best results fire to 1220°C/2228°F/ cone 5–6 with fifteen-minute soak. Decorative use only. Example on porcelain

Purples and pinks

MFP1: Deep Blue-Purple Shiny (Emmanuel Cooper base recipe)		MFP2: Violet Shiny		MF3: Rose Pink Shiny	
Feldspar	40	Cornish stone	30	Nepheline syenite	30
Cornish stone	13	Calcium borate frit	33	Calcium borate frit	33
Whiting	23	Whiting	12	Whiting	12
Zinc oxide	7	China clay	10	Flint	15
Ball clay	10	Flint	15	China clay	10
China clay	7	+		+	
+		High temperature		Tin oxide	6
Cobalt oxide	1.5	red stain	8	Chrome tin pink stain	8
Manganese dioxide	4	Cobalt oxide	0.5		
Notes: Example on porcelain		Notes: Example on porcelain		Notes: Example on porcelain	

CRAWL GLAZES

If you apply any glaze too thick, there is a good chance it will crawl – whereby the glaze pulls back into bead-like globules and exposes the clay body underneath. This is usually caused by high surface tension in the glaze and regarded as a defect. However, crawl glazes are specifically formulated to accentuate this quality even further as an attractive feature and are sometimes referred to as 'brain crawl' glaze because of the uncanny resemblance. Crawl glazes contain light, fluffy materials such as magnesium carbonate or zinc oxide because these materials shrink upon drying, causing a web of cracks within the surface which widen during the firing. Crawl glazes can take a little practice to get right. Firstly, you need to apply them very thick – at least 5mm–75mm, equivalent to three or four layers of glaze. You should be able to see cracks in the dry glaze before firing as this is a good indication the glaze will crawl in the firing. Optimum firing range for the examples below is between 1200°C–1220°C/2192°F–2228°F/cone 5–6. If fired too high, the crawl effect can melt and lose definition.

Crawl Glaze Base Recipe		MFCG1: Pastel Yellow Crawl		MFCG2: Blue Crawl	
Nepheline syenite	60	Base		Base	
Magnesium Carbonate light	25	+		+	
Ball clay	10	Sun yellow stain	6	Cobalt oxide stain	1
Zirconium silicate	5				
		Notes: Best results 1220°C/2228°F/cone 6			

MFCG4: Matt Crawl Glaze		MFCG5: Matt Crawl Glaze Turquoise		MFCG6: Very Dry Crawl Glaze	
Nepheline Syenite	45	Soda Feldspar	45	Soda Feldspar	28
Magnesium Carbonate light	35	Magnesium Carbonate light	35	Magnesium Carbonate light	37
Borax Frit	10	Borax Frit	10	China clay	20
Whiting	10	Whiting	10	Talc	10
		+		Zinc	5
		Copper Carbonate	1	+	
				Cobalt Oxide	1
Notes: Excellent base for colour additions. Example on red clay body		Notes: Example on red clay body		Notes: Example on red clay body	

METALLIC GLAZES

Metallic glaze colours range from seductive golds, bronzes and graphite-black. They are usually quite dry-matt to the touch and notoriously runny. This is due to the fluxing effect of the oxides – particularly manganese dioxide, which requires a large amount in the recipe to produce the gold/bronze tones. Therefore, make sure to protect your kiln shelves and wipe away glaze from near the base to allow for the extra flow as the glaze melts. Most metallic glazes will tolerate a higher temperature up to 1260°C/2300°F/cone 8, but for best results, and less running, aim to keep within the confines of mid-temperature 1200–1220°C/2192°F–2228°F/cone 5–6. Metallic glazes can omit toxic fumes during the firing due to the high oxide content, so make sure the room is well-ventilated and only use this type of glaze for decorative purposes.

MFM1: Gold Metallic

Manganese dioxide	60
Red clay powder	20
China clay	10
Copper oxide	10

MFM2: Bronze Metallic

Red clay powder	60
Standard borax frit	30
Quartz	5
Ball clay	5
+	
Manganese dioxide	50
Cobalt carbonate	5
Copper carbonate	5

MFM3: Bronze-Black Metallic

Manganese dioxide	80
Ball clay	20
+	
Copper oxide	20

STONEWARE OXIDIZED GLAZES

1240°C–1280°C/2264°F–2336°F/Cone 6–9

Stoneware glazes are incredibly versatile and can produce a wide range of distinctive colours and unique surface qualities. This section is divided into oxidized and reduction glaze recipes, although many oxidized recipes will tolerate reduction atmosphere and vice versa. If you have access to a selection of different kiln types such as at a college or educational course, a useful exercise is to put a batch of tests in oxidization and another in reduction and compare the results afterwards. The difference between some glazes will be marginal, whereas for others it could be quite dramatic – particularly if the recipe contains colouring oxides.

The test tiles used here were made from White St Thomas – a medium-grogged stoneware body, as well as some smooth stoneware and porcelain tiles. A selection of different clay bodies was used to illustrate how the body can impact the colour and texture of the glaze to gain the best attributes. The oxidized glazes were fired in an electric kiln to 1280°C/2336°F/ cone 9 with a ten-minute soak, unless specified differently. Most will fire comfortably from 1260°C/2300°F onwards.

Neutrals

SW1: Shiny Transparent		SW2: Shiny Transparent		SW3: Shiny Semi-Transparent (Emmanuel Cooper)	
Cornish stone	70	Soda feldspar	45	Nepheline syenite	25
Whiting	20	Whiting	20	Whiting	15
China clay	10	Quartz	15	Zinc oxide	15
		Calcium borate frit	10	Flint	30
		Ball clay	5	China clay	15
		China clay	5		
Notes: Excellent glaze for colour and stain additions		Notes: Good, reliable glaze		Notes: Slightly milky when applied thick	

SW4: Shiny Semi-Transparent		SW5: Bright White Satin		SW6: Satin Matt White	
Soda feldspar	45	Potash feldspar	75	Nepheline syenite	40
Flint	25	Zinc oxide	13	Whiting	25
Whiting	10	Ball clay	12	China clay	20
Wollastonite	8	Notes: Firing range from 1260°C/2300°F onwards		Flint	10
China clay	12			Bone ash	5

SW7: Smooth Satin White

Potash feldspar	38
Cornish stone	18
Whiting	18
China clay	18
Zinc oxide	8

SW8: Satin Iridescent White

Cornish stone	50
China clay	20
Dolomite	20
Quartz	5
Whiting	5

Notes: Excellent on porcelain

Base glazes for porcelain

SW9: Smooth Transparent
(Frank & Janet Hamer)

Potash feldspar	30
Whiting	25
Flint	25
China clay	20

Notes: Suitable for oxidized and reduction firing

SW10: Shiny Transparent

Cornish stone	40
Flint	25
Whiting	15
China clay	15
Borax frit	5

SW11: Satin Matt

Potash feldspar	38
Cornish stone	18
Whiting	18
Zinc oxide	8
China clay	18

SW12: Matt-Dry White

Cornish stone	40
Quartz	25
Whiting	15
China clay	10
Talc	10

Blacks and browns

SWB1: Shiny Black

Potash feldspar	35
Flint	30
Whiting	20
China clay	15
+	
Pitch black stain	8

SWB2: Oil Shiny Black

Cornish stone	65
Wollastonite	15
China clay	15
Talc	5
+	
Red iron oxide	4
Cobalt carbonate	1

SWB3: Mottled Matt Black

Nepheline syenite	48
Whiting	20
China clay	20
Talc	12
+	
Nickel oxide	2
Copper oxide	1.5

SWB4: Purple Black Matt

Potash feldspar	50
Whiting	18
Wollastonite	8
China clay	16
Talc	8
+	
Copper oxide.	2
Manganese dioxide	3

Notes: Shiny on smooth clay body such as porcelain

SWB5: Iron-Phosphorus Orange-Red

Potash feldspar	41
Talc	9
Bone ash	13
Lithium carbonate	2
Ball clay	13
Flint	13
Red iron oxide	9

Notes: Fire to 1240°C–2264°F/cone 6 for best results

SWB6: Toffee Brown Shiny
(Frank & Janet Hamer base)

Potash feldspar	30
China clay	20
Flint	25
Whiting	25
+	
Red iron oxide	6

Notes: Example on porcelain. Additions of 2–8% red iron oxide will produce light to dark brown

SWB7: Textured Matt Brown

Potash feldspar	50
Whiting	30
China clay	20
+	
Red iron oxide	3

SWB8: Mottled Pink-Brown

Potash feldspar	50
Whiting	30
China clay	20
+	
Red iron oxide	3
Rutile	8

Yellows, oranges and reds

SWY1: Straw Yellow, Shiny
(Lucie Rie base recipe)

Potash feldspar	64
Dolomite	13
Whiting	13
China clay	10
+	
Sun yellow stain	3
Black iron oxide	0.5

Notes: Example on porcelain

SWY2: Glassy Pale Yellow

Potash feldspar	50
Whiting	15
Wollastonite	10
China clay	15
Talc	10
+	
Sun yellow stain	4

Notes: Example on porcelain. Try 1.5% red iron oxide for similar colour

SWY3: Dry Matt Yellow-White

Cornish stone	40
Quartz	25
Whiting	15
China clay	10
Talc	10
+	
Sun yellow stain	6

SWY4: Pale Yellow, Frothy Matt

Soda feldspar	20
Nepheline syenite	25
Magnesium carbonate	35
Calcium borate frit	10
Whiting	10

Notes: Fire to 1260°C/2300°F/cone 8. Can be used as a crawl glaze when applied thickly

SWY5: Bright Satin Yellow

Cornish stone	50
China clay	20
Dolomite	20
Quartz	5
Whiting	5
+	
Sun yellow stain	6

Notes: Example on porcelain

SWY6: Antique Yellow Satin

Cornish stone	50
China clay	20
Dolomite	20
Quartz	5
Whiting	5
+	
Sun yellow stain	6
Red iron oxide	0.5

Notes: Example on smooth white stoneware body

SWY7: Bright Orange Shiny

Potash feldspar	35
Flint	30
Whiting	20
China clay	15
+	
Orange stain	8

Notes: For brown-orange, add 0.5% red iron oxide

SWY8: Satin Red

Cornish stone	70
Whiting	20
China clay	10
+	
High temperature red stain	6

Notes: Example on porcelain

Greens

SWG1: Warm Green Satin

Cornish stone	41
Flint	27
China clay	16
Whiting	11
Dolomite	5
+	
Zinc	1.5
Copper oxide	0.5

Notes: Example on porcelain

SWG2: Shiny Pale Green

Soda feldspar	45
Whiting	20
Quartz	15
Calcium borate frit	10
Ball clay	5
China clay	5
+	
Bramble green stain	8
Red iron oxide	1

Notes: Try substituting stain for 0.5% copper carbonate

SWG3: Matt Pale Green

Cornish stone	40
Quartz	25
Whiting	15
China clay	10
Talc	10
+	
Bramble green stain	6

Notes: Substitute the stain for 0.25% copper carbonate for similar effect

SWG4: Textured Lime Green Matt

Soda feldspar	20
Nepheline syenite	25
Magnesium carbonate	35
Calcium borate frit	10
Whiting	10
+	
Copper oxide	1

SWG5: Lime Green Satin
(Leach 4321 base)

Potash feldspar	40
Flint	30
Whiting	20
China clay	10
+	
Yellow stain	8
Copper oxide	1

Notes: Alternatively, add 8% lime green stain

SWG6: Metallic Black-Green

Potash feldspar	50
Whiting	30
China clay	20
+	
Red iron oxide	3
Copper carbonate	3

SWG7: Glossy Green-Brown	**SWG8: Oily Green**
(Leach 4321 base)	(Frank & Janet Hamer base)

SWG7		SWG8	
Potash feldspar	40	Potash feldspar	30
Flint	30	China clay	20
Whiting	20	Flint	25
China clay	10	Whiting	25
+		+	
Copper carbonate	2	Red iron oxide	6
		Copper oxide	0.25

Notes (SWG8): Example on porcelain. Swap copper for 0.25% cobalt carbonate to create blue-brown colour

Notes (SWG7): Example on porcelain. Produces textured matt glaze on a grogged body

Blues and turquoise

SWBT1: Deep Turquoise-Green Shiny	**SWBT2: Mottled Blue-Green Shiny**	**SWBT3: Matt Blue-Green**

SWBT1		SWBT2		SWBT3	
Cornish stone	50	Cornish stone	65	Nepheline syenite	40
China clay	20	Wollastonite	15	Whiting	25
Dolomite	20	China clay	15	China clay	20
Quartz	5	Talc	5	Flint	10
Whiting	5			Bone ash	5
+		+		+	
Azure blue stain	6	Titanium dioxide	6	Turquoise green stain	6
Cobalt carbonate	0.5	Cobalt carbonate	1		

Notes (SWBT3): Swap stain for 0.5% copper carbonate and 0.5% cobalt carbonate for similar colour

Notes (SWBT1): Example on smooth white stoneware body

SWBT4: Mottled Texture Matt Turquoise

Nepheline syenite	78
Barium carbonate	12
Lithium carbonate	8
Bentonite	2
+	
Copper oxide	1.5
Vanadium pentoxide	3

Notes: Requires a thicker application (2–3mm) to achieve colour. Decorative use only. Example on grogged stoneware

SWBT5: Aqua Blue Shiny

Potash feldspar	40
Flint	30
Whiting	20
China clay	10
+	
Azure blue stain	8

Notes: Example on smooth white stoneware body

SWBT6: Powder Blue Satin

Nepheline syenite	42
Whiting	25
Flint	18
China clay	15
+	
Azure blue stain	6
Zirconium silicate	6

Notes: Example on smooth white stoneware body

SWBT7: Powder Blue-Green Speckled

Potash feldspar	47
Ball clay	25
Whiting	18
Petalite	10
+	
Titanium dioxide	8
Cobalt carbonate	0.5

Notes: add 0.25% copper carbonate for stronger green-blue colour

SWBT8: Creamy Blue Shiny

Potash feldspar	56
Flint	22
Whiting	12
Petalite	10
+	
Titanium dioxide	4
Cobalt carbonate	0.5

SWBT9: Royal Blue Shiny

Cornish stone	45
Wollastonite	20
Whiting	15
China clay	10
Petalite	5
Borax frit	5
+	
Cobalt oxide	2

Notes: Example on smooth white stoneware body

SWBT10: Glossy Blue

Cornish stone	70
Whiting	20
China clay	10
+	
Cobalt carbonate	1

SWBT11: Pale Blue Matt

Soda feldspar	70
China clay	10
Whiting	15
Flint	5
+	
Tin oxide	8
Cobalt carbonate	1.5

SWBT12: Mottled Yellow-Blue

Soda feldspar	55
Whiting	20
China clay	15
Flint	5
Talc	5
+	
Cobalt oxide	1.5
Vanadium pentoxide	4

Purples and pinks

SWP1: Blue-Purple Shiny

Cornish stone	70
Whiting	20
China clay	10
+	
High temperature red stain	6
Cobalt carbonate	1

Notes: Example on porcelain

SWP2: Violet Shiny
(Frank & Janet Hamer base)

Potash feldspar	30
China clay	20
Flint	25
Whiting	25
+	
High temperature red stain	6
Cobalt carbonate	0.5

Notes: Excellent on porcelain

SWP3: Rich Purple Shiny

Soda feldspar	45
Whiting	20
Quartz	15
Calcium borate frit	10
Ball clay	5
China clay	5
+	
High temperature red stain	8
Cobalt carbonate	0.5

SWP4: Purple Haze Matt

Potash feldspar	50
Whiting	10
Barium carbonate	13
Talc	17
Flint	5
Zinc oxide	5
+	
Cobalt carbonate	3

Notes: Decorative use only

SWP5: Pink Blush Matt

Cornish stone	40
Quartz	25
Whiting	15
China clay	10
Talc	10
+	
Chrome pink stain	6

Notes: Example on porcelain

SWP6: Opalescent Chun For Oxidization (Greg Daly)

Nepheline syenite	38
Whiting	9
Barium carbonate	9
Borax frit	9
Flint	30
China clay	5
+	
Rutile	8

Notes: Apply over the top of blue or purple glazes for iridescent effects

SWP7: Mottled Powder Pink Matt

Potash feldspar	50
Whiting	30
China Clay	20
+	
Rutile	8

SWP8: Speckled Green-Pink Matt

Nepheline syenite	42
Whiting	25
Flint	18
China clay	15
+	
Chrome oxide	0.5
Rutile	4

Notes: Decorative use only

OIL SPOT

Oil-spot glazes are attractive, iron-rich glazes typically containing around 5–8 per cent red iron oxide. They originate from China and are essentially an oxidized tenmoku glaze, characterized by silvery spots within the surface of deep brown-black glaze. In brief, the unique spotting effect occurs when bubbles of oxygen gas are released from iron oxide as it decomposes at high temperatures, and pulls spots of iron to the surface with it.

These bubbles then smooth over and form a mottled, lustrous texture within the glaze. Oil-spot glazes require quite a thick application (around 3–5mm) and high-fire in oxidization to 1280°C/2336°F/cone 9–10. Oil-spot glazes can be enhanced further with the addition of a covering glaze – usually a white opaque glaze (or you can add oxides for further colour variation), which is applied over the top of the oil-spot layer and then fired together. As the pits and spots form, the covering glaze fills the voids – resulting in beautiful, variegated surfaces.

SWOS1: Candace Black Oil Spot Satin Matt (John Britt)		SWOS1 + Cover Glaze 1 (John Britt)		SWOS1+ Cover Glaze 2	
Potash feldspar	65	Nepheline syenite	13	Nepheline syenite	13
Flint	20	Flint	24	Flint	24
Dolomite	5	Whiting	9	Whiting	9
China clay	5	Dolomite	11	Dolomite	11
Whiting	5	Borax frit	32	Borax frit	32
+		Bone ash	11	Bone ash	11
Red iron oxide	8			+	
Cobalt carb	5			Copper oxide	1.5

SWOS1 + Cover Glaze 3 (Stephen Murfitt)	**SWOS1 + Cover Glaze 4** Opalescent Chun for oxidization (Greg Daly)	**SWOS2: Brown-Black Oil Spot**

Potash feldspar	60	Nepheline syenite	38	Potash feldspar	63
Dolomite	20	Whiting	9	Red clay powder	24
Quartz	15	Barium carbonate	9	Talc	6
China clay	5	Borax frit	9	Bone ash	2
+		Silica	30	Red iron oxide	5
Rutile	3	China clay	5		
		+			
		Rutile	8		

SWOS2+ Cover Glaze 1	**SWOS2+ Cover Glaze 2**	**SWOS2+ Cover Glaze 1 & Cover Glaze 3**
		Notes: Cover glaze 1 applied on left corner. Cover glaze 3 applied on right corner

SWOS2 + Cover Glaze 4		

CRATER GLAZES

Characterized by large, frothy bubbles and pitted surfaces, crater glazes, also known as lava or volcanic glazes, are highly distinctive and tactile. Silicon carbide is the key ingredient in the glaze and works by emitting carbon dioxide bubbles of gas that pop and burst through the molten glaze, resulting in large, erupted blisters and craters in the surface that do not heal over. It is particularly effective in matt glazes containing barium or strontium carbonate and only requires a small amount of 0.5–2 per cent to generate the bubbles. Amounts of 3–5 per cent will exaggerate the effect further, but tinge the glaze grey. The addition of titanium dioxide in the glaze will also react well with the silicon carbide, creating large craters as a result. Silicon carbide can cause localized reduction in the glaze and with the addition of copper (but no titanium), the glaze becomes turquoise-red (see glaze SWL7). Crater glazes are extremely volatile and will completely cover a surface and any decoration or textures underneath. Application is important too – if the glaze is thin (1–2mm), the bubbles tend to be small and quite foamy, and if applied thickly (3–5mm) the effect is more dramatic with large blisters and froth. Another tip is to lightly sand away the surface of the glaze after firing to reveal even more bubbles inside. The optimum firing range is 1260°C–1280°C/2330°F–2336°F/cone 8–9 – these examples were fired to 1280°C/2336°F/cone 9.

SWL1: White Crater		SWL2: Blue Crater		SWL3: Green-Brown Crater	
Potash feldspar	50	Potash feldspar	50	Potash feldspar	50
Whiting	25	Whiting	25	Whiting	25
China clay	13	China clay	13	China clay	13
Flint	12	Flint	12	Flint	12
+		+		+	
Titanium dioxide	8	Titanium dioxide	8	Titanium dioxide	8
Silicon carbide	3	Silicon carbide	3	Silicon carbide	3
		Azure blue stain	8	Copper oxide	1.5
		Notes: Swap stain for 1% cobalt oxide for dark blue			

SWL4: Yellow-Brown Crater

Potash feldspar	50
Whiting	25
China clay	13
Flint	12
+	
Titanium dioxide	8
Silicon carbide (fine)	3
Rutile	4

SWL5: Grey Crater
(Adapted from original recipe by Aki Moriuchi)

Nepheline syenite	60
Barium carbonate	18
China clay	10
Flint	12
+	
Silicon carbide (fine)	4

SWL6: Yellow-Grey Crater
(Aki Moriuchi base recipe)

Nepheline syenite	60
Barium carbonate	18
China clay	10
Flint	12
+	
Silicon carbide (fine)	4
Yellow stain	8

SWL7: Turquoise-Red Crater
(Aki Moriuchi base recipe)

Nepheline syenite	60
Barium carbonate	18
China clay	10
Flint	12
+	
Silicon carbide (fine)	4
Copper oxide	1.5

SWL8: Pink Foamy Crater

Potash feldspar	60
Whiting	20
China clay	10
Quartz	10
+	
Titanium dioxide	9
Silicon carbide (coarse)	3
Red stain	8

Notes: Small, frothy bubbles

SWL9: Soft Crater Glaze

Nepheline Syenite	58
Barium Carbonate	12
Whiting	8
Flint	12
China Clay	10
+	
Titanium Dioxide	8
Silicon carbide (fine)	3

Notes: Excellent base for oxides and stain additions.

CRYSTALLINE GLAZES

Crystal formation occurs in many glazes during cooling and solidification and is referred to as microcrystalline – whereby the crystals are so incredibly small to the point of being microscopic – compared to the other extreme of large crystal formation, known as macrocrystalline which are big enough to see by eye. Crystalline glazes are specifically formatted to achieve the large macro crystals. They are some of the most beautiful, yet elusive, of all glazes and require very careful and precise conditions in order to develop successful crystal growth.

The most important element starts with the recipe itself. Crystalline glazes are fired to stoneware temperatures of 1260°C–1300°C/2300°F–2372°F/cone 8–10 but are actually over-fired, low-temperature glazes with very low alumina content. This makes the glaze very fluid and allows the crystals to float and freely arrange into a crystal formation during the firing. Critically, the recipe must contain zinc oxide or titanium dioxide and silica, which combine to make zinc-silicate crystals and act as the 'seed' to establish further crystal growth. Crystals can grow in a variety of intriguing ways, commonly as needle-like spurs that fan and spread across the surface. Colouring oxides such as cobalt, nickel or manganese are added to the glaze to promote desirable colours and often the glaze colour will separate, whereby the background colour will differ to the colour of the crystals. For example, nickel oxide can produce striking grey-blue crystals against an orange-tan background colour.

Crystalline glazes are generally not food safe and for decorative application only. They require a very precise firing schedule of soaking (holding) and cooling the kiln over a long period of time to achieve successful crystal growth. A kiln controller that can accommodate multiple ramps and segments (as outlined in the firing schedule below) will make this task much easier. As a result, these glazes can be incredibly runny and will require some sort of drip-catcher or pedestal saucer underneath to protect the kiln shelves and the piece itself. A coat of batt wash is applied to both the drip-catcher and base of the piece to prevent sticking and aid removal. After firing, the base of the piece is then lightly heated with a blow torch and detached from the saucer. Any surplus glaze is ground off and the base made good. Crystalline glazes are best applied to porcelain or smooth white stoneware clay body to act as a canvas and showcase the true beauty of the glaze. The glazes illustrated here were fired using the following firing programme, as advised by crystalline specialist, Matt Horne:

1. Set kiln temperature to 1260°C/2300°F/cone 8
2. When kiln reaches temperature – hold (soak) for ten minutes
3. Allow the kiln to cool to 1060°C/1940°F – hold for four hours
4. Increase the temperature to 1120°C/2048°F and hold for two hours
5. End of programme

SWCR1: Blue Crystalline
(Matt Horne)

Ferro frit 3110	47
Zinc oxide	24
Flint	19
Bentonite	3
+	
Cobalt carbonate	1.5

Notes: Large, feathery crystal growth. Refer to Chapter 5 to view extended palette of oxide percentages and colour range using this glaze recipe

SWCR2: Semi-Matt Brown-Blue Crystalline

High alkaline frit	52
Zinc oxide	22
China clay	22
Flint	4
+	
Nickel oxide	1
Cobalt carbonate	1

Notes: Shiny brown to matt blue. Try substituting high alkaline frit for ferro frit 3110

SWCR3: Yellow/Pink-Blue Crystalline

High alkaline frit	49
Flint	25
Zinc oxide	22
Lithium carbonate	4
+	
Rutile	6
Cobalt carbonate	1.5

Notes: Yellow-brown glaze with blue crystals

SWCR4: Blue-Green Crystalline

High alkaline frit	42
Zinc oxide	25
Flint	25
China clay	6
Titanium dioxide	2
+	
Cobalt carbonate	1
Copper carbonate	1

Notes: Green to blue in thinner areas

SWCR5: Brown/Orange-Turquoise Crystalline

Ferro frit 3110	42
Zinc oxide	25
Flint	25
China clay	6
Titanium dioxide	2
+	
Cobalt carbonate	1
Rutile	6

Notes: Rust brown to orange mottled texture with fine crystals

SWCR6: Yellow-Blue Crystalline

Potash feldspar	36
Zinc oxide	24
Flint	15
Whiting	13
Lithium carbonate	7
China clay	5
+	
Nickel	1

Notes: Light yellow with attractive blue crystals on thick areas

CRACKLE EFFECT

Very similar to crawl glazes, crackle or lichen-effect glazes are made with light, fluffy materials, such as magnesium carbonate or zinc that shrink and pull away as they dry, creating a surface that resembles a dried-out riverbed. Apply quite a thick layer (3–5mms) of the mixture on top of glazes, slips and coloured clay bodies for decorative effect.

SWC1		SWC2		SWC3	
Nepheline syenite	50	Nepheline syenite	50	Commercial glaze	50
Zinc oxide	50	Magnesium carbonate	50	Magnesium carbonate	50

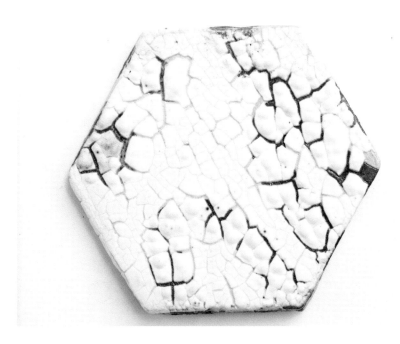

Crackle glaze SWC1 is applied thickly over a tile that has a combination of red terracotta and white clay. This has created an interesting contrast between the colours and textures of the crackle effect.

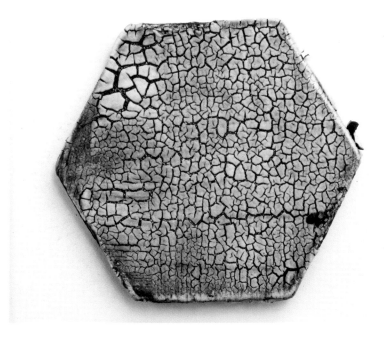

A washy coating of cobalt oxide is applied to the bisque tile and a crackle effect glaze painted on top. The cobalt has bled through the layers, giving an aged aesthetic.

REDUCTION GLAZES

Reduction-fired glazes offer a rich and beautiful palette of colours and textures. The varied nature of the firing allows for greater chance and interaction between results, which is very appealing. Many of the reduction glazes we use today, such as celadon and tenmoku, originate from East Asia and have been perfected over the centuries. Traditionally, the materials used to make these glazes would have been sourced locally, for example, rust (a source of iron) from the local blacksmith to colour the glazes, or straw and rice hull from the farmer's field to make ash glazes.

The following glazes have been categorized into colours and glaze types. All glazes in this section were fired in a gas-fuelled kiln to a temperature of 1280°C/2336°F/cone 9. Reduction was instigated from 900°C/1652°F, with medium reduction held to top temperature. The damper was opened and the kiln cooled to 1000°C/1832°F, then closed and the kiln left to cool down gradually. Refer to Chapter 4 for examples of reduction firing schedules. A mixture of grogged stoneware (White St Thomas), smooth white stoneware and porcelain was used for the tiles. Be mindful that due to the nature of the process, each kiln and firing will vary from one to the next and your results could differ from the examples illustrated below.

Neutrals

Any of these glazes can be developed further to make your own colours using oxides and stains (refer to the chart at the beginning of the chapter).

RN1: Smooth Blue-White		RN2: Satin White (Janice Tchalenko)		RN3: Stoneware Transparent	
Potash feldspar	65	Potash feldspar	55	Cornish stone	50
Whiting	10	China clay	15	Borax frit	35
Ball clay	7	Quartz	15	Flint	5
Flint	13	Whiting	10	China clay	5
Zinc	5	Talc	5	Whiting	5
		Notes: Excellent base glaze for colour additions		Notes: Blue + cobalt carbonate 0.25 Celadon + 1.5% red iron oxide	

RN4: Smooth White

Potash feldspar	40
Whiting	17
Flint	38
China clay	5

RN5: Satin Matt White

Cornish stone	70
Whiting	15
China clay	5
Zirconium silicate	10

RN6: Matt White
(Beate Kuhn)

Potash feldspar	22
Flint	40
Whiting	12
Magnesium carbonate	16
China clay	10

Notes: Prone to crawling when applied too thickly

RN7: White Rust Satin

Soda feldspar	47
China clay	20
Dolomite	24
Whiting	4
Zircon silicate	5

RN8: Creamy Matt Satin

Nepheline syenite	55
Whiting	16
Talc	13
China clay	16

RN9: Kuanko

Potash feldspar	80
Whiting	7
Flint	7
Wood ash	6

Notes: Thick, milky glaze with crazed surface.
Example on porcelain

R10: Classic Shino

Nepheline syenite	80
China clay	20

Notes: Apply quite thickly for crawled texture effect. Works well over glazes

Blacks and browns

Tenmoku is a traditional, iron-rich glaze (typically 8–12% red iron oxide), famed for its deep glossy black-brown colour that breaks to a rust on edges and rims. Variations of tenmoku include tessha – a black-brown glaze with substantial rust patches, and kaki – a rust-red/tomato colour all over.

TM1: Tenmoku
(Adapted from Fran Westerveld's recipe)

Cornish stone	47
China clay	11
Quartz	20
Whiting	14
Red Iron oxide	8

Notes: Rich, mottled texture ranging from rust red to black

TM2: Classic Tenmoku
(Shoji Hamada)

Potash feldspar	23
Quartz	40
Calcium carbonate	11
China clay	6
Wood ash	8
Red iron oxide	12

Notes: Reliable, consistent glaze

TM3: Oil Black-Brown Tenmoku
(Leach 4321 base)

Potash feldspar	40
Flint	30
Whiting	20
China clay	10
+	
Iron oxide	10

Notes: Example on smooth stoneware

TM4: Good All-Rounder Tenmoku

Cornish stone	70
Wollastonite	20
China clay	10
+	
Red iron oxide	11

Notes: Add 2–4% iron spangles to give textural effect. Example on smooth stoneware

TM5: Bronze-Black Tenmoku

Potash feldspar	42
Flint	27
Whiting	3
Borax frit	9
Dolomite	9
Zinc	2
Barium carbonate	5
China clay	3
+	
Red iron oxide	10

TM6: Gloss Black-Rust Tenmoku

Cornish stone	70
Wollastonite	20
China clay	10
+	
Red iron oxide	8

Notes: Example on smooth stoneware

TM7: Tessha		TM8: Kaki	
(Shoji Hamada)		(Kanjiro Kawai)	

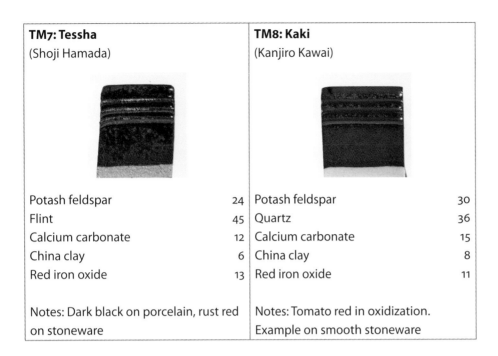

Potash feldspar	24	Potash feldspar	30
Flint	45	Quartz	36
Calcium carbonate	12	Calcium carbonate	15
China clay	6	China clay	8
Red iron oxide	13	Red iron oxide	11

Notes: Dark black on porcelain, rust red on stoneware

Notes: Tomato red in oxidization. Example on smooth stoneware

Greens, blues and greys

Celadon glazes have a serene and quiet presence that is incredibly beautiful. The delicate colour derives from a small amount of red iron oxide (0.5–3%) and is typically shades of grey-green to grey-blue. These examples were fired on a smooth stoneware body, unless specified differently.

CE1: Deep Celadon		CE2: Ying Ch'ing Celadon		CE3: Soft Blue-Green Crackle Celadon	
		(David Leach)			
Quartz	21	Cornish stone	25	Potash feldspar	80
China clay	27	China clay	25	Whiting	8
Potash feldspar	19	Whiting	25	Wollastonite	3
Wollastonite	33	Quartz	25	Flint	7
Red iron oxide	0.5	+		Bone ash	1
		Red iron oxide	0.5	Bentonite	1
				+	
				Red iron oxide	1.5

Notes: Example on porcelain (as used by potter Chris Keenan)

Notes: High craze when applied thickly

CE4: Green/Grey Celadon

Potash feldspar	45
Whiting	20
China clay	10
Flint	25
+	
Red iron oxide	2.5

CE5: Jade Green Celadon (David Leach)

Cornish stone	25
China clay	25
Whiting	25
Quartz	25
+	
Red iron oxide	2

CE6: Classic Celadon

Potash feldspar	40
Whiting	12
Barium carbonate	10
Flint	30
Zinc oxide	3
China clay	5
+	
Red iron oxide	3

CE7: Dark Green Celadon

Potash feldspar	45
Quartz	25
Whiting	17
China clay	9
Dolomite	4
+	
Bone ash	2
Red iron oxide	1

Notes: Olive green on iron-rich stoneware bodies

CE8: Yellow Celadon (David Leach)

Potash feldspar	31
Whiting	14
Quartz	33
Talc	12
China clay	7
Red iron oxide	3

Notes: Rich mustard yellow colour on porcelain

CE9: Pale Grey-Green Celadon

Cornish Stone	70
Wollastonite	20
China Clay	10
+	
Red Iron Oxide	1

OPALESCENCE

Opalescence is primarily an optical illusion caused by tiny bubbles within the glaze that scatter light, giving a bluish tint. Glazes that contain phosphorus materials such as bone ash or wood ash can develop this effect. Amounts of calcium borate frit, colemanite, rutile or titanium can also produce a similar quality in glazes. The ancient Chinese glaze Chun (Jun), is characterized by a light pale blue, opalescent colour on porcelain and stoneware. Chun-type glazes are often high in silica and low in alumina, and require quite a thick application (2-3mm) to achieve the best results. If applied too thinly, the glaze can appear transparent with none of the opalescent qualities. These types of glazes are prone to running so make sure to protect your kiln shelves from drips. The following glazes have opalescent qualities; try using in combination with other glazes by overlapping or applying on top to create mottled and streaked effects. Examples fired on smooth stoneware body, unless specified differently.

CH1: Pale Blue Chun (Derek Emms)

Potash feldspar	40
Flint	30
Whiting	20
Standard borax frit	10
+	
Talc	5
China clay	2
Red iron oxide	1

Notes: Example on porcelain

CH2: Opalescent Chun

Potash feldspar	38
Quartz	25
Calcium borate frit	18
Whiting	15
Dolomite	3
Bone ash	1

Notes: More opalescence in thicker areas. Add 0.25% iron oxide to create a blue-opal colour

CH3: Creamy Yellow Opalescent

Potash feldspar	50
Flint	23
Whiting	14
Zinc oxide	11
+	
Rutile	6
Copper carbonate	0.25

CH4: Pale Blue-Grey Chun
(Adapted from an original recipe by Nigel Wood)

Potash feldspar	45
Flint	29
Whiting	11
Dolomite	6.5
China clay	5
Bone ash	2
Red iron oxide	1.5

CH5: Iridescent Blue-Brown

Potash feldspar	71
Whiting	10
Talc	10
China clay	5
Red clay	4
Titanium	4
+	
Cobalt carbonate	0.25

CH6: Iridescent Dark Blue-Grey

Potash feldspar	50
Flint	23
Whiting	14
Zinc oxide	11
+	
Rutile	6
Cobalt carbonate	0.25

REDS

Copper-red glazes – also known as sang de boeuf (French, meaning 'oxblood') – originate from China and are famed for their spectacular colours, ranging from deep cherry-red to vivid purple-red. They are essentially low-alumina, high-alkaline glazes, and as the name suggests, the colour derives from a small amount of copper oxide or carbonate (0.25–2 per cent) which turns red in reduction. The addition of 1–5 per cent tin oxide to the glaze stabilizes the colour and helps maintain its intensity and brightness. Copper-red glazes can be a little tricky to perfect but the pay-off is especially beautiful. Like Chun glazes, copper-red glazes require quite a thick application and achieve better results when applied to porcelain or a smooth white stoneware clay body. They respond best to a moderate amount of reduction – if too heavy, this can dull the colour of the glaze.

CR1: Bright Gloss Red/Pink		CR2: Deep Red/Purple		CR3: Deep Red with Green Speckles	
Soda feldspar	45	Cornish stone	50	Soda feldspar	45
Quartz	17	Whiting	20	Quartz	17
Borax frit	15	Flint	15	Borax frit	15
Whiting	13	China clay	15	Whiting	13
China Clay	5	+		China clay	5
Tin oxide	5	High alkaline frit	2	Tin oxide	5
+		Copper carbonate	2	+	
Copper oxide	0.5			Copper oxide	2.5
		Notes: The addition of 2% Tin oxide will produce a dark-pink red purple. Example on porcelain		Notes: Reduce copper amount to 0.75% for lighter colour. Example on porcelain	
Notes: Example on porcelain					

CR4: Pale Pink-Red

Potash feldspar	42
Flint	27
Borax frit	10
Dolomite	9
Barium carbonate	5
Whiting	3
China clay	2
Zinc	2
+	
Tin	3
Copper carbonate	1

Notes: Will produce a speckly effect on grogged clay bodies. Example on smooth stoneware

CR5: Speckled Cherry Red
(Derek Emms)

Soda feldspar	42
Flint	19
Whiting	14
High alkaline frit	14
China clay	5
Tin oxide	5
Copper carbonate	1

Notes: Apply medium to thick for deep red colour, or thinly for pink blush. Example on porcelain

CR6: Rich, Glossy Red

Nepheline syenite	36
Flint	28
Borax frit	9
Barium carbonate	9
Whiting	9
China clay	5
Talc	4
+	
Tin oxide	5
Copper carbonate	0.5

Notes: Apply medium-thick for best results. Example on smooth stoneware

CR7: Sang de Boeuf
(Glynn Hugo)

Potash feldspar	35
Whiting	20
China clay	15
Quartz	20
Barium carbonate	10
+	
Tin oxide	3
Copper oxide	0.75

Notes: Example on smooth stoneware

CR8: Dark Pink/Red

Potash feldspar	40
Whiting	17
Flint	38
China clay	5
+	
Tin oxide	4
Copper oxide	2

Notes: Reduce copper amount to 0.5% for lighter colour. Example on smooth stoneware

CR9: Deep Copper Red

Nepheline syenite	38
Flint	25
High alkaline frit	10
Barium carb	9
Whiting	8
Talc	5
China clay	5
+	
Tin oxide	3
Copper carb	0.75

Notes: Example on grogged stoneware

OTHER USEFUL RECIPES

In this section are an assortment of useful, go-to recipes for other glaze and firing types that you might come across. These include:

Egyptian paste

A selection of artefacts made using the Egyptian paste recipe. The rich turquoise colour was achieved with the addition of copper oxide, and the deep blue colour was from cobalt oxide.

850°C–1000°C/1562°F–1832°F/cone 013–06
Egyptian paste is a self-glazing modelling material that can be used to make beads, amulets and small decorative items. It contains soluble alkali materials in the form of soda ash, therefore wear protective gloves when mixing and handling the material to prevent irritation of the skin. The examples here were fired to 1000°C (1832°F/cone 06).

Step by step

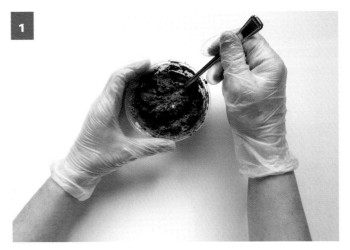

Combine the dry materials with a small amount of water until it reaches a dough-like consistency.

Gently knead the paste until smooth and all ingredients are blended.

Shape and sculpt the material as desired. For making beads, thread the clay on to a wooden stick and roll against a flat surface.

Soda feldspar	38%
Quartz (silica)	38%
Ball clay	12%
Soda ash	10%
Bentonite	2%

Additions:

Turquoise	Copper oxide	2%
Blue	Cobalt oxide	0.5–2%
Plum	Manganese dioxide	3%
Yellow	Vanadium pentoxide	4–6%
Or for colour add stain	4–8%	

With regards to firing, suspend beads on kanthal wire during drying and firing for a smooth and rounded shape. For free-standing or flat items, apply a coat of batt wash and lightly dust the kiln shelves with alumina powder prior to firing to prevent sticking.

Raku

950°C–1000°C/1742°F–1832°F/cone 08–06

Raku is a low-temperature, rapid firing technique that originated from Japan in the sixteenth century. The process involves quickly firing the wares, removing them from the kiln, and either leaving them in the open air to cool, or buried in combustible material to smoulder and reduce. The base recipes below are all clear crackle glazes but can be expanded with the additions for colour as listed separately.

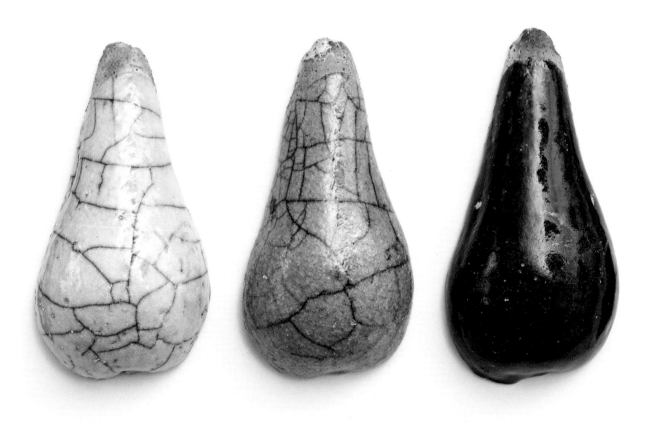

A beautiful array of rich colours can be achieved using raku techniques. Copper oxide will turn metallic copper if subjected to a heavy reduction but will fade back to turquoise as it reoxidizes over time. Left to right – examples of white tin, copper and cobalt raku glazes.

1)		2)		3)	
High alkaline frit	94	High alkaline frit	85	Borax frit	85
China clay	5	Whiting	10	China clay	10
Bentonite	1	Ball clay	5	Whiting	5
4)		**5)**		**Additions**	
Calcium borate frit	80	Calcium borate frit	75	Turquoise	
Soda feldspar	20	Nepheline syenite	13	Copper carbonate	1–4%
		China clay	12	Blue	
				Cobalt oxide	0.5–2%
				White	
				Tin oxide	4–8%
				Or	
				Zirconium silicate	8–10%
				Purple	
				Manganese dioxide	1–3%

Slips for wood, soda and salt glaze

A selection of high-alumina slips for wood firing, soda and salt firings. Paint or spray a very thin coat to bisque ware or raw pots prior to firing to create flashing effects and rich surfaces.

White Slip		**White-Tan Orange**		**Shino Orange**	
China clay	80	China clay	80	Nepheline syenite	60
Nepheline syenite	20	Nepheline syenite	10	AT ball clay	40
		Flint	10		
		+			
		Bentonite	5		
Orange-Red		**White-Pink Shino**		**White Orange**	
Nepheline syenite	40	Soda feldspar	30	China clay	40
China clay	50	Nepheline syenite	30	HVAR ball clay	40
AT ball clay	10	AT ball clay	40	Flint	10
Additions to try:					
Blue					
Cobalt carbonate	0.25–1%				
Yellow					
Titanium dioxide	8				
Pink-brown					
Rutile	3				

Ash glazes, for oxidization and reduction

1200°C–1350°C/2192°F–2462°F/cone 5–13

Wood ash has been used as a natural source of flux in glazes for centuries. The ash for these recipes can be washed or unwashed – both methods will yield attractive results. Refer to Chapter 2 for more information regarding processing and preparation of wood ash. It is also possible to substitute natural wood ash quantities in the listed recipes for synthetic wood ash (commercially prepared product which acts as a direct substitute).

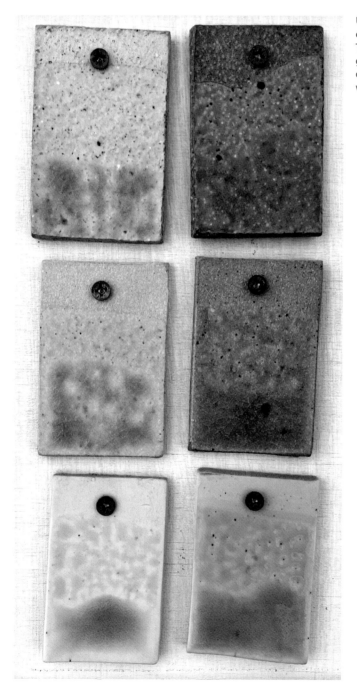

Using the recipe 50 per cent feldspar and 50 per cent wood ash, applied to different clay bodies. The top row is a grogged body, middle row – semi grogged and the bottom row is porcelain. The left column was oxidized fired and the right column was reduced.

1)		2)		3)	
Potash feldspar	50	Wood ash	40	Wood ash	40
Wood ash	50	Cornish stone	40	Potash feldspar	40
		Silica	20	Ball clay	20
4)		5)		6)	
Wood ash	40	Cornish stone	60	Wood ash	50
Cornish stone	35	Wood ash	40	China clay	50
Silica	25				
7)		8) Nuka Glaze (Phil Rogers)		Additions:	
Wood ash	50	Wood ash	34	Blue	
Potash feldspar	40	Potash feldspar	33	Cobalt carbonate	0.5–1%
Borax frit	10	Flint	33	Green	
				Copper carbonate	0.5–2%
		Notes: Traditionally rice hull ash would have been used in this recipe, but this can be substituted for general wood ash		Warm yellow	
				Red iron oxide	1–3%

Decorative slips

Apply to raw, leather-hard clay and bisque fire. Apply a transparent glaze over the top to enhance the colours further. Or use with a coloured honey or green shiny glaze in the style of traditional slipware.

Basic earthenware

Ball clay 100% (Hyplas 71, TWVD)

Basic stoneware

High plas 71	60
China clay	40

+

Oxides or stains for colouring effects

Blue	2% cobalt oxide or 8% blue stain
Green-blue	2% cobalt oxide & 2% copper oxide or 8% Persian blue stain
Black	8% black stain
Red-brown	4–6% red iron oxide
Yellow	8% yellow stain

Engobe

Vitreous slip – 1060°C–1280°C/1940°F–2336°F/cone 04-9. Apply to greenware or bisque ware. Use by itself (engobes are slightly self-glazing by nature) or in conjunction with glazes and brushwork.

Nepheline syenite	50
China clay	50

+

Oxides or stains for colouring effects as listed above

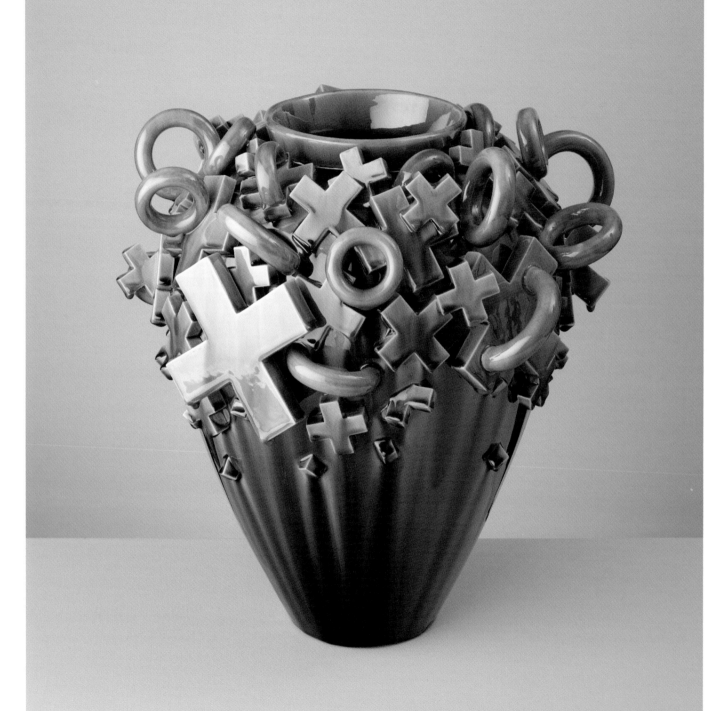

GLOSSARY

Ash

Raw material that derives from natural sources, the most common being wood, or straw. Ash is a natural source of silica and flux, and in combination with alumina such as china clay, it will produce a basic stoneware glaze with a firing range from cone 6 to 14.

Alkali metals

Oxides containing sodium, potassium and lithium. Typically used as primary fluxes in glazes.

Alkaline earths

Oxides containing magnesium, calcium, strontium and barium. Common sources of secondary fluxes.

Ball clay

Fine grained, highly plastic sedimentary clay, which fires to a white or buff colour. Used as a base for slip decoration.

Base

A core set of ingredients mixed together to create a foundation to carry different glazes and colours.

Batt wash

A layer of refractory slip applied to kiln shelves and furniture.

Bentonite

Very fine particle clay, highly plastic. Used to add plasticity to clay bodies and to help suspend glaze ingredients.

Bisque/Biscuit firing

The first firing of ceramicware – typically at a low temperature of 1000°C (1832°F). The purpose is to drive the water content off the clay to render it permanent and strong enough to accept glaze before its final firing.

Bisque/Biscuit ware

Unglazed ware that has been fired once. It provides a point whereby the ceramic is durable enough to receive a glaze before being fired a second time to melt the glaze and fuse it to the body.

Bone china – developed in the UK around the mid eighteenth century. A type of porcelain, the key ingredient consisting of bone ash derived from cattle bone. Typically, a high-fired slip casing clay body, pure white in colour and translucent. Bisque fired to approx. 1200°C (2192°F) and followed by a low-temperature glaze, 1080°C (1976°F).

Brush-on glaze

A type of thick glaze with added binder (CMC) that can be applied to bisque ware with a brush, without affecting the quality of the melt. Brush-on glazes are usually commercially prepared and bought from a pottery supplier.

Celadon

A light green-grey-blue stoneware and porcelain glaze. The colour derives from the addition of low quantities of red

◀ Joshua Aubrook, *As it Rains* (2021). H: 45cm. Thrown and assembled vessel, with carved additions. White earthenware, glaze fired to 1100°C (2012°F/cone 02). The artist imagines what ceramics will look like after the end of the world, with visions of the sky falling, breaking into pieces and raining down, collecting around the neck of this vase like ash, mounting into a collar of debris.

iron oxide in a base recipe, typically fired in a reduction atmosphere.

Ceramic
Any type of clay form that has undergone physical changes as a result of being fired in a kiln.

Ceramic fibre/blanket/paper
Refractory ceramic material with high temperature resistant properties. Used to insulate kilns or aid support when firing wares.

Chun
A traditional high-fire glaze, originating in China – characterized by vibrant iridescent blue and purple colours.

Clay
A naturally occurring material taken from the ground composed of fine materials that have derived from weathered granite and feldspathic rocks. Different clay bodies will vary in maturing temperature, strength and colour when fired.

CMC
Carboxymethyl cellulose, a water-soluble glaze binder and suspending agent.

Cone number
(*See* pyrometric cones.) Refers to the corresponding temperature point.

Contraction
A reversible physical shrinkage of clay or glaze during cooling.

Crawling
The beading or pulling of glaze into globules, exposing the clay body underneath. A technical fault caused by grease or dust on the ceramic wares prior to glaze firing, but can also be used for decorative effect.

Crazing
A series of fine cracks in the surface of a glaze caused by greater contraction of a glaze than the clay body. Typically a technical fault but used for decorative effect in raku technique.

Cristobalite
A crystalline form of silica, which forms in the clay body at temperatures above 1100°C (2012°F). Upon cooling, at 226°C (439°F) it undergoes a sudden volume change which can cause issues with cracking.

Crystalline
A glaze where crystals have grown during the firing.

Decal
Imagery or pictures printed on to ceramic transfer paper. Decals are usually applied to a fired-glazed surface, and then refired at a very low temperature. It is another name for a transfer.

Dipping
Applying a glaze or slip to ceramic ware by submerging or part-submerging the object into a liquid.

Dunting
Cracking in the ware caused by rapid cooling or surface tension from thick application of glaze.

Earthenware
Low-fired ceramics/pottery that has not been fired to the point of vitrification, therefore the body remains porous but can be made impervious to water by covering in a glaze.

Egyptian paste
A low-temperature, self-glazing medium that originated from Ancient Egypt, considered to be one of the earliest types of ceramic glaze.

Enamels
Low-temperature colours containing fluxes, typically applied to a fired-glazed surface and refired. Also known as on-glaze or china paints.

Engobe
A white or coloured vitreous slip containing flux which renders it somewhere between a glaze and slip. It is applied to biscuit ware (rather than leather-hard clay) before firing.

Eutectic
The lowest melting combination of two materials.

Extruder
A tool used to compress clay through a die to form continuous lengths of clay in various shapes. Used to make coils, handles, test tiles, tubes and more.

Expansion
The reversible swelling of clay or glaze during heating. Also known as thermal expansion.

Flashing
The visual effect created on a clay or glaze surface when in contact with a direct flame.

Frit
The mixture of silica and fluxes that have been fused at high temperature to make a glass that is ground down into a fine powder. Frits are used in glazes to supply an insoluble form of toxic oxides, such as lead or boron, that would be too harmful to use in their raw state.

Flux
The function of a flux is to lower the melting point of the main glass formers in glazes, clay bodies and other ceramic materials. Fluxes also influence colour, strength and durability of a glaze.

Glaze
A thin coating of glass fused to the clay body.

Glaze fit
Term given to the thermal expansion compatibility between glaze and clay body.

Grog
Coarse-ground refractory material added to a clay body to provide strength and 'tooth'. Grog can aid drying, and reduce the overall shrinkage, minimalising the risk of cracking and warping.

Green ware
Raw, unfired, clay ware.

Heat work
The amount of heat a piece of ceramic has been subjected to during a firing, represented in terms of time and temperature. Heat work is measured by pyrometric cones placed inside the kiln.

Kiln
Piece of equipment or built chamber used to fire ceramic wares. Kilns can be fuelled by electric, gas, oil or wood.

Maiolica (Majolica)
Decorated tin glaze earthenware, with applied colourful decoration on top of the raw glaze, which originated from the Mediterranean around the fifteenth century.

Matt (or matte)
A soft, non-reflective surface.

Maturing point
The temperature at which the clay and glaze become hard and durable.

Mid fire
Glaze firing temperature point between 1200–1240°C (2192–2264°F).

Melting point
The temperature at which a given material will melt from a solid to a liquid.

On-glaze
Applying decoration using oxides or stains directly on top of a glaze, typically a tin glaze (*see* Maiolica).

Opaque
When the glaze colour is not transparent, it hides the colour of the surface it is covering.

Oxide
The chemical combination of oxygen with another component such as metal (for example copper oxide).

Oxidization
Firing where a sufficient oxygen supply is present throughout, for example an electric kiln.

Phosphorus
Present in bone ash and wood ash, phosphorus has glass-forming properties and can add opalescent, bluish tints to glazes.

Pyrometric cones

Slim pyramids of ceramic material designed to soften and bend at specific temperature points in correlation to time, to gauge the heat work during the firing.

Prop

A refractory pillar or piece of kiln furniture used to support shelves during firing. A prop can also be a clay support which bears the weight of a piece as it dries to help maintain a specific position.

Raku

A rapid-firing technique in which pots are placed in a kiln chamber and fired to 1000°C (1832°F). The pots are removed red-hot and left to cool. In Western raku, the pots are transferred to a pit to smoulder in combustible material such as sawdust or hay to create a heavy reduction atmosphere. After a period of time, the pots are plunged into a bucket of water to produce attractive crackle effects.

Recipe

A list of ingredients that constitute a glaze

Reduction

The process of reducing the amount of oxygen present in the kiln chamber during a firing to cause a chemical change to occur in oxides present in clay and glazes – resulting in unique colours and surfaces.

Salt firing

A process whereby parcels of salt (sodium chloride) are added to the chamber of a kiln at top temperature (cone 9–14) in a reduction atmosphere. The salt volatises and reacts with the silica present in the clay body and slips, causing a distinctive orange peel effect.

Sang de boeuf

A deep red reduction glaze produced by the addition of copper oxide. Sang de boeuf translates as 'oxblood'.

Silica

Silicon dioxide – the primary glass former in all glazes. Found in flint, quartz or sand.

Shino

Traditional Japanese glaze, characterized by high iron content which creates black to red colours. Shinos with high feldspar content can be used to create desirable crawling and textural effects when applied thickly.

Sieving

The process of removing impurities or lumps by putting glaze, slip or clay through a metal mesh of variable grades.

Semi-matt

Part shiny, part matt surface.

Sgraffito

An Italian word for 'scratch back'. The method involves simply drawing through layers of slip to reveal the clay body underneath, creating a striking contrast.

Soak

Holding the temperature in the kiln at a specific point to even the distribution of heat and bring glazes and clay body to a point of maturity.

Soda firing

The process of adding soda (sodium carbonate) or common salt in the kiln chamber at high temperatures to produce a glaze surface.

Stains

A type of frit, whereby metal oxides and ceramic materials are combined through a refractory process to produce reliable, consistent colours that can be added to a clay body or glaze. Stains are very good for achieving vibrant colours such as yellows, blues and reds.

Stilts

Small triangular or rectangular shapes of refractory material, often with metal or wire spurs that lift the piece away from the kiln shelf, allowing for a complete coating of glaze. Particularly useful as a way to seal earthenware where the body remains porous.

Stoneware

Vitrified clay body fired above 1200°C (2192°F).

Test tile

A sample of a trial glaze to examine specific qualities and desirable traits that could be used in application.

Tenmoku

A stoneware glaze heavily coloured by iron oxide. Typical colours range from black through to rust browns.

Thermal shock

The sudden expansion or contraction of clay or glaze as a result of extreme temperature change (hot to cold) that can cause it to break.

Transparent

Clear base glaze or material that is free of colour or opacity.

Refractory

Ceramic materials that are resistant to high temperatures.

Resist techniques

The application of a decorative medium such as wax or latex to a ceramic object to repel glaze.

Vitrification

The fusion of material or body during the firing process around 1200°C (2192°F), rendering it non-porous and impervious to water.

Underfired

Clay or glaze has not reached temperature during the firing and therefore the material has not melted or matured sufficiently.

Underglaze

A colour applied to either green ware or bisque surface, followed by a coating of glaze.

Unity molecular formula (UMF)

Developed by Hermann Seger in the nineteenth century, the Seger formula or UMF is a method to analyse glazes based on molecular weights instead of raw material weights.

Wood firing

Firing ceramic wares in a kiln using wood as a source of fuel. Ash from the wood deposits on the wares, reacts with the silica in the clay body and slips producing beautiful, random effects.

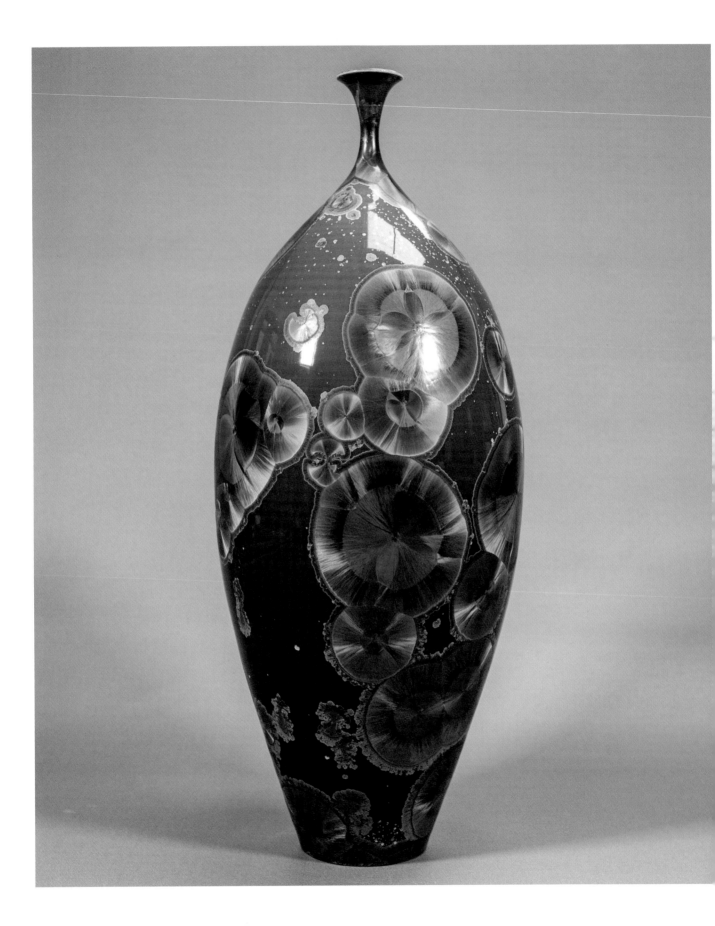

APPENDICES

APPENDIX 1:

Orton cone reference chart

Pyrometric cones are made from a blend of ceramic materials and their purpose is to measure heat work during the firing. A slower temperature climb will cause the cone to melt at a lower temperature.

Cone number	60°C/hour	108°F/hour	150°C/hour	270°F/hour
09	917	1683	928	1702
08	942	1728	954	1749
07	973	1783	984	1805
06	995	1823	985	1852
05	1030	1886	1046	1915
04	1060	1940	1070	1958
03	1086	1987	1101	2014
02	1101	2014	1120	2048
01	1117	2043	1137	2079
1	1136	2077	1154	2109
2	1142	2088	1162	2124
3	1152	2106	1168	2134
4	1160	2120	1181	2158
5	1184	2163	1205	2201
6	1220	2228	1241	2266
7	1237	2259	1255	2291
8	1247	2277	1269	2316
9	1257	2295	1278	2332
10	1282	2340	1303	2377
11	1293	2359	1312	2394
12	1304	2379	1324	2415
13	1321	2410	1346	2455
14	1388	2530	1366	2491

◀ Matt Horne, *Green & Blue Bottle Form* (2022). H: 49cm. Hand thrown in porcelain, crystalline glaze. The artist uses a complex firing schedule of multiple ramps and soaking periods to create unique crystal growth formation. The kiln is fired to a maximum temperature of 1300°C (2372°F/cone 10).

APPENDIX 2:

UK–US material equivalents
Equivalent materials with similar composition

UK Material	US Equivalent
High alkaline frit	Ferro 3110, Pemco P-25
Low expansion frit	Ferro 3249
Borax frit	Ferro 3124, Pemco-54, Gerstley borate, Gillespie borate
Calcium borate frit	Ferro 3134, Ferro 3195, Colemanite
China clay (kaolin)	Kaolin (EPK), Georgia china clay, Tile 6 Kaolin, Grolleg kaolin
Cornish stone	Cornwall stone, Carolina stone, Kona A-3,
Potash feldspar	Custer feldspar, G-200, K-200, Mihavir feldspar
Soda feldspar	Kona F-4, Spruce Pine, NC 4, Minspar 200, Unispar 50
Flint, quartz	Silica
Fremington red clay	Alberta slip, Red Art
AT ball clay	Kentucky OM-4 ball clay
Hyplas 71 Ball clay	Kentucky stone
HVAR ball clay	Tennessee ball clay
Zirconium silicate	Zircopax, Superpax, Ultrox
Commercial stains	Mason Stains

SUPPLIERS

UK

Bath Potters' Supplies
www.bathpotters.co.uk

Clayman
www.claymansupplies.co.uk

Ceramatech Ltd
www.ceramatech.co.uk

CTM Potters Supplies (Exeter)
www.ctmpotterssupplies.co.uk

Hesketh Potters' Supplies
www.heskethps.co.uk

Potclays Ltd
www.potclays.co.uk

Potterycrafts
www.potterycrafts.co.uk

The Potter's Connection
www.pottersconnection.co.uk

Scarva Pottery Supplies
www.scarva.com

Top Pot Supplies
www.toppotsupplies.co.uk

Valentine Clays Ltd
www.valentineclays.co.uk

W.G. Ball Ltd
www.wgball.co.uk

United States & Canada

American Art Clay Company – Amaco
www.amaco.com

Axner
www.axner.com

Big Ceramic Store
www.bigceramicstore.com

Bailey Ceramic Supplies
www.baileypottery.com

Laguna Clay
www.lagunaclay.com

Minnesota Clay Co.
www.mnclay.com

Tuckers Pottery Supplies Inc
www.tuckerspotteryeshop.com

Laboratories for leach testing of glazes

Lucideon
www.lucideon.com

BSC Labs
www.bsclab.com/pottery-testing

CONTRIBUTORS

Artists

Joshua Aubrook
www.joshuaaubrookceramics.co.uk
Photo: Justin Webb Photography

Anna Barlow
www.annabarlowceramics.co.uk
Photo: Jose Esteve

Matthew Blakely
www.matthewblakely.co.uk
Photo: by artist
Image of wood kiln courtesy of the artist

Linda Bloomfield
www.lindabloomfield.co.uk
Photo: Henry Bloomfield

Paul Briggs
psbriggs.com
Photo: by artist

Alma Boyes
www.almaboyes.co.uk
Photo: Simon Punter

Rachel Cox
www.rachelcoxceramics.com
Photo of artwork and sketchbook by Justin Webb Photography

Melisa Dora
www.melisadora.com
Photo: by artist
Chapter 5 additional images courtesy of the artist, photography by Alexander Edwards

Tessa Eastman
www.tessaeastman.com
Photos: Agata Pec (pages 8 and 172) and Lorenzo Belli (page 87)

Tanya Gomez
www.tgceramics.co.uk
Photo: Jonathan Basset
Firing chapter 8 reduction test tiles

Matt Horne
www.matthornepottery.co.uk
Photo: by artist

Lisa Katzenstein
www.lisakatzenstein.com
Photo: Alex Brattell

Chris Keenan
www.chriskeenan.co.uk
photo: Michael Harvey

Russell Kingston
www.russellkingstonceramics.co.uk
Photo of jug: by artist
Photo of kiln and artist portrait by Jessica Turrell

Katharina Klug
www.katharinaklugceramics.com
Photo: Zuza Grubecka
Process images of wax crayons courtesy of the artist, photographed by Layton Thompson

Emma Lacey
www.emmalacey.com
Photo: by artist
Additional images courtesy of the artist and Yeshen Venema

Agalis Manessi
www.agalismanessi.com
Photo: Rob Kesseler

Albert Montserrat
www.albertmontserrat.co.uk
Photo: by artist
Image of artist spraying glaze by Ben Boswell

Louisa Taylor
www.louisataylorceramics.co.uk
Cornflower, Lemon decanter, Tutone pots, Ven photographed by Matthew Booth
Jug pots photographed by Ben Boswell
Additional photography supplied by author

Anna Silverton
www.annasilverton.com
Photo: Justin Webb Photography

Jonathan Wade
Jwadeceramics.com
Photo: by artist
Wood ash process images courtesy of the artist

Supporting contributors

Glazy.org
Derek Au
Licence number: CC BY-NC-SA 4.0

Orton Ceramic Foundation
www.ortonceramic.com
Pyrometric cones

Simon Punter
General photography and process images

Tony Seddon
Chapter 5 illustrations

David Shaw
Raku kiln

Veega Tankun
Front cover & Chapter 8 glaze tiles

University of Brighton
Use of premises for photography, glaze preparation and firing

BIBLIOGRAPHY

Bloomfield, Linda. 2020. *Special Effect Glazes.* Herbert Press

Bloomfield, Linda. 2018. *The Handbook of Glaze Recipes.* Herbert Press

Bloomfield, Linda. 2017. *Science for Potters.* American Ceramic Society

Bloomfield, Linda. 2012. *Colour in Glazes.* A & C Black

Britt, John. 2014. *The Complete Guide to Mid-Fire Glazes: Glazing & Firing at Cone 4-7.* Lark Books

Britt, John. 2004. *The Complete Guide to High-Fire Glazes: Glazing & Firing at Cone 10.* Lark Books

Constant, Christine and Ogden, Steve. 1996. *The Potter's Palette.* Quarto

Cooper, Emmanuel. 2004. *The Potter's Book of Glaze Recipes.* A&C Black

Currie, Ian. 2000. *Revealing Glazes using the Grid Method.* Bootstrap Press

Daly, Grey. (2013). *Developing Glazes.* Herbert Press Ltd

Eden, Michael and Victoria. (1999) *Slipware – Contemporary Approaches.* A&C Black

Fraser, Harry. 1973. *Glazes for the Craft Potter.* Pitman

Fraser, Harry. 1994. *The Electric Kiln.* A&C Black Publishers Ltd

Green, David. 1978. *A Handbook of Pottery Glazes.* Faber and Faber

Hamer, Frank & Janet. 2004. *The Potter's Dictionary of Materials and Techniques.* A&C Black Publishers Ltd

Kline, Gabriel. 2018. *Amazing Glaze.* Voyageur Press

Levy, Matt; Shibata, Takuro; Shibata, Hitomi. 2022. *Wild Clay: Creating Ceramics and Glazes from Natural and Found Resources.* Herbert Press

Mathieson, John. 2005. *Raku Ceramics Handbook.* A&C Black Publishers Ltd

Murfitt, Stephen. 2002. *The Glaze Book.* Thames and Hudson

Oesterritter, Lindsay. 2019. *Mastering Kilns and Firing.* Quarry Books

Parmelee, C.W. 1973. *Ceramic Glazes.* Revised by C.G. Harman, Third edition, Cahners Publishing Company

Rhodes, Daniel. 1989. *Clay and Glazes for the Potter.* Chilton Book Company

Rogers, Phil. 2002. *Salt Glazing.* A&C Black Publishers Ltd

Rogers, Phil. 2023. *Ash Glazes.* Third Edition. Herbert Press Ltd

Taylor, Brian & Doody, Kate. 2014. *Ceramic Glazes: The Complete Handbook.* Thames and Hudson

Tudball, Ruthanne. 1995. *Soda Glazing.* A&C Black

Wood, Nigel. 2011. *Chinese Glazes.* A&C Black

Colour theory

Batty, Patrick, et al. 2021. *Nature's Palette.* Thames and Hudson

Fine, Aaron. 2021. *Colour Theory: A Critical Introduction.* Bloomsbury

Perryman, Laura. 2021. *The Colour Bible: The Definitive Guide to Colour in Art & Design.* Ilex Press

St Clair, Kassia. 2016. *The Secret Lives of Colour.* John Murray Publishers

REFERENCES

Digital Fire
www.digifire.com

Matt & Rose Katz
Ceramics Material Workshop
www.ceramicsmaterialworkshop.com

Glazy
www.Glazy.org

Ceramic Arts Daily
www.ceramicartsdaily.com

Ceramics: Art and Perception
www.ceramicart.com.au

Ceramics Monthly
www.ceramicsartdaily.org

Ceramic Review
www.ceramicreview.com

Studio Pottery
www.studiopottery.co.uk

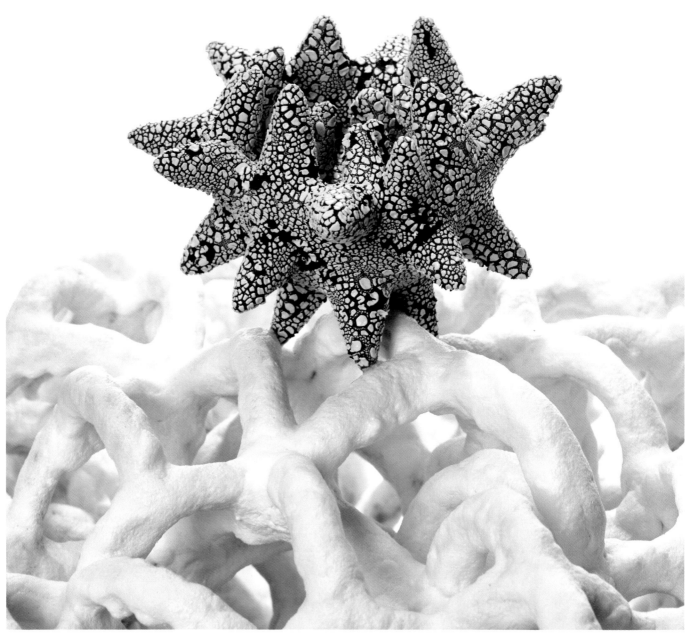

Tessa Eastman, *Pollinating Creature on Low Density Snow Cloud* (detail), 2021. L: 40 x W: 40 x H: 40cm. Hand-built, multiple glazed stoneware to 1240°C (2264°F).

INDEX

Entries in bold indicate main content.

Dedication

For my parents, Carol & Stuart Taylor

Acknowledgements

I would sincerely like to thank everyone who has supported me through the production of this book, particularly my husband Matt, our children, family and friends. Special thanks to Eusebio Sanchez, Tanya Gomez, Hannah Redfern Hughes, Jonathan Wade and Melisa Dora for their generous help and assistance. Thank you to The Crowood Press for the opportunity to write this book, and everyone from the 3D Design & Craft course at the University of Brighton for supporting the project. I am very grateful to Linda Bloomfield and Matt Horne for their expert advice and guidance, and Jo Taylor for the introduction to The Crowood Press. I would also like to thank all the fantastic artists and their photographers who have contributed to this book. I am indebted to the photographic talents of Veega Tankun and Simon Punter, and graphics by Tony Seddon. I would also like to extend my thanks to the generosity of the ceramics community, especially Felicity Aylieff and the late Emmanuel Cooper who sparked my interest for glaze when I was a student. Finally, this book is in memory of my friend Janice Tchalenko, who really was the ultimate glaze queen and inspired so many.

First published in 2023 by
The Crowood Press Ltd
Ramsbury, Marlborough
Wiltshire SN8 2HR

enquiries@crowood.com
www.crowood.com

This impression 2024

© Louisa Taylor 2023

British Library Cataloguing-in-Publication Data
A catalogue record for this book is available from the British Library.

ISBN 978 0 7198 4240 5

Cover design by Sergey Tsvetkov

Frontispiece: Albert Montserrat, *Frog #1 White and Black Vessel* (2021), Height: 19.5cm. Thrown porcelain vessel, finished with a combination of glazes and fired to 1300°C (2372°F/cone 10).

Typeset by Envisage IT
Printed and bound in
India by Nutech Print Services - India